For
Matt & Beth,

All things food was
released by Dean Edward
O'Connor and distributed
November 4, 2007.
Enjoy a taste from home!

Merry Christmas 2007!

Love,
Aunt Jeffrey

All Things Good

Palates & Palettes of the Cathedral Parish of Saint Andrew

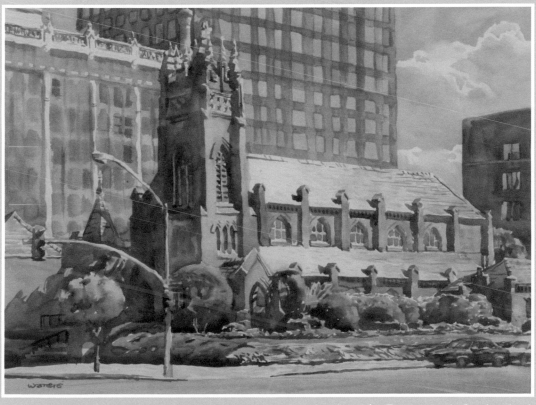

St. Andrew's Episcopal Cathedral
Jackson, Mississippi

All Things Good

Palates & Palettes of the Cathedral Parish of Saint Andrew

ISBN 978-0-9800152-0-1

The purpose of this book is to strengthen the church community within St. Andrew's Episcopal Cathedral by working together for a common goal. All proceeds from the sale of this book will be used for the glory of God and in support of the outreach ministries of St. Andrew's Cathedral. For a complete listing and more information, see page 308.

Front and back cover artwork are paintings by Miriam Wilson Weems, popular local artist and communicant of St. Andrew's Cathedral.

Title page art by Wyatt Waters.

To order: www.standrewscathedral.org or call 601.354.1535

All Things Good
P.O. Box 16965
Jackson, MS 39236-6965

Photography of artwork by Greg Campbell Photography, Inc.

Disclaimer: No claim is made as to the originality of these recipes.
However, they have been tried, tested, adapted, adopted, adored, and enjoyed!!

WIMMER
COOKBOOKS

A CONSOLIDATED GRAPHICS COMPANY

800.548.2537 wimmerco.com

\mathscr{T}ABLE OF \mathscr{C}ONTENTS

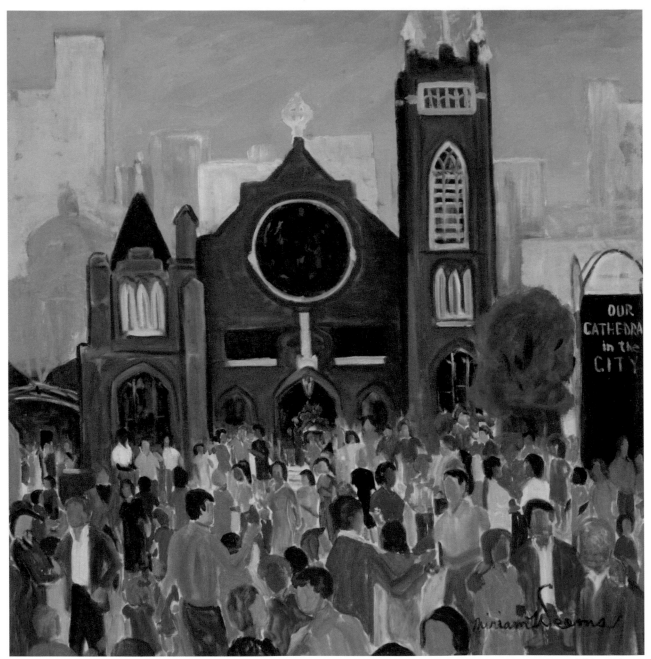

Miriam Weems

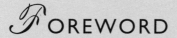

FOREWORD

John Fontaine

The people of St. Andrew's have been known through the years for faithfully following at least one biblical injunction: "Feed my sheep." This collection of prized personal and family recipes shows how well the sheep have been fed. So, go and do thou likewise.

St. Andrew's not only feeds its own but for over a half century has made an organized effort to feed the needy. First, was the Families in Crisis Service that included a small stock of ready-to-eat canned goods. Then came the joint effort of Stewpot and its much expanded food pantry, local Meals on Wheels, and daily noonday meals. Today, St. Andrew's also extends hospitality to the homeless at the weekly Tuesday breakfast.

For years, the Fall Bazaar included a showcase of parishioners' culinary skills and attracted crowds downtown. The first dietitian presiding over food service was the diminutive Becky Lipscomb. Her plate lunches were a feature of the Bazaar. Hamburgers were dressed with Bessie Saik's famous cole slaw. In an early kitchen remodeling, the old unsightly big griddle had been removed. Becky demanded its return because there was now no way to cook all those Bazaar hamburgers. The present commercial kitchen was guided to completion in honor of Jane Brock, another of our favorite food folk.

Bill Phelps and Jack McIntyre cooked Bazaar turkeys and hams on a battery of hickory smokers in the courtyard. An occasional nip of the bourbon stashed in the bushes behind them made recruiting assistants an easy task since that was one of the rewards.

This cookbook also commemorates and celebrates some memorable food folk at St. Andrew's. What better model than our own Winifred Green Cheney and her cookbooks of original regional recipes.

Ida Anderson was the second dietitian and trained her successor, Juanita Jefferson, for the transition to a fulltime position. Before Juanita's retirement, Edgar Glover became sexton and her collaborator. He's now also a sometime chef as well as a host at the Tuesday breakfasts.

At some break in the succession was the brief reign of Willie Braxton, best remembered for elaborate Lenten breakfasts that were feasting and not fasting. We had Mardi Gras all through Lent. Willie was so zealous as chief chef that he would arrange Velveeta cheese topping the spaghetti in the shape of a cross when the Bishop came to visit! We all breathed a sigh of relief when he stopped short of dyeing the pasta purple.

Now, it's your turn to become one of the food folk noted for feasting all year long. It's all here in the St. Andrew's Cookbook of 2007…tested, tried, and true. All Things Good! Enjoy!

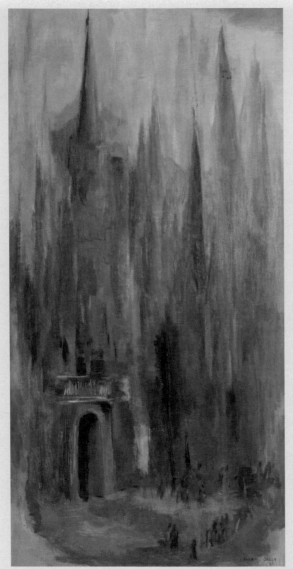

Myra Green

\mathscr{I}NTRODUCTION

Dorothy Hannah Kitchings

". . .our three basic needs, for food and security and love are so mixed and mingled and entwined that we cannot straightly think of one without the others."

~M.F.K. Fisher

In the foreword to her book, The *Gastronomical Me*, the late food and fiction writer M.F.K. Fisher wrote, "There is a communion of more than our bodies when bread is broken and wine drunk." We Episcopalians at St. Andrew's agree. We love the sense of warmth and goodwill when we eat together. After all, we are a Eucharistic people, sharing the bread and wine every Sunday in a communion that feeds us with spiritual food, warms our hearts as well as our bodies, fills us with goodwill toward each other, and sends us on our way with uplifted spirits.

When we hear the dismissal each Sunday, urging us to "Go in peace to love and serve the Lord," we leave the nave knowing that "loving and serving the Lord" means loving all our fellow human beings. There are many ways we show that love. One way is by cooking and eating at home with our families and friends. Another is to get better acquainted with our fellow parishioners at some of our many church meals: the suppers on Wonderful Wednesdays, the annual Mardi Gras Pancake Supper where we *laissez les bon temps rouler,* and the pig roast on Stewardship Sunday. We gather in Foyer groups and make new church friends over suppers in our homes, we bring potluck to our small-group meetings, and no committee functions without food. And, of course, food is an essential when we celebrate a wedding or console those who are sick or in mourning.

We also take seriously our Lord's command to share food with the needy. To help those who are hungry we serve breakfast on Tuesdays to the homeless and send loads of food to Stewpot where some of us serve. We also prepare meals and deliver them for Meals on Wheels. Food is a common need, no matter who we are, and we who have much share gladly with those who have little.

When the idea of a St. Andrew's cookbook emerged, many exclaimed, "What could be more appropriate?" When the group who conceived the idea (cooking in the church kitchen) made its presentation to the Vestry, our leaders were enthusiastic, with one suggesting that we call our work "gastro-evangelism." The Vestry gave the green light to the project.

Soon after, the very appropriate title: *All Things Good: Palates and Palettes of the Cathedral Parish of Saint Andrew* was selected. The subtitle not only refers to the enjoyment of good food, but also to the enjoyment of the beautifully-crafted paintings, created or owned by our own parishioners, gracing the pages of this book.

Apparently the congregation agreed that we should have a cookbook, for more than 1000 recipes were submitted! This shower of culinary treats reminded the Cookbook Committee that food is indeed a powerful tie that binds. We have read all these recipes and also the amusing anecdotes

and comments that accompanied some of them. We could not resist including a number of these in the pages that follow. A flock of generous volunteers then tested the recipes, bringing the number of communicants involved in this project into the hundreds.

St. Andrew's has been blessed with a number of memorable cooks in our past, both in the congregation and among the professionals who have reigned over the Cathedral kitchen, appropriately dedicated to the memory of a great cook among us, Jane Brock. Their names and some of their recipes have a place in these pages. They left us a tasty gastronomical legacy.

The chief aim of making this book was to bring us together more often, to get to know more of our fellow members and to encourage a sense of camaraderie. This we have surely achieved, but the binding work of the cookbook will go on as we share our experiences with these delicious recipes. We are grateful that the task of organizing this cookbook produced in us a deeper appreciation for each other and for our various gifts.

Finally, here is a word for those who don't cook. This book is for you too. We subscribe to the philosophy of William Makepeace Thackeray who wrote, "Next to eating good dinners, a healthy man [or woman] with a benevolent turn of mind must like, I think, to read about them." With much pleasure the Parish of St. Andrew's presents *All Things Good.*

Enjoy!

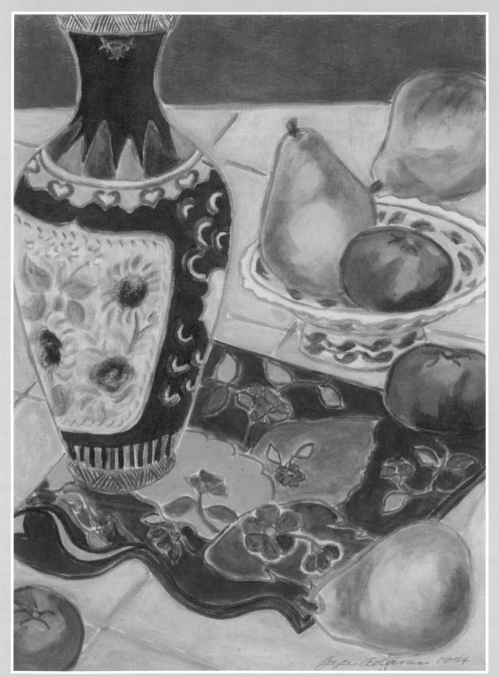

Gayle Adams

"They eat, they drink, and in communion sweet quaff immortality and joy."

~ Milton

Appetizer: that wonderful bite-sized savory, a small food that excites the appetite or gives relish before dinner—a combination of flavors, unexpected, even mysterious, but oh, so good!

Appetizers these days tend to be lighter than in years past, but nonetheless delicious, promising the guest a tasty dinner within the hour. In fact, an entire table full of appetizers can serve as dinner, and we call the event a cocktail buffet.

All Things Good, however, cannot ignore the gastronomic memories of some of our communicants, like John Fontaine, one of our unofficial archivists, who contributed a recipe for Sardine Canapé Allison's Wells. This dish was a childhood favorite of his at his family's resort north of Canton, now the site of Gray Center. Served as a first course, this dish also pleased the hotel guests as well. In tune with today's need for faster preparation, a simpler, also very appetizing, version of the recipe lies on page 12.

Another one of us, Tay Wise, is herself noted for her delicious and numerous appetizers. Tay and Sherwood's many guests remember that at their dinner parties almost every table in the living room held a platter or bowl containing a different one of these toothsome treats. Some of these guests may remember the night when there were so many appetizers that everybody, including the hosts, forgot about dinner! The Wise children were so accustomed to Tay's many appetizers that one of them, noticing a bowl of something enticing on a table near the front door, plopped into his mouth a handful of potpourri and chewed it up with a somewhat puzzled look.

We may not serve so many appetizers these days, but when we serve just one succulent, hot or cold delicacy before dinner, our guests are immensely pleased and so are we.

\mathcal{A}PPETIZERS

\mathscr{S}ARDINE \mathscr{C}ANAPÉ (\mathscr{S}IMPLIFIED)

Cut rounds of thin white bread, using a large biscuit cutter. Lightly toast the rounds of bread. Place on top the following:

Slice of peeled tomato ½ hard-boiled egg, point up

2 sardines

Pour homemade mayonnaise thinned with fresh lemon juice over the egg. Add a dash of paprika and a sprig of parsley.

\mathscr{S}ARDINE \mathscr{C}ANAPÉ \mathscr{A}LLISON'S \mathscr{W}ELLS

8	rounds of bread (Use large biscuit cutter and toast lightly.)	24	small sardines packed in oil. Use 3 per canapé
8	(¼-inch) thick slices of firm tomato, such as Beefsteak	4	hard-boiled eggs, halved lengthwise for pointed ends

Boiled dressing (recipe below) or, as a shortcut, ½ cup Durkee's dressing thinned with 1 tablespoon each olive oil and lemon juice. On individual salad plates, layer ingredients in order given. Spoon warm or chilled dressing over the assembled canapés. Sprinkle with paprika and garnish with sprigs of parsley, chicory, or watercress. Serves 8.

FOR THE BOILED DRESSING

1	tablespoon sugar	½	cup wine vinegar plus ¼ cup water
1	tablespoon dry mustard	¼	cup warm whole milk
1	tablespoon flour	1	tablespoon olive oil
1	teaspoon salt	1	teaspoon Worcestershire sauce
2	eggs plus 2 tablespoons water before beating		*dash of Tabasco if desired

Stir together sugar, mustard, flour and salt. Beat eggs until just fluffy. Stir in vinegar and then dry ingredient mix. Cook over medium heat in a non-aluminum saucepan until thickened. Stir frequently. Do not boil. Stir in milk and olive oil. Leftover dressing is good in chicken salad or as a dip for raw vegetables.

Basil Pesto Torte

8 ounces provolone cheese, thinly sliced
½ (8-ounce) package cream cheese, softened
4 tablespoons butter, softened
¾ cup basil pesto

1 roasted red pepper, chopped, or
1 (4- to 6-ounce) jar sun-dried tomatoes, drained and chopped
¼ cup pine nuts, lightly toasted
fresh basil for garnish

Line a 3-cup loaf pan with plastic wrap, allowing wrap to hang over the sides. Arrange a thin layer of provolone cheese slices on the bottom and sides of pan.

Blend cream cheese and butter with a fork. Mix in pesto. Spread one-third of mixture over cheese slices in bottom of pan. Top with half of the roasted pepper and sprinkle with 1 tablespoon pine nuts.

Repeat cheese, pesto, pepper and pine nut layers, pressing down between layers, ending with a third layer cheese and then pesto. Refrigerate until firm.

To serve, invert torte onto a serving dish. Decorate with remaining pine nuts and fresh basil. Serve with crackers.

Yield: 6 to 8 servings

Appetizers

Savory Taco Cheesecake

3	(8-ounce) packages cream cheese, softened
2	eggs

1	(1.25-ounce) package dry taco seasoning
2½	cups shredded Monterey Jack cheese

TOPPINGS

quartered grape tomatoes
diced red, green and yellow bell peppers

sliced ripe olives
thinly sliced green onion

Beat cream cheese until smooth. Add eggs, one at a time, until well blended. Add taco seasoning and cheese and mix well. Spoon mixture into a greased 8- or 9-inch springform pan.

Bake at 350 degrees for 30 minutes or until done. Cool completely in pan. Place pan on a serving platter and remove sides of pan. Sprinkle with toppings. Serve with crackers of your choice.

Yield: 18 servings

This was served at a reception at St. John's Church, Pascagoula, for the Bishop and a group of confirmands. For smaller groups, recipe may be halved or quartered.

Toasted Pecans

4	cups pecan halves

⅓	cup salt

Combine pecans and salt in a bowl. Add enough warm water to cover and stir until salt dissolves. Soak pecans about 30 minutes. Pour off water and drain pecans on paper towels. Let stand 2 hours.

Spread pecans on a baking sheet. Bake at 250 degrees, stirring every 15 minutes, for about 1 hour or to desired doneness.

Yield: 24 servings

Black Bean, Corn and Cranberry Relish in Pastry Shell

2 cups water

1½ cups frozen whole kernel corn

2 (15-ounce) cans black beans, rinsed and well drained

1 fresh jalapeño pepper, seeded and minced

¾ cup fresh cranberries, chopped

1 green onion, minced

2 tablespoons canola oil

1 teaspoon finely shredded orange zest

2 tablespoons orange juice

2 tablespoons honey

2 tablespoons chopped cilantro

1 teaspoon grated fresh ginger

½ teaspoon salt

1 (3-ounce) package goat cheese, or 1 (3-ounce) package cream cheese and ½ package Boursin cheese, softened and blended

2 (15-count) packages phyllo pastry shells

Bring 2 cups water to a boil in a small saucepan. Add corn and remove from heat. Let stand 5 minutes; drain well to remove all excess water. Combine drained corn with black beans, jalapeño, cranberries and green onion in a large mixing bowl.

Mix oil, orange zest, orange juice, honey, cilantro, ginger and salt in a separate bowl. Blend until well combined. Pour over bean mixture and toss to coat. Cover and chill several hours or overnight. Let stand at room temperature before serving.

To serve, place ½ teaspoon goat cheese in the bottom of each pastry shell. Top with a small amount of black bean mixture. If desired, garnish top of each shell with a small cilantro leaf or orange peel curl.

Yield: 15 servings

Mushroom Almond Pâté

1	bunch green onions, chopped	⅛	teaspoon nutmeg
1	small clove garlic, minced	⅛	teaspoon white pepper
8	ounces mushrooms, sliced	6	ounces sliced almonds, toasted and coarsely chopped
3	tablespoons butter		
¼	cup chopped fresh parsley, or 1 tablespoon dried	¼	cup marsala wine or sherry
		1	(8-ounce) package cream cheese, softened
½	teaspoon salt	½	cup toasted sliced almonds for garnish
½	teaspoon tarragon		

Sauté onions, garlic and mushrooms in butter until most of liquid is absorbed. Stir in parsley, salt, tarragon, nutmeg and white pepper.

In a food processor, combine mushroom mixture with almonds and wine. Process briefly. Add cream cheese and pulse several times to desired consistency. Adjust seasonings as desired.

Mound pâté in a bowl and garnish with toasted almonds. Serve with sliced bread, bagel chips or crackers.

Yield: about 2 cups

Blueberry Salsa

2	cups coarsely chopped fresh blueberries	2	jalapeño peppers, seeded and chopped
1	cup whole blueberries	¼	cup chopped red onion
¼	cup lemon juice	½	teaspoon kosher salt
3	tablespoons chopped cilantro		

Combine all ingredients in a bowl and chill.

Serve with corn chips or on fish, pork or chicken.

Yield: 3 cups

CRANBERRY SALSA

2 cups cranberries
1 cup boiling water
2 plum tomatoes, chopped
¼ cup chopped cilantro

2 green onions, minced
2 teaspoons seeded and chopped jalapeño pepper
1 clove garlic, minced
½ teaspoon kosher salt

Cook cranberries in 1 cup boiling water until they burst. Drain and transfer to a bowl. Mix in tomato, cilantro, onion, jalapeño, garlic and salt. Adjust seasonings, adding sugar or more salt as needed.

Refrigerate at least 6 hours. Bring to room temperature before serving. Serve with chips as an appetizer or with pork or poultry. Good with turkey at Thanksgiving.

Yield: 2½ to 3 cups

GRAPE SALSA

½ cup red grapes, halved or quartered
½ cup green grapes, halved or quartered
½ cup chopped red, yellow or orange bell pepper
¼ cup chopped scallions
2 tablespoons chopped fresh cilantro or basil
1 tablespoon olive oil

1 tablespoon lime juice
1 teaspoon lime zest
2 teaspoons finely chopped jalapeño pepper
1 teaspoon salt
½ teaspoon hot pepper sauce

Combine all ingredients. Mix well. Refrigerate at least 1 hour to allow flavors to blend.

Serve with dipping tortilla chips or large corn chips.

Yield: 2 cups

Remember jalapeño pepper seeds are very hot; you can choose whether to add seeds or not.

Appetizers

Artichoke Bread

1 (2-loaf) package French bread or extra sour dough
2 cloves garlic, minced
1 stick butter
1 (14½-ounce) can artichoke hearts, drained and chopped

1 (16-ounce) container sour cream
8 ounces mozzarella cheese, shredded
8 ounces Cheddar cheese, shredded
dash of cayenne pepper
freshly grated Parmesan cheese to taste
paprika to taste

Cut the top off of each loaf of bread and hollow out centers. Place bread centers into a food processor and process into crumbs.

Sauté garlic in butter in a skillet. Add bread crumbs, chopped artichoke and sour cream. Add half of mozzarella and half of Cheddar cheese. Season with cayenne pepper.

Stuff cheese mixture into hollowed out loaves. Top with remaining mozzarella and Cheddar cheeses. Sprinkle with Parmesan cheese and paprika. Wrap bread in foil.

Bake at 350 degrees for 15 to 20 minutes. For crustier bread, leave foil open at the top. Slice and serve warm.

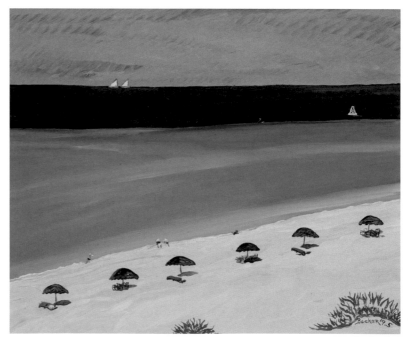

Jim Becker

Mango Salsa

3 ripe mangoes, peeled and cut into ¼-inch cubes
1 jalapeño pepper, seeded and finely chopped
1 clove garlic, finely chopped
½ small red onion, finely chopped

1 tablespoon finely chopped lime zest
½ cup freshly squeezed lime juice
1 teaspoon sugar
¼ cup chopped fresh cilantro or mint (optional)

Combine all ingredients in a bowl and toss gently. Serve within 1 day.

Yield: 1½ to 2 cups

Three cups of any peeled and chopped ripe fruit, such as nectarines, papaya or peaches, may be substituted for the mango. Very good served over grilled salmon.

Jackie's Pineapple Salsa

1 medium onion, quartered
2 cloves garlic
1 teaspoon olive oil
2 (8-ounce) cans crushed pineapple, divided
2 (4-ounce) cans green chiles, divided

 handful of cilantro
1 tablespoon pickled jalapeño peppers
 dash of lemon liqueur, lemon juice or white wine
 heavy dash of Cavender's Greek seasoning

Toss onion and garlic with olive oil in a glass bowl and heat in microwave on high power for 1 to 2 minutes. Drain off any juices and transfer to a blender. Add 1 can undrained pineapple and 1 can undrained chiles and blend. Transfer mixture to a large bowl.

Drain remaining can of pineapple and remaining can of chiles. Place half the can of pineapple and all the chiles in blender. Add cilantro, jalapeño and lemon liqueur. Blend and add to onion mixture in bowl. Stir in remaining half can of pineapple and mix well. Season with Greek seasoning.

Yield: 3½ to 4 cups

Big Ann's Cheese Straws

1½ cups flour	½ teaspoon salt
1 stick butter, softened (do not use margarine)	½ teaspoon cayenne pepper, or to taste
1 (10-ounce) package extra sharp Cheddar cheese, shredded	

Combine all ingredients in a food processor and blend. Pipe mixture onto an ungreased baking sheet.

Bake at 375 degrees for about 7 minutes. Rotate pan and bake 7 minutes longer.

Yield: 2 to 3 dozen

Double Baked Pretzels

1 bag large Bavarian pretzel twists	2 (1-ounce) packages dry Italian dressing mix, divided
½ cup olive oil, divided	4 tablespoons Worcestershire sauce, divided

Break pretzels into large pieces; set aside.

In a large mixing bowl, combine ¼ cup olive oil, 1 package dressing mix and 2 tablespoons Worcestershire sauce. Add pretzels to bowl and mix until well coated. Spread pretzels on an ungreased baking pan.

Bake at 350 degrees for 8 to 10 minutes.

Meanwhile, mix remaining ¼ cup olive oil, 1 package dressing mix and 2 tablespoons Worcestershire sauce.

Remove pretzels from oven and toss with oil mixture. Return to baking pan. Bake 5 to 7 minutes longer. Cool before storing in an airtight container.

Miniature Gourgères

1	cup water		pinch of dry mustard
1	stick butter, cut into small pieces		pinch of cayenne pepper
½	teaspoon salt	4	eggs
1	cup all-purpose flour	1½	cups shredded Gruyère cheese

To make pâté a choux, combine water, butter and salt in a saucepan and bring to a boil over high heat. Reduce heat to medium and add flour, mustard and cayenne pepper all at once. Stir with a wooden spoon until mixture pulls away from sides of pan.

Transfer mixture to a bowl. Using an electric mixer on high speed, beat in eggs, 1 at a time, beating well after each addition. Stir in cheese.

Drop by spoonfuls onto a lightly greased baking sheet. Bake at 375 degrees for 30 minutes or until puffed, golden and crisp. Serve warm.

Yield: 4 dozen

Gourgères keep in refrigerator for several days in a sealed plastic bag. They can also be frozen. To reheat, thaw and bake, uncovered, at 375 degrees for 10 to 15 minutes.

Hot Ryes

1	(16-ounce) package thin rye sandwich bread, or bread of choice	¼	cup minced green onion
1	cup finely shredded Swiss cheese	1	(4½-ounce) can chopped ripe olives
¼	cup crumbled cooked bacon	1	teaspoon Worcestershire sauce
		¼	cup mayonnaise

Trim crust off bread and cut slices into squares or triangles.

Combine cheese, bacon, onion, olives, Worcestershire sauce and mayonnaise. Spread mixture over bread and place on a baking sheet.

Bake at 375 degrees for 10 to 15 minutes.

Yield: 36 servings

Can be frozen after baking and reheated when ready to serve.

Marinated Tomatoes and Goat Cheese

2	pints grape tomatoes, halved	1	tablespoon capers
	salt	¼	cup dried basil
1	tablespoon red wine vinegar		olive oil
2	cloves garlic, halved		goat cheese

Place tomatoes, cut-side down, on a baking sheet. Sprinkle with salt. Bake at 200 to 250 degrees for 2 hours.

Transfer baked tomatoes to a container with a cover. Add vinegar, garlic, capers and basil. Add olive oil to cover. Refrigerate at least overnight.

Serve at room temperature over goat cheese with crackers or crostini.

Yield: 2 to 3 cups

Roma Tomato Appetizers

1	(15-ounce, 2-crust) package frozen rolled pie crusts, thawed	
	extra virgin olive oil	
8	ounces Asiago cheese, shredded	

9-10 ripe Roma tomatoes, sliced
chopped fresh basil
salt and pepper to taste

Unroll pie crusts on a floured surface. Cut into circles with a 2-inch cutter. Spray or coat both sides of dough circles with olive oil and place on a parchment-lined baking sheet. Bake at 350 degrees for 10 minutes.

Top each baked circle with 1 teaspoon Asiago cheese. Sprinkle with fresh basil and place 1 tomato slice on top. Season with salt and pepper and sprinkle with more Asiago cheese and basil. Top each with several drops olive oil.

Bake 15 to 20 minutes. Let stand at least 5 minutes before serving.

Yield: 3 to 4 dozen

Roma tomatoes are available year round, making this a party hit no matter what or when the occasion.

Savory Tartlets

1 (12-ounce) can flaky biscuits (1 can per filling recipe)

BACON AND TOMATO FILLING

6 slices bacon, cooked and crumbled
1 medium tomato, peeled, seeded and chopped
3 ounces mozzarella cheese, shredded

½ cup mayonnaise
1 teaspoon Italian seasoning
garlic powder to taste

BLEU CHEESE AND WALNUT FILLING

6 slices bacon, cooked and crumbled
4 ounces bleu cheese, crumbled
¼ cup walnut or pecan halves, chopped

3 green onions, chopped
½ cup mayonnaise

Split each biscuit into 3 layers; the flaky biscuits should pull apart easily into layers. Press split biscuits into greased mini muffin tins; not all the biscuits may be used.

Mix filling ingredients. Spoon filling into pastries. Bake at 350 degrees for 10 to 15 minutes.

Yield: 24 tarts

Tarts can be baked, cooled and stored in a zip-top bag. Reheat at 350 degrees for 8 to 12 minutes.

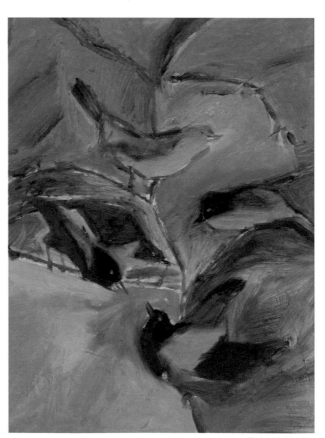

Richard McKee

Parmesan Rounds

1 cup mayonnaise
5 green onions, finely chopped
½ cup Parmesan cheese
¼ teaspoon garlic powder

½ teaspoon Worcestershire sauce
 cayenne pepper to taste
 French baguettes, cut into ¼-inch slices

Combine all ingredients except bread. Spread mixture over bread slices. Broil until lightly toasted. Serve warm.

Yield: 24 to 36 rounds, depending on size of baguettes

TOAST POINTS

small French baguettes or 1 loaf white bread

If using baguettes, slice into ¼-inch thick rounds. If using white bread, trim away crust and flatten each slice with your hands or a rolling pin, then cut each slice into 4 triangles. Place bread on a baking sheet.

Bake at 250 degrees until light golden and dried out, being careful not to burn. Cool before transferring to plastic zip-top bags.

Yield: 88 points from 1 loaf white bread

Great for hot dips. Prepare up to a week ahead and store in an airtight container.

Toast points can also be brushed with butter or olive oil and seasoned before baking.

Appetizers

Toasted Pecan Tea Sandwiches

TOASTED PECANS
2 teaspoons butter, melted
3 tablespoons Worcestershire sauce
3 dashes Tabasco sauce

salt to taste
2 cups pecan halves

SANDWICHES
1 (8-ounce) package cream cheese, softened
 dash of Worcestershire sauce
 dash of Tabasco sauce

garlic salt to taste
cayenne pepper to taste
fresh white bread, thinly sliced

Combine butter, Worcestershire sauce, Tabasco and salt in a mixing bowl. Add pecans and stir until thoroughly coated. Let stand 5 minutes to marinate.

Drain pecans and spread in a single layer on a large baking sheet. Bake at 300 degrees for 15 minutes or until dry. Chop pecans and set aside.

To make filling, blend cream cheese with a dash of Worcestershire sauce, dash of Tabasco, garlic salt and cayenne pepper in a bowl. (Do not overseason as pecans are spicy.) Stir in chopped pecans. Adjust seasoning as needed.

Trim crusts from bread and cut each slice diagonally into 2 triangles. Spread a thin layer of filling on 1 triangle. Top with another triangle and place on a serving platter.

Yield: about 20 sandwiches

Kathy's Cheese Ball

2	(8-ounce) packages cream cheese, softened	1	clove garlic, minced
2	ounces bleu cheese, softened	1	cup chopped pecans, divided
1	(10-ounce) jar Old English cheese, softened	¾	cup chopped fresh parsley, divided

Combine all cheeses and garlic in a food processor. Add ⅔ cup pecans and ⅔ cup parsley. Process until mixed. Shape mixture into a large ball or 2 smaller balls.

Roll ball in remaining ⅓ cup pecans and parsley.

Yield: 12 servings

Cheese ball can be frozen. After thawing, use only parsley to roll ball in before serving.

Olive Cheese Ball

1	(8-ounce) package cream cheese, softened	1	tablespoon olive juice
1	stick butter or margarine, softened	1	tablespoon lemon juice
4	ounces bleu cheese, softened	3-4	green onions, chopped
4	ounces stuffed olives, chopped	1	cup chopped pecans or walnuts

Combine all ingredients except chopped nuts. Refrigerate until mixture is firm enough to roll into a ball.

Form chilled mixture into a ball. Spread chopped nuts on wax paper. Roll cheese ball back and forth in nuts until completely covered. Reshape ball and chill.

To serve, place cheese ball on a serving platter surrounded with crackers such as Carr's water crackers or Triscuits.

Yield: 12 servings

Appetizers

Sherried Cheese Pâté

1½ cups shredded Cheddar cheese	¼ cup dry sherry
½ cup chopped green onion	½ cup sliced almonds, toasted
¾ cup mayonnaise	1 jar roasted garlic and onion jam, lightly warmed
1 tablespoon curry powder	

Combine Cheddar cheese and green onion in a bowl. Add mayonnaise, curry, sherry and almonds and mix well.

Line a greased 1-quart mold or container with plastic wrap for easy unmolding. Press cheese mixture into prepared mold. Cover and chill until ready to serve.

Invert cheese mold onto a serving platter. Glaze with jam. Garnish platter with fruit and crackers such as Bremner wafers or large wheat thins.

Yield: 2 cups

I like to use a mold with a tube in the center. A Bundt pan or a springform pan with a glass in the center will also work.

Hot Bleu Cheese Spread

2 cloves garlic, minced	1 drop liquid smoke (optional)
1 tablespoon butter	4 ounces bleu cheese
1 (8-ounce) package cream cheese, softened	3 tablespoons snipped fresh chives
¼ cup heavy cream	3 tablespoons chopped pecans

Sauté garlic in butter. Mix in cream cheese, cream, liquid smoke, bleu cheese and chives. Spread mixture in a baking dish. Sprinkle pecans on top.

Bake at 350 degrees for 20 to 25 minutes or until hot. Serve with assorted crackers.

Yield: about 2 cups

Cheese spread is also good with apple or pear slices dipped in lemon juice to prevent browning.

Baked Brie
with Cranberry Chutney

⅔ cup sugar

⅔ cup water

1⅓ cups cranberries

4 teaspoons apple cider vinegar

⅓ cup raisins

¼ cup coarsely chopped walnuts

2 teaspoons brown sugar

¼ teaspoon ground ginger

½ teaspoon minced garlic

1 small hoop Brie cheese

Dissolve sugar in water in a saucepan. Add cranberries, vinegar, raisins, walnuts, brown sugar, ginger and garlic. Cook 7 to 10 minutes or until chutney starts to thicken.

Place Brie in a baking dish. Pour cranberry chutney over cheese. Bake at 350 degrees for 10 minutes.

Yield: 10 servings

This can be used as an appetizer and spread on crackers or Melba toast, or as a side dish during the holidays. For larger gatherings, triple the chutney recipe and use a larger hoop of Brie cheese.

Lemon Pepper Boursin

1 clove garlic, chopped

1 teaspoon chopped fresh chives

1 teaspoon minced fresh basil

1 (8-ounce) package cream cheese, softened

1 teaspoon caraway seeds

1 teaspoon dill

lemon pepper to taste

Blend garlic, chives and basil. Mix in cream cheese. Blend in caraway seeds and dill. Form mixture into a ball. Roll ball in lemon pepper.

Wrap ball in wax paper and chill. Serve with crackers.

Yield: 1 cup

Appetizers

Butter Bean Hummus

2 cups chicken broth
1½ cups fresh or frozen butter beans
1 bay leaf
¼ teaspoon dried thyme
¼ teaspoon dried rosemary
3 cloves garlic, crushed

½ cup extra virgin olive oil
 juice and zest of 1 lemon
⅓ cup heavy cream
 salt and pepper to taste
 dash of cayenne pepper

Bring broth to a boil in a saucepan. Add beans, bay leaf, thyme and rosemary. Reduce heat and cook 25 to 30 minutes or until beans are very tender. Check broth while cooking and add more as needed; majority of broth should cook away.

Combine beans with garlic and olive oil in a food processor. Blend, adding lemon juice and zest and cream. Season with salt and pepper and cayenne pepper. If too thick, add a bit more olive oil. Serve with toasted pita chips.

Yield: about 2 cups

Clara's Corn Dip

1 (14-ounce) can white shoepeg corn, drained
1 cup shredded Cheddar cheese
½ cup shredded Parmesan cheese
1 bunch green onions, chopped

2-3 jalapeño peppers, chopped
3 tablespoons mayonnaise
 garlic salt to taste
 black pepper to taste
 cayenne pepper to taste (optional)

Mix all ingredients.

Yield: 3 cups

Great for tailgating! Serve with Fritos Scoop chips.

UMMUS

1	tablespoon chopped fresh garlic	⅓	cup finely chopped onion
1	teaspoon salt	5	tablespoons fresh lemon juice
1	tablespoon extra virgin olive oil, plus extra for garnish	5	tablespoons tahini, or 2 jars sesame seeds
2	(16-ounce) cans chickpeas (garbanzo beans), 1 tablespoon liquid from can reserved		paprika, preferably Hungarian
			chopped fresh Italian parsley

Combine garlic, salt and 1 tablespoon olive oil in a food processor. Process into a paste. Add chickpeas with 1 tablespoon liquid, onion, lemon juice and tahini and process until smooth.

Spoon hummus onto a large platter. Use a spoon to spread hummus to the edge of platter, forming a rim around the edge like a pizza crust.

Pour a thin stream of olive oil around the top of the hummus, making a design if desired, but do not pour into a puddle. Dust top lightly with paprika and sprinkle with parsley.

Yield: 20 servings

Tahini is a thick paste of ground sesame seeds found in gourmet grocery stores.

Serve with Herbed Pita Chips (recipe below).

ℋERBED 𝒫ITA 𝒞HIPS

6	tablespoons olive oil	1	teaspoon kosher salt
2	teaspoons dried basil	5	large wheat pita bread pockets, each split and cut into eighths
2	teaspoons garlic powder		

Combine olive oil, basil, garlic powder and kosher salt in a large bowl. Add pita pieces and toss until well coated. Spread pita pieces in a single layer on 1 or 2 baking sheets.

Bake at 450 degrees for 4 minutes. Use tongs to turn pita pieces. Bake 4 minutes longer. Cool completely. Store in an airtight container. Reheat, if desired, before serving.

Yield: 40 pieces

Appetizers

Mrs. Sandifer's Vegetable Mold

2 (¼-ounce) packages unflavored gelatin
½ cup boiling water
3 stalks celery, chopped
2 avocados, chopped
4 green onions, chopped
2 tomatoes, peeled and chopped
½ green bell pepper, chopped
1 cucumber, peeled and chopped
½ cup chopped stuffed green olives
2 teaspoons salt
5 tablespoons freshly squeezed lemon juice
 cayenne pepper to taste
1 cup mayonnaise

Dissolve gelatin in boiling water.

Combine celery, avocado, onion, tomato, bell pepper, cucumber and olives in a mixing bowl. Mix in salt, lemon juice, cayenne pepper, mayonnaise and dissolved gelatin.

Pour mixture into a 3-quart casserole dish. Refrigerate 1 to 2 hours before serving. Serve with crackers such as Triscuits or Wheat Thins.

Yield: 18 servings

Wonderful when summer vegetables are abundant.

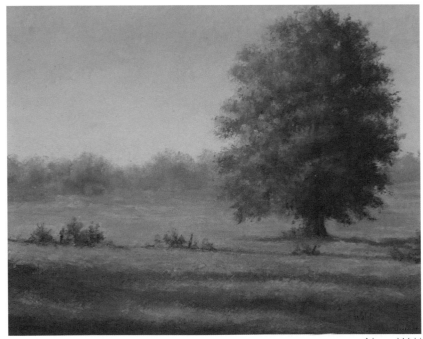

Nancy Wahl

Lump Crabmeat Rondele

1	pound jumbo lump crabmeat	1	tablespoon dried thyme
¼	cup freshly squeezed lemon juice	1	tablespoon dried oregano
2	tablespoons lemon pepper seasoning	1	tablespoon dried basil
1	tablespoon chopped fresh Italian parsley	1	tablespoon dried dill
	Creole seasoning to taste		trimmed green onions and lemon slices for garnish
	salt to taste		
2	(8-ounce) packages cream cheese, softened		

Pick through crabmeat to remove any shell; do not break up lumps. Season crab with lemon juice, lemon pepper, parsley, Creole seasoning and salt. Chill until ready to serve.

Use the paddle attachment of an electric mixer to combine cream cheese, thyme, oregano, basil and dill. Spread mixture over a serving platter.

Spoon crab mixture over cream cheese layer. Garnish with green onions and lemon slices. Serve with Savory Cheese Wafers (recipe below).

Yield: 4 cups

SAVORY CHEESE WAFERS

2 sticks unsalted butter, softened
2 cups finely shredded sharp Cheddar cheese

2 cups all-purpose flour
cayenne pepper or hot pepper sauce to taste

Combine all ingredients using the paddle attachment of an electric mixer, mixing lightly. Transfer dough to a cookie press. Press wafers onto a parchment-lined baking sheet.

Bake at 325 degrees for 45 minutes or until golden brown.

Yield: about 3 dozen wafers

Appetizers

Hot Crab Canapés

8	ounces crabmeat	¼	teaspoon garlic powder
½	cup shredded Cheddar cheese	2	teaspoons grated onion
¼	cup mayonnaise	1	tablespoon minced fresh Italian parsley
¼	teaspoon salt	20	slices thin sandwich bread
¼	teaspoon white pepper		

Combine crabmeat, cheese, mayonnaise, salt, white pepper, garlic powder, onion and parsley.

Trim crusts from bread and cut each slice into quarters. Spread crabmeat mixture over each square and place on an ungreased baking sheet.

Bake at 350 degrees for 10 to 15 minutes or until lightly browned.

Yield: 6½ dozen canapés

Hot Crawfish Dip

1	stick butter	2	(16-ounce) packages crawfish tails, Louisiana preferred
½	cup chopped celery	½	cup white wine, preferably Chablis
1	onion, finely chopped		salt and pepper to taste
1	green bell pepper, chopped		cayenne pepper to taste
½	yellow bell pepper, chopped	1½	(8-ounce) packages cream cheese
½	red bell pepper, chopped	½	cup Italian bread crumbs

Melt butter in a large heavy pot over low heat. Add celery, onion and all bell peppers and sauté until tender.

Rinse and drain crawfish. Chop crawfish and add to pot with sautéed vegetables. Continue to cook over low heat. Stir in wine. Season with salt and pepper and cayenne pepper.

Cut cream cheese into small pieces. Gradually stir cream cheese cubes into mixture until melted. Mix in bread crumbs; do not add too many bread crumbs as mixture will become too stiff. Serve with crackers, toast points or chips.

Yield: 6 to 8 servings

Chafing Dish Oysters

2	dozen raw oysters	4	teaspoons freshly squeezed lemon juice
	salt and pepper to taste	¼	cup A-1 steak sauce
	flour	2	jiggers dry sherry
4	tablespoons butter		

Blot oysters on both sides with paper towel until completely dry. Season with salt and pepper and lightly dust with flour. Arrange oysters on a greased baking sheet. Broil briefly until oysters curl slightly.

Combine butter, lemon juice, steak sauce and sherry in a saucepan and heat until butter is melted. Stir to mix sauce. Add oysters to sauce. Transfer oysters and sauce to a chafing dish. Serve with crackers or by themselves with toothpicks.

Yield: 6 to 8 servings

Oysters in Pastry Shells

1	large onion, finely chopped		juice of ½ lemon
1	stick butter	⅛	teaspoon lemon zest
6	green onions, finely chopped		finely chopped parsley
½	cup plus 1 tablespoon flour		salt and pepper to taste
1	quart oyster liquid (may add chicken broth to equal 4 cups)	8	large or 24 small pastry shells, baked according to package
1	quart medium oysters		

Sauté onion in butter. Add green onion and cook until softened. Stir in flour until well blended. Gradually stir in oyster liquid as needed to make a well-blended sauce of medium thickness. Add oysters, lemon juice and zest. Simmer 10 minutes.

Add parsley and season with salt and pepper. Serve from a chafing dish over pastry shells.

A small amount of white wine or champagne may be added to sauce.

Use small oysters in this dish as they are sweeter and easier to serve in the pastry shells.

Appetizers

Spicy Asian Lettuce Wraps

2½ ounces bean threads (cellophane noodles)
¼ cup minced fresh cilantro
¼ cup low-sodium soy sauce
1 tablespoon chile garlic paste
 (available at Asian markets)

2 teaspoons dark sesame oil
2 cups chopped roasted, skinless chicken
12 large leaves Boston or romaine lettuce

Cover bean threads with boiling water and let stand 5 minutes or until softened. Drain and rinse with cool water. Chop noodles.

While bean threads soak, combine cilantro, soy sauce, chili paste and sesame oil in a large bowl with a whisk. Add chopped noodles and chicken and toss well until coated.

Spoon about ⅓ cup of mixture down center of each lettuce leaf and roll up.

Chopped cooked shrimp or pork can be substituted for the chicken.

Yield: 4 servings

Biloxi Butter

8 large boiled and peeled shrimp
¼ cup whipped butter, softened
2 teaspoons fresh ground horseradish

garlic salt to taste
black pepper to taste

Chop shrimp in a blender or with a small food chopper. Place shrimp in a bowl. Blend in butter using the back of a teaspoon until well mixed. Add horseradish, garlic salt and pepper in the same manner.

Refrigerate until chilled. Serve cold as a spread with crackers.

Yield: 4 servings

ROLLING STONE SHRIMP

2-3 pounds peeled medium shrimp
2 tablespoons extra virgin olive oil per pound
 shrimp

1½ cups brown sugar per pound shrimp, divided
1 tablespoon unsalted butter per pound shrimp,
 divided

Combine shrimp with 2 tablespoons olive oil and ¾ cup brown sugar per pound shrimp. Cover and marinate in refrigerator.

When ready to cook, melt 1 tablespoon butter per pound of shrimp in a nonstick skillet over low heat. Add another ¾ cup brown sugar per pound shrimp and stir until dissolved. Add shrimp and marinade and cook over medium heat for 5 to 6 minutes or until pink. Serve with vegetables of your choice.

Yield: 4 servings

Great on a hoagie as a po' boy. Use leftover reduction on vegetables or as au jus with the po' boy.
Still wondering why I named it Rolling Stone Shrimp?
Remember the first cut on the Rolling Stones' 1971 Sticky Fingers album?
Brown Sugar! The song is pretty good, the shrimp are great!

Shrimp and Avocado Seviche

1	quart water	¼	cup cider vinegar
4	limes	2	teaspoons finely chopped fresh thyme
2	pounds medium shrimp	1	teaspoon dried oregano, preferably Mexican
¼	cup freshly squeezed lime juice	2	large ripe avocados, peeled and diced
6	green onions, finely chopped	¼	cup finely chopped fresh cilantro
2-4	serrano chile peppers, finely chopped (optional)	2	teaspoons salt

Fill a large pot with 1 quart water. Cut 4 limes in half. Squeeze juice into pot and add lime halves to pot. Bring to a boil. Turn off heat and let steep about 10 minutes.

Return liquid in pot to a boil. Add shrimp to pot. As soon as liquid returns to a rolling boil, pour shrimp into a colander, discarding liquid and lime halves. Return shrimp to pot, cover and let stand 15 minutes.

Spread shrimp over a baking sheet. Let stand until cool enough to handle. Peel and devein shrimp and cut each into thirds.

Transfer shrimp to a medium bowl. Stir in ¼ cup lime juice, green onion, chiles, vinegar, thyme and oregano. Let stand at room temperature for 1 hour, stirring occasionally.

When ready to serve, stir in avocado, cilantro and salt. Serve with tortilla chips.

Yield: 8 to 10 servings

Disappearing Shrimp Delight

½ cup finely chopped white onion
2 teaspoons butter
1 (8-ounce) package cream cheese, cubed and softened
1 (4-ounce) can chopped green chiles, drained
1 clove garlic, minced

2-3 drops liquid crab boil (optional)
salt to taste
Tabasco sauce or cayenne pepper to taste
½ cup peeled and chopped tomato
1 cup cooked, peeled, deveined and coarsely chopped shrimp

Sauté onion in butter until softened. Stir in cream cheese until melted. Add chiles, garlic and crab boil, stirring to a soft consistency. Remove from heat.

Season with salt and Tabasco. Mix in tomato and shrimp. Chill 4 hours before serving. Serve chilled or warm as a dip or spread, or serve as a luncheon salad on lettuce.

Yield: 6 to 8 servings

Delicious Catfish "Thingy"

1 pound catfish
½ cup water
¼ teaspoon salt
2 teaspoons liquid smoke
1½ cups cream cheese
2 tablespoons mayonnaise

2 tablespoons Worcestershire sauce
1 tablespoon lemon juice
½ cup finely chopped onion
freshly minced garlic or garlic powder to taste
½ cup chili sauce
paprika and parsley for garnish

Poach catfish in ½ cup water with salt and liquid smoke. Drain and chill.

Combine cream cheese, mayonnaise, Worcestershire sauce, lemon juice, onion, and garlic in a food processor and blend well. Refrigerate until chilled.

To serve, spread cream cheese mixture on a serving platter. Top with chili sauce. Flake catfish and scatter over chili sauce. Garnish with paprika and parsley. Serve with saltines.

Yield: 6 to 8 servings

Shrimp or Crabmeat Rhodes

1 pound fresh shrimp, cooked and peeled, or
 1 pound jumbo lump crabmeat
2 (8-ounce) packages cream cheese, softened
¼ cup fresh lemon juice
¼ cup mayonnaise
½ teaspoon seasoned salt
½ teaspoon lemon pepper seasoning

¼ teaspoon Worcestershire sauce
1 (12-ounce) jar cocktail sauce
2 cups shredded Monterey Jack cheese
3 green onions, chopped
½ cup chopped green bell pepper
½ cup sliced ripe olives (optional)

Beat cream cheese with an electric mixer on medium speed until light and fluffy. Add lemon juice, mayonnaise, seasoned salt, lemon pepper seasoning and Worcestershire sauce. Beat until smooth. Spread mixture into a 10-inch circle on a large serving platter. Cover and chill at least 30 minutes.

Spread cocktail sauce evenly over cream cheese layer. Add layers of cheese, green onion, bell pepper and olives. Cover and chill thoroughly. Serve with assorted crackers.

Yield: 25 servings

Lake Cavalier Seviche

2 bay leaves
 salt and freshly ground pepper to taste
1 cup freshly squeezed lemon juice
½ teaspoon dried oregano
¼ - ½ teaspoon garlic salt
1 pound bass or crappie fillets, diced
1 red or white onion, diced

1 bell pepper, diced
 (color of choice, or combination)
1 fresh tomato, peeled and chopped
3 cups mild distilled vinegar
1 cup water
½ cup chopped fresh cilantro

Combine bay leaves, salt and pepper, lemon juice, oregano and garlic salt. Place fish in a glass or plastic container. Pour lemon juice marinade over fish and refrigerate overnight.

The next day, combine onion, bell pepper, tomato, vinegar and water and marinate 2 to 3 hours.

Drain and discard marinade from fish and vegetables. Combine fish and vegetables and toss to mix. Adjust seasoning as desired. Add cilantro.
Serve with butter crackers.

Yield: 8 servings

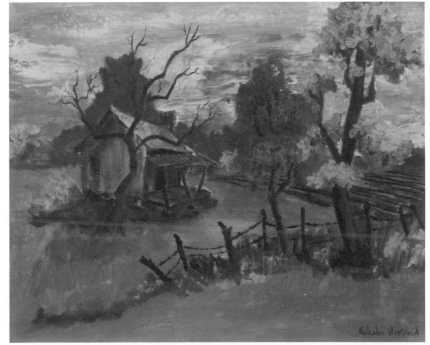

Malcolm Norwood

HARLEQUIN SALMON WITH YELLOW AND BLACK MUSTARD SEEDS

1	side salmon, skin removed	½	cup spicy brown mustard
	juice of 1 lemon	½	cup prepared horseradish
	garlic powder to taste	½	cup yellow mustard seeds
	salt to taste	½	cup black mustard seeds

Cover a baking pan with foil and rub with oil. Place fish on foil. Rub with lemon juice and sprinkle with garlic powder and salt. Combine brown mustard and horseradish and spread generously over salmon. (Mix more if needed, depending on size of salmon.) Cover with yellow and black mustard seeds in desired pattern, such as stripes, diagonal lines, squares or like scales.

Bake at 350 degrees for 35 to 45 minutes. Transfer carefully to a serving platter using 1 to 2 spatulas, being careful to keep fish whole. Garnish as desired and serve with toast points or crackers of choice.

Yield: 30 servings

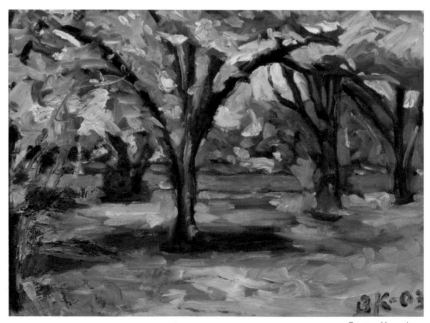

Baxter Knowlton

Chicken Liver Pâté

1	pound chicken livers	1	teaspoon white pepper
	milk	2-3	dashes Worcestershire sauce
1	cup finely chopped onion	1	dash cayenne pepper
1	clove garlic, smashed and chopped	1	bay leaf
1½	sticks butter, (no substitutions)	⅛	teaspoon dried oregano
1	tablespoon flour	2	tablespoons brandy
1	teaspoon salt		

Rinse and drain livers. Transfer to a bowl and cover with milk. Cover bowl and refrigerate overnight.

Sauté onion and garlic in 1 stick butter in a skillet. Drain livers. Add livers with remaining ½ stick butter to skillet and cook until tender. Sprinkle with flour and season with salt, pepper, Worcestershire sauce, cayenne pepper, bay leaf and oregano. Cook until livers are done. Remove bay leaf and stir in brandy.

Transfer mixture to a food processor or blender. Process until smooth. Refrigerate pâté until chilled or for up to 1 week. Serve with toast points.

Yield: 2 cups

Chutney Sausage Bites

2	pounds sausage	1	(9-ounce) bottle Major Grey's chutney
1	cup sour cream	½	cup finely chopped celery

Roll sausage into small balls. Cook sausage balls until browned and fully cooked. At this point, sausage balls can be frozen until ready to serve.

Combine sour cream, chutney and celery and pour into a chafing dish. Add balls to mixture and heat. Serve with toothpicks.

Yield: 10 to 12 servings

Bacon Artichoke Wraps with Creole Sauce

10-12 thick slices bacon
1 (14-ounce) can artichoke bottoms, each cut into 8 wedges

3 tablespoons Creole mustard
¼ cup heavy cream

Cut each bacon slice crosswise into 4 pieces. Wrap a piece of bacon around an artichoke wedge and secure with a toothpick. Place on a baking sheet. Repeat with remaining bacon and artichoke wedges.

Bake at 400 degrees for 20 to 30 minutes or until bacon is crisp and browned. Drain thoroughly.

Combine mustard and cream with a whisk. Refrigerate until chilled. Serve with wraps.

Yield: 45 bite-size pieces

Serves beautifully on a rectangular tray lined with a banana tree leaf.

In place of heavy cream, sour cream or mayonnaise or a combination may be used. This is an easy, tangy addition to any party table.

Elizabeth Wolfe

"Better is bread with a happy heart than wealth with vexation."

~Amenemope, 6

Bread—the basic diet of human beings for millennia, still holds that honored place, and the fragrance of baking bread still entices us and invites us to have, as Milne writes, "a little bit of butter to my bread."

The array of bread recipes in this book will delight devoted cooks and challenge novices to try their hand at producing irresistible loaves. Besides the quick rolls—the easiest recipe ever, there are the muffins and quick breads flavored with cranberries, bananas, pumpkin and poppy seed. Delicious English scones are here too, as well as biscuits and a renowned French bread baked in renowned pans!

John Milton wrote that "it was a common saying among the Puritans that brown bread and the gospel is good fare." Although we are probably happy we are no longer Puritans, the truth of this pious saying is evident. Bread warms our kitchens and our palates and does indeed make good fare as we listen and learn from the gospel, reach out to the hungry and take care of our fellow members. Our way of greeting visitors or newcomers to St. Andrew's or expressing our condolences is the delivery of a loaf of bread. And so we spread the gospel. As Corita Kent has observed, "There are so many hungry people that God cannot appear [to them] except in the form of bread."

As for brunch, Marion Rombauer and husband Eric Becker in their newest edition of the venerable *Joy of Cooking* remind us that brunch is the perfect choice for the novice cook who wants to entertain. They recommend a stand-by like quiche, or French toast. A newer star on the brunch scene, however, is the frittata, which you will find in these pages, as well as corn and Danish pancakes, waffles and the amazing Breakfast of Champions.

Breakfast, Breads and Brunch

Brunch Biscuits

1 (10-ounce) can refrigerated biscuits
1 stick butter, melted

1 (4-ounce) package crumbled bleu cheese

Cut each biscuit into 4 pieces and place in a 9-inch cake pan. Mix melted butter with cheese and pour over biscuits.

Bake at 450 degrees for 8 to 12 minutes or until brown.

Yield: 32 small biscuits

Melt-in-Your-Mouth Biscuits

1 stick butter
1 cup sour cream

2 cups biscuit mix

Melt butter in a microwave-safe dish. Stir in sour cream and baking mix. Drop batter by tablespoons into greased mini muffin tins.

Bake at 350 degrees for 8 to 14 minutes or until biscuits start to brown on top.

Yield: 15 to 30 biscuits

Sweet Potato Biscuits

2 cups all-purpose flour
2 teaspoons baking powder
½ teaspoon baking soda
½-1 teaspoon salt

1 cup mashed sweet potato
2 tablespoons sugar, or more to taste
1 cup buttermilk, warmed
1 stick butter, melted

Combine flour, baking powder, baking soda and salt in a mixing bowl; set aside.

In a separate bowl, mix sweet potato and sugar. Stir in buttermilk and butter. Mix in dry ingredients until thoroughly blended. Turn dough out onto a floured surface and knead lightly. Roll dough to ½-inch thickness. Cut into biscuits using a 1½-inch biscuit cutter or a glass jar. Place biscuits on a parchment-lined baking sheet.

Bake at 400 degrees for 12 to 15 minutes; biscuits will not rise very much. Serve warm, sliced and buttered.

Yield: 2 to 4 dozen

Good with chutney and ham or turkey and cranberry sauce.

Banana Nut Bread

4 tablespoons butter
½ cup sugar
2 eggs
2 cups all-purpose flour
½ teaspoon salt

1 teaspoon baking soda
1 teaspoon vanilla
3 bananas, mashed
½ cup chopped pecans
½ cup applesauce

Cream butter with sugar and eggs in a large bowl with an electric mixer. Add flour, salt, baking soda, vanilla, banana, pecans and applesauce and mix.

Pour batter into a lightly greased loaf pan. Bake at 300 degrees for 1 hour. Freezes well.

Yield: 1 loaf

CRANBERRY NUT BREAD

⅔ cup shortening
1⅓ cups sugar
3 eggs
2 cups mashed banana (about 4)
3½ cups all-purpose flour
4 teaspoons baking powder

½ teaspoon baking soda
¾ teaspoon salt
1 teaspoon lemon zest
1 cup fresh cranberries
1 cup chopped walnuts
1 (16-ounce) can whole berry cranberry sauce

Cream shortening and sugar in a mixing bowl. Add eggs and beat well. Stir in banana.

In a separate bowl, combine flour, baking powder, baking soda, salt and lemon zest. Gradually add dry ingredients to banana mixture. Stir in cranberries, walnuts and cranberry sauce.

Pour batter into 2 greased and floured loaf pans. Bake at 350 degrees for 50 to 60 minutes. Freezes well.

Yield: 2 loaves

POPPY SEED BREAD

BATTER
3 cups self-rising flour
2⅓ cups sugar
3 eggs
1½ cups milk

1 cup oil
1½ teaspoons vanilla
1½ teaspoons almond extract
2 tablespoons poppy seeds

GLAZE
½ teaspoon vanilla
½ teaspoon almond extract

¼ cup orange juice
¾ cup sugar

Combine all batter ingredients and pour into 2 greased and floured loaf pans. Bake at 325 degrees for 1 hour, 10 minutes. Cool 15 minutes before adding glaze.

To make glaze, mix all ingredients. Pour half of glaze over each baked loaf. Bread freezes well.

Yield: 2 loaves

Pumpkin Bread

3 cups sugar
1 cup oil
4 eggs, beaten
1 (16-ounce) can pumpkin
3½ cups all-purpose flour
2 teaspoons baking soda
2 teaspoons salt

1 teaspoon baking powder
1 teaspoon nutmeg
1 teaspoon allspice
1 teaspoon cinnamon
½ teaspoon ground cloves
⅔ cup water

Cream together sugar and oil in a mixing bowl. Mix in eggs and pumpkin.

In a separate bowl, combine flour, baking soda, salt, baking powder, nutmeg, allspice, cinnamon and cloves. Add dry ingredients alternately with water to pumpkin mixture.

Pour mixture into 2 greased loaf pans. Bake at 350 degrees for 1½ hours. Let stand 10 minutes before slicing. Bread freezes well.

Yield: 2 loaves

If baking in mini loaf pans, shorten baking time.

SPOON BREAD

3	cups milk	1	tablespoon salt
1	cup cornmeal	1	tablespoon sugar
6	tablespoons butter	6	eggs, separated

Bring milk to a boil in a saucepan. Add cornmeal and cook, stirring frequently, until the consistency of mush. Remove from heat. Stir in butter, salt and sugar. Cool. Beat egg yolks and add to cooled mixture. If making ahead, cover and refrigerate.

Thirty minutes before serving, beat egg whites until stiff. Fold whites into cornmeal batter and pour into a greased 3-quart casserole dish. Bake, uncovered, at 375 degrees until bread is nicely raised and brown on top.

Yield: 6 servings

Cleta Ellington

Broad Street
Morning Glory Muffins

Breakfast is always busy at Broad Street, and one of our most popular pastries is the "Morning Glory" muffin.

1¼ cups sugar
2¼ cups all-purpose flour
1 tablespoon cinnamon
2 teaspoons baking soda
½ teaspoon salt
½ cup shredded sweetened coconut
½ cup dark raisins
2 cups shredded carrot

1 Red Delicious or Granny Smith apple, shredded
1 (8-ounce) can crushed pineapple, drained
½ cup chopped pecans
3 eggs
1 cup canola oil
1 teaspoon vanilla

Sift together sugar, flour, cinnamon, baking soda and salt into a large mixing bowl. Add coconut, raisins, carrot, apple, pineapple and pecans and stir until mixed.

In a separate bowl, whisk eggs with oil and vanilla. Add to dry ingredients and mix well.

Spoon batter into greased muffin tins, filling to slightly below the rim. Bake at 375 degrees for 35 minutes or until a toothpick comes out clean. Cool in pan at least 10 minutes before turning out onto a wire rack.

Mississippi Sunshine Bran Muffins

1	cup unbleached all-purpose flour	1/3	cup dark raisins
1 1/2	teaspoons baking soda	1/3	cup chopped dates
1/2	teaspoon kosher salt	1	carrot, shredded
1	teaspoon cinnamon	2	cups All-Bran cereal
1/2	teaspoon freshly grated nutmeg	1	egg
1/4	cup wheat germ	1 1/2	cups buttermilk
1/2	cup light brown sugar	1/4	cup peanut oil
1/3	cup dried cranberries	1	teaspoon vanilla

Combine flour, baking soda, salt, cinnamon and nutmeg in a large bowl. Stir in wheat germ and brown sugar. Add cranberries, raisins, dates, carrot and cereal and toss with fingers to combine.

In a medium bowl, beat egg with a whisk. Add buttermilk, oil and vanilla and whisk well. Add dry ingredients and stir gently with a rubber spatula. Let batter stand 15 to 20 minutes so the liquid thoroughly moistens the cereal.

Spoon batter into greased muffin tins, filling almost to the top. Bake at 375 degrees in lower third of oven for 15 to 20 minutes or until muffins are deep brown and spring back when gently pressed. Cool in pan 5 minutes before inverting to remove muffins. Cool on a wire rack. Serve warm or at room temperature with Orange Butter (see recipe below).

Yield: 6 giant or 12 regular-size muffins

ORANGE BUTTER

4 oranges
1/2 pound confectioners' sugar

1 pound butter, softened

Grate zest from 2 of the oranges. Extract juice from all 4 oranges and strain. Mix zest with juice. Add sugar and stir to dissolve as much as possible.

Add juice mixture to butter in a mixing bowl and mix until well blended. Chill before serving.

Yield: 2 cups

FRENCH BREAKFAST CAKES

BATTER

1½	cups all-purpose flour	½	cup sugar	
1½	teaspoons baking powder	1	egg	
½	teaspoon salt	½	cup milk	
5	tablespoons butter, softened	1	(3-ounce) package cream cheese, softened	

TOPPING

1	cup sugar	1	stick unsalted butter, melted
2	teaspoons cinnamon		

Combine flour, baking powder and salt in a small bowl. In a large mixing bowl, cream together butter, sugar and egg. Add dry ingredients alternately with milk, stirring just until combined. Fold in cream cheese.

Spoon batter into greased mini muffin tins, filling each two-thirds full. Bake at 350 degrees for 15 to 20 minutes or until golden.

For topping, combine sugar and cinnamon in a shallow dish. Dip tops of muffin in melted butter, then roll in cinnamon sugar to cover entire muffin top.

Yield: 2 dozen muffins

Pecan Pie Muffins

1	cup chopped pecans	3	eggs
½	cup granulated sugar	⅔	cup butter, melted
1	cup brown sugar	1	teaspoon vanilla
⅔	cup all-purpose flour		

Combine pecans, both sugars and flour in a large bowl, making a well in the center. In a separate bowl, beat eggs. Mix butter and vanilla into eggs, then add to center of dry ingredients. Stir lightly until just mixed.

Spoon batter into greased muffin tins, filling each two-thirds full. Bake at 350 degrees for 20 to 25 minutes. Remove from muffin tins and serve warm.

Yield: 1 dozen muffins

Cranberry Wheat Scones

1	cup all-purpose flour	1	cup dried cranberries
1¼	cups whole wheat flour	¼	cup raisins
⅓	(heaping) cup sugar	½	cup buttermilk
2¼	teaspoons baking powder	1	teaspoon vanilla
½	teaspoon baking soda	1	tablespoon all-purpose flour
1	stick butter, cut into chunks		

Combine 1 cup all-purpose flour, whole wheat flour, sugar, baking powder and baking soda in a large bowl. Cut in butter using a pastry blender until mixture resembles coarse crumbs. Stir in cranberries and raisins. Mix in buttermilk and vanilla; mixture will be dry. Form dough into 2 equal balls.

Sprinkle a clean work surface with 1 tablespoon all-purpose flour. Work 1 dough ball into a 6-inch circle, about ½-inch thick. Cut circle into 6 equal wedges and place on a nonstick baking sheet, spacing about 1 inch apart. Repeat with second dough ball.

Bake at 400 degrees for 10 to 15 minutes or until lightly browned. Remove scones to a wire rack to cool. Serve with clotted cream.

Yield: 12 scones

Santa Barbara Scones

2¼ cups all-purpose flour
⅓ cup sugar
1 tablespoon baking powder
¼ teaspoon lemon zest

11 tablespoons unsalted butter, chilled and cut into small pieces
¾ cup heavy cream
⅔ cup diced crystallized ginger
2 tablespoons heavy cream

Blend flour, sugar, baking powder and lemon zest in a food processor. Add butter and pulse on and off until mixture resembles coarse meal. Transfer mixture to a large bowl and make a well in the center. Add ¾ cup cream and stir with a fork just until moistened. Mix in ginger.

Transfer dough to a floured surface and gently knead 8 turns or until smooth. Divide dough in half. Pat each half into a ¾-inch round. Cut each round into 6 wedges and transfer to a lightly greased baking sheet, spacing 1 inch apart. Brush top of scones with 2 tablespoons cream.

Bake at 400 degrees for 18 minutes or until light brown. Cool completely. Store in an airtight container at room temperature for up to 1 day. Rewarm in a 350 degree oven before serving.

Yield: 12 scones

Easy Rolls

2 cups self-rising flour
¼ cup mayonnaise

1 cup milk
1 teaspoon sugar

Mix together all ingredients. Spoon dough into 12 lightly greased muffin tins. Bake at 425 degrees for 16 to 18 minutes.

Yield: 1 dozen rolls

Cloud Rolls

2	packages dry yeast	1	cup boiling water
1	cup warm water	2	eggs, well beaten
1	teaspoon sugar	6	cups flour
1	cup shortening	2	teaspoons salt
½	cup sugar	1	stick butter, melted

Dissolve yeast in warm water with 1 teaspoon sugar. In the mixing bowl of an electric mixer, combine shortening, ½ cup sugar and boiling water. Mix well with a dough hook until shortening is melted. Cool to lukewarm. Add dissolved yeast mixture. Add eggs. Gradually mix in flour and salt. Beat until well blended. Cover and refrigerate overnight.

The next day, working with half the dough at a time, turn out onto a lightly floured surface. Roll dough to ¼- to ½-inch thickness. Cut rolls using a lightly floured 2½-inch round biscuit cutter. Dip one end of each roll in melted butter and fold in half. Place rolls on a baking sheet with sides, arranging so rolls are touching each other. Brush rolls with remaining butter. Let rise in a warm, draft-free place for about 2 hours.

Bake at 450 degrees for 10 to 12 minutes. Rolls freeze well.

Yield: 3 to 4 dozen rolls

Jim Becker

Monroe's French Bread

1	package dry yeast	2	cups warm water (110 degrees)
	pinch of sugar	1	tablespoon salt
½	cup warm water (110 degrees)	5½-6 cups bread flour	

Dissolve yeast and sugar in ½ cup warm water and allow to proof. Add yeast mixture to 2 cups warm water in a large bowl. Stir in salt and 4 cups flour and mix well. Continue adding flour until mixture pulls away from the sides of the bowl. Turn out onto a floured surface and knead until dough is smooth and just barely sticky, or not sticky at all.

Grease a large bowl with butter. Add dough to bowl and turn to coat surface with butter. Cover bowl with a damp towel and allow to rise until doubled in bulk. Punch down dough and form into 4 long loaves. Twist loaves like a rope and place on baking sheets.

Bake at 450 degrees for 15 minutes or until bread starts to brown, spraying with water about every 5 minutes. Reduce oven temperature to 350 degrees and bake 20 to 25 minutes longer. Loaves should sound hollow when tapped on the bottom. Cool on a rack.

Yield: 4 loaves

This recipe came from a Craig Claiborne New York Times magazine article, probably in the early 1970's. Claiborne was writing about bread pans developed by Clyde Brooks. Unfortunately, you cannot buy the pans any longer. Most cookware stores today have fancier, more expensive pans. I have Mr. Brooks' pans and the fancier pans, but prefer Mr. Brooks' because they make better bread. I do not loan these pans out.

QUICKIE QUICHE

1	(9-inch) prepared pie crust	½	teaspoon black pepper	
1	cup chopped red onion	½	teaspoon chopped fresh basil	
2	cups frozen broccoli florets		(about 2 leaves)	
3	eggs	8	ounces cottage cheese	
½	teaspoon garlic powder	¼	cup shredded Cheddar cheese	
½	teaspoon dried oregano	¼	cup Parmesan cheese	
½	teaspoon salt	¼	cup feta cheese	

Place pie crust in a pan and pierce bottom of crust with a fork. Bake at 350 degrees for 10 minutes.

Microwave onion and broccoli on high for 4 minutes. In a separate bowl, beat eggs with a fork. Mix in garlic powder, oregano, salt, pepper and basil. Blend in cottage, Cheddar, Parmesan and feta cheeses. Add cooked onion and broccoli and mix with fork. If mixture seems too thick, add a little milk. Pour mixture into baked crust.

Bake at 350 degrees for 40 minutes or until set; cover with foil if crust gets too brown while baking.

Yield: 1 quiche

Green Chile Frittata

½ cup all-purpose flour
1 teaspoon baking powder
10 eggs, lightly beaten
4 tablespoons butter, melted and slightly cooled

2 cups small curd cottage cheese
1 pound Monterey Jack cheese, shredded
3 (4-ounce) cans diced green chiles
 salt and freshly ground pepper to taste

Mix flour and baking powder in a mixing bowl. Add eggs and butter and blend well. Stir in cottage cheese, Monterey Jack cheese, chiles and salt and pepper. Pour batter into a greased 9x13-inch shallow baking dish.

Bake at 350 degrees for 35 to 45 minutes or until set. Cut into squares and serve hot.

Yield: 8 servings

Good served with salsa, fresh fruit and poppy seed bread or lemon muffins.

Frittata can be baked and then frozen. Thaw to room temperature before rewarming in a 200 to 250 degree oven.

Sausage and Vegetable Quiche

1 pound bulk hot sausage
2 deep dish pie crusts
1 bunch green onions, chopped
8 ounces mushrooms, sliced
1 green bell pepper, chopped
1 tablespoon butter
1 cup shredded sharp Cheddar cheese

1 cup shredded Swiss cheese
6 eggs, beaten
2 cups half-and-half
1 teaspoon salt
1 teaspoon freshly ground white pepper
1 dash of Tabasco sauce

Sauté sausage in a skillet; drain fat. Divide sausage between pie crusts. In same skillet, sauté green onion, mushrooms and bell pepper in butter. Spread vegetables over sausage. Sprinkle with both cheeses.

Beat eggs, half-and-half, salt, white pepper and Tabasco in a bowl. Pour into pie crusts.

Bake at 350 degrees for 30 minutes or until firm. Freezes well.

Yield: 2 quiches

Mediterranean Quiche

2 tablespoons butter
1 cup sliced onion
1 medium zucchini, diced
8 ounces button mushrooms, sliced
1 clove garlic, minced
4 ounces oil-packed sun-dried tomatoes, drained
 and chopped
3 tablespoons chopped fresh basil
½ teaspoon dried thyme

½ teaspoon salt
 black pepper to taste
3 eggs
1¼ cups half-and-half
½ cup shredded Gruyère cheese
½ teaspoon dried red pepper flakes
1 (9-inch) deep dish pie crust
3 ounces goat or tomato-basil feta cheese,
 crumbled

Melt butter in a large skillet over medium heat. Add onion and zucchini and sauté 6 minutes. Add mushrooms and cook until liquid has evaporated and vegetables are wilted. Add garlic and cook 1 minute. Mix in tomato, basil, thyme, salt and pepper.

Beat eggs with half-and-half in a bowl. Add Gruyère cheese and pepper flakes.

Fit pie crust into a 10-inch tart pan with a removable bottom, trimming excess pastry from sides of pan. Spoon vegetable mixture into pie crust. Pour egg mixture over the top. Sprinkle with goat cheese.

Bake at 350 degrees for 30 to 50 minutes or until set. Cool 30 minutes before serving. Serve warm or at room temperature.

Yield: 8 servings

Marie Hull

Sunrise Brunch Eggs

4 tablespoons butter
¼ cup minced onion
4 tablespoons all-purpose flour
3 cups warm milk
1 (8-ounce) package cream cheese
1 tablespoon Dijon mustard
1 teaspoon garlic salt
¼ teaspoon white pepper
2 tablespoons chopped fresh parsley

1 dash Tabasco sauce, or to taste
12 eggs
½ cup Parmesan or Swiss cheese, or more to taste
paprika for garnish
6 English muffins, split, toasted, buttered and kept warm
capers for garnish

Melt butter in a skillet. Add onion and sauté. Stir in flour and cook a few minutes. Add warm milk and whisk until thickened and smooth. Warm cream cheese in a microwave for 1 to 1½ minutes on high power. Stir warmed cream cheese into skillet. Add mustard, garlic salt, pepper, parsley and Tabasco. Pour sauce into two 8x8-inch casserole dishes.

Gently break 6 eggs into each casserole dish. Sprinkle Parmesan cheese equally over both dishes. Dust with paprika. Bake at 350 degrees for 20 to 30 minutes or until eggs are set.

To serve, ladle an egg with sauce over a toasted English muffin half. Sprinkle with a few capers. Serve with Sunny Mary (recipe below)

Yield: 6 servings

Crack each egg into a teacup first before adding to casserole dish; if a yolk breaks, substitute another egg.

SUNNY MARY

2 parts Bloody Mary mix or your favorite concoction

1 part fresh orange juice
vodka

Mix all ingredients and serve over ice. Garnish with orange slices.

If vodka is omitted, it's called a Bloody Shame!

Baked French Toast

day-old bread, French bread, white bread or
 Texas toast bread
6 eggs
1½ cups milk
1 cup light cream
1 teaspoon vanilla

¼ teaspoon cinnamon
¼ teaspoon nutmeg
4 tablespoons butter, softened
½ cup brown sugar
1 tablespoon light corn syrup
 warm maple syrup

Arrange bread slices in a greased 9-inch square baking pan, overlapping slices to completely fill pan.

Combine eggs, milk, cream, vanilla, cinnamon and nutmeg and mix well. Pour mixture over bread slices. Cover pan and refrigerate overnight. Remove pan from refrigerator 45 minutes before ready to bake.

Combine butter, brown sugar and corn syrup and mix well. Spread mixture evenly over bread. If desired, spread some of mixture between bread layers. For extra sweetness, drizzle a little syrup between bread layers.

Bake at 350 degrees for 45 to 60 minutes or until puffed and golden brown. Serve with warm maple syrup.

Yield: 6 to 8 servings

This is great to serve for a brunch with Grillades and Grits (page 135) and fresh fruit.

Blueberry Stuffed French Toast

12 slices home-style white bread
2 (8-ounce) packages cream cheese, cut into
 1-inch cubes
1 cup fresh blueberries

12 eggs
⅓ cup maple syrup
2 cups milk

Trim away crusts and cut bread slices into 1-inch cubes. Arrange half of bread cubes in a greased 9x13-inch baking dish. Scatter cream cheese cubes over bread. Sprinkle blueberries over cream cheese and top with remaining bread cubes.

In a large bowl, whisk together eggs, syrup and milk. Pour mixture over bread. Cover dish and refrigerate overnight.

When ready to bake, cover dish with foil. Bake at 350 degrees for 30 minutes. Remove foil and bake 30 minutes longer or until puffed and brown. Serve with sauce (recipe below). Recipe can be baked ahead and rewarmed in oven before serving.

Yield: 12 to 15 servings

SAUCE
1 cup sugar
2 tablespoons cornstarch
1 cup water

1 cup blueberries
1 tablespoon butter

Combine sugar, cornstarch and water in a small saucepan. Cook over medium heat, stirring occasionally, for 5 minutes or until thickened. Stir in blueberries and simmer 10 minutes longer. Stir in butter until melted. Serve sauce over blueberry toast.

Cornmeal Pancakes

½	cup all-purpose flour	1	teaspoon salt
½	cup cornmeal	1	egg
1	tablespoon baking powder	1	tablespoon corn or canola oil
1	teaspoon baking soda	1¼	cups buttermilk

Mix flour, cornmeal, baking powder, baking soda and salt in a bowl. In a separate bowl, beat egg with oil. Add buttermilk and beat. Add egg mixture to dry ingredients and stir just until combined; do not overmix or pancakes will be tough. Batter should be slightly lumpy. Allow to stand for at least 15 minutes.

Spoon about 1 to 1½ tablespoons of batter per pancake onto a lightly greased hot or very hot griddle and cook until bubbles form. Flip pancakes and cook another 1 to 1½ minutes.

Yield: 2 to 3 servings

Danish Pancakes

4	eggs	1	cup milk
1	cup flour	2	tablespoons butter, melted
3	tablespoons sugar	½	teaspoon butter
¼	teaspoon salt		lingonberry preserves

Beat eggs in a bowl. Stir in flour and mix. Add sugar, salt and milk. Stir in 2 tablespoons melted butter.

Heat an 8- to 10-inch skillet. Add ½ teaspoon butter to skillet. Pour ½ cup batter into skillet and tilt back and forth to spread batter evenly in skillet. When batter does not stick, turn pancake; do not overcook.

To serve, fold pancake in half or thirds. This is an authentic Danish recipe, traditionally served with lingonberry preserves.

Yield: 8 to 9 servings

GINGERBREAD Waffles

2	cups flour	1	teaspoon baking powder
1	teaspoon ground ginger	¼	cup sugar
½	teaspoon cinnamon	3	eggs, separated
¼	teaspoon ground cloves	½	cup molasses
½	teaspoon salt	1½	cups buttermilk
1	teaspoon baking soda	1	stick butter, melted

Sift together flour, ginger, cinnamon, cloves, salt, baking soda, baking powder and sugar in a large bowl.

In a medium bowl, whisk together egg yolks, molasses, buttermilk and butter. Pour liquid mixture into dry ingredients and stir until just combined. In a separate medium bowl, beat egg whites until stiff but not dry. Fold into batter.

Jim Becker

Ladle about ⅓ cup batter into each section of a very hot waffle iron and spread almost to edge. Close lid and cook 5 minutes or until waffle stops steaming.

Yield: 4 to 6 servings

Breakfast, Breads and Brunch

ROQUEFORT POPOVERS

1½ cups milk
6 ounces Roquefort cheese, crumbled
1 teaspoon salt

freshly ground black pepper to taste
2 cups all-purpose flour
6 eggs

Set oven rack to its lowest position. Generously grease 12 popover tins (preferably nonstick) with oil or shortening; do not use butter.

Warm milk and cheese in a small saucepan over medium-low heat until cheese melts. (Or melt cheese in milk in a glass measuring cup in microwave on low power for 1 minute.) Remove from heat and whisk in salt and pepper.

Place flour in a medium mixing bowl. Whisk in milk mixture until just combined; batter may be a bit lumpy. Add eggs, one at a time, whisking well after each addition. Pour batter into prepared tins.

Bake at 400 degrees on lowest shelf for 20 minutes. Without opening oven door, reduce oven temperature to 350 degrees and bake 15 minutes longer or until popovers are browned and fully puffed. Immediately remove popovers from tins to keep them from getting soggy. Poke each popover with a knife to release steam. Serve immediately.

Yield: 12 popovers

ℬREAKFAST OF 𝒞HAMPIONS

1 cup frozen wild blueberries
½ cup fresh berries, or ½ banana or peach
 (optional)

2 tablespoons Great for Your Heart Cereal, or
 more to taste (recipe below)
1 tablespoon protein powder (optional)
½-1 cup soy, almond or rice milk, or any milk

Process all ingredients in a blender, using enough milk to reach desired consistency. Eat as is, or top with honey, cinnamon or granola.

Yield: 1 serving

GREAT FOR YOUR HEART CEREAL

1 cup flax seeds
1 cup raw almonds
½ cup oat bran

1 ¼ cups wheat bran
1 cup vanilla-flavored whey protein powder

Grind flax seeds in a coffee grinder. Place almonds in a shallow baking pan and bake at 350 degrees for 5 minutes. Grind toasted almonds in coffee grinder. Mix ground flax seeds, ground almonds, oat bran, wheat bran and protein powder. Store in an airtight container and use as needed. May be frozen.

To make a bowl of hot cereal, place ½ cup of cereal mixture in a bowl. Add ¾ cup boiling water or milk and stir to mix. Let stand a few minutes before eating. If desired, top with yogurt or add to a smoothie.

Yield: 9 servings

Breakfast, Breads and Brunch

Garlic Cheese Grits Soufflé

1½ cups quick-cooking grits
2 teaspoons salt
5 cups boiling water
1 roll garlic cheese, sliced

1½ sticks butter
2 tablespoons Worcestershire sauce
5 eggs, separated

Cook grits with salt in boiling water until done. Stir in cheese, butter and Worcestershire sauce until cheese is melted. Beat egg yolks and add to mixture.

In a separate bowl, beat egg whites until stiff. Gently fold whites into grits mixture. Pour batter into a greased casserole dish.

Bake at 300 degrees for 45 minutes.

Yield: 6 to 8 servings

Hot Tomato Grits

2 slices bacon, chopped
2 (14½-ounce) cans chicken broth
½ teaspoon salt
1 cup quick-cooking grits

2 large ripe tomatoes, peeled and chopped
1 (4-ounce) can chopped green chiles, drained
1 cup shredded Cheddar cheese
¼ cup chopped tomatoes for garnish

Cook chopped bacon in a heavy saucepan until crisp. Gradually add broth and salt and bring to a boil. Stir in grits, tomato and chiles. Return to a boil and cook, stirring often, for 15 to 20 minutes.

Remove from heat. Stir in cheese and let stand 5 minutes or until cheese is melted. Garnish with chopped tomatoes.

Yield: 6 to 8 servings

One cup canned diced tomatoes and chiles can be substituted for the 2 tomatoes and the green chiles.

Mildred Nungester Wolfe

*"This bouillabaisse a noble dish is —
a sort of soup or broth or brew."*

~Ballads (1855)

From the Jane Brock kitchen at St. Andrew's came the soups that can be credited with birthing *All Things Good.* As communicants Anne McKeown and Susan Hill stirred their Minestrone and Beef, Leek and Barley Stew (while having considerable fun preparing Ash Wednesday lunch) they were also stirring their minds. We should publish a St. Andrew's cookbook! The entire congregation could submit recipes, volunteers could test them, various committees could arrange them, and voila! The Cathedral would have its own culinary guide. All this activity would bring us closer together, introduce us to some church members we don't know, and spread a spirit of camaraderie — all good things.

Good soups and salads or sandwiches: classic offerings for school lunches, office lunches, Saturday lunches, in fact, any lunch or supper. These can hardly be beat for ease and quick preparation (especially if you keep a good soup in the freezer), good nutrition, and the sheer gastronomical comfort they can bring, especially on an extremely cold or hot day. If you are serving soup and salad, add a good bread and you have delightful fare that even the most exacting gourmets will applaud.

Among the delectables submitted to *All Things Good* was Frank Duke's recipe for his Mother's Frozen Tomato Salad. We can call this recipe historical because his mother was Lillian Montgomery Duke, and her father, W.A. Montgomery, was on the building committee formed in 1902 to study the plans which resulted in the present location and structure of St. Andrew's. Frank's grandson, Ethan Montgomery Hendricks, represents the fifth consecutive generation of his family to worship here.

Two other historical salads that are published elsewhere and enjoyed by thousands at the old St. Andrew's Bazaar are St. Andrew's Cathedral Bazaar Gourmet Salad and Mrs. Saik's famous St. Andrew's Slaw that garnished many a hamburger. The former serves 800! You may not need that much salad every day, but it offers a lasting reminder of the popularity of the Bazaar when it seemed that all of Jackson came for lunch.

Among the soups submitted was Jane Johnston's famous Seafood Gumbo. Any visitor at Harvey and Jane's beach house in Orange Beach, Alabama, enjoyed this superb dish, originally published by Foley Woman's Club in 1962.

Soups, Salads and Sandwiches

Beef, Leek and Barley Stew

3	tablespoons butter	¼	cup chopped fresh Italian parsley	
1	leek, white part only, chopped	1	bay leaf	
2	stalks celery, chopped	½	teaspoon dried thyme	
1	onion, chopped		salt and freshly ground black pepper to taste	
1	pound beef stew meat or rump roast, cubed	1	potato, diced	
4	cups chicken broth	1	cup light cream	
⅓	cup barley			

Melt butter in a large pot. Add leek, celery, onion and meat and sauté over low heat for about 20 minutes, stirring occasionally. Add broth and barley and bring to a boil. Add parsley, bay leaf, thyme and salt and pepper. Cover and simmer about 2 hours. Add potato. Cover and simmer 30 to 40 minutes longer. Remove bay leaf. Stir in cream. Heat 5 minutes or until warm.

Yield: 4 servings

Kay Child

CHRISTINE'S BROWN STEW

2	pounds beef stew meat or rump roast, cut into 1½-inch cubes		2	bay leaves
	all-purpose flour		1	tablespoon salt
2	tablespoons vegetable oil		½	teaspoon black pepper
4	cups boiling water		½	teaspoon paprika
1	teaspoon lemon juice			dash ground cloves or allspice
1	teaspoon Worcestershire sauce		1	teaspoon sugar
1	clove garlic, minced		6	carrots, quartered
1	medium onion, sliced		4	small whole onions, quartered
			3-5	new potatoes, quartered

Dust beef with flour and brown, in batches, in vegetable oil. Transfer beef to a large pot. Add boiling water, lemon juice, Worcestershire sauce, garlic, onion, bay leaves, salt, pepper, paprika, cloves and sugar to pot. Cover and simmer 2 hours, stirring occasionally.

Add carrot, onion and potato to stew and cook, covered, until vegetables are tender. Serve with a green salad and toasted French bread.

Yield: 6 to 8 servings

Stew can be made ahead and frozen.

Soups, Salads and Sandwiches

Black Bean Chili with Pork

1	pound dried black beans		1	cup chopped red onion
2	pounds boneless pork loin, cut into 1-inch cubes		1	(28-ounce) can crushed tomatoes, undrained
4	cloves garlic, minced		½	(4-ounce) can jalapeño peppers, or to taste
1	tablespoon ground cumin		1	red bell pepper, chopped
1	teaspoon dried oregano		1	tablespoon lime juice
1	tablespoon salt			avocado for garnish

Soak beans in water overnight; drain. Place beans in a pot with pork, garlic, cumin, oregano, salt and onion. Add water to cover and bring to a boil. Reduce heat and simmer 4 hours, adding extra water as needed.

Add tomatoes with juice, jalapeño peppers, bell pepper and lime juice and cook 1 hour or until thickened. Garnish with avocado.

Yield: 6 servings

Chicken and Leek Soup

4	tablespoons butter		¼	cup flour
1½	cups chopped chicken		¾	cup half-and-half
2	cups chopped leek		2	cups whole milk
2	cups chicken broth		1	teaspoon poultry seasoning
¾	cup cooked barley, or 1 package wild rice, cooked		2	tablespoons minced fresh parsley
4	tablespoons butter			salt and pepper to taste

Melt 4 tablespoons butter in a medium saucepan. Add chicken and sauté. Remove chicken with a slotted spoon. Add leek to pan drippings and sauté until tender. Add broth and barley to pan; set aside.

Melt 4 tablespoons butter in a small saucepan. Blend in flour and cook 5 minutes. Slowly whisk in half-and-half and milk. Cook, stirring constantly, until thickened. Add cream sauce to barley mixture. Season with poultry seasoning, parsley and salt and pepper. Adjust seasonings as needed. Simmer 20 minutes. Add chicken to soup during last 5 minutes of cooking.

Yield: 6 servings

Chicken and Sausage Gumbo

1	whole chicken, cut into 8 pieces, or 1 package chicken breasts
¼	cup vegetable oil
¼	cup flour
3	smoked sausage links, cut into slices
1	(10-ounce) package frozen sliced okra
1	(15-ounce) can tomato sauce
1	(28-ounce) can puréed or crushed tomatoes
2	medium onions, chopped
6	stalks celery, chopped

1	bunch green onions, chopped
2	cloves garlic
1	(14-ounce) can chicken broth or water (optional)
1	teaspoon crab boil
	Tabasco sauce to taste
	salt and pepper to taste
	Italian seasoning to taste
	Tony Chachere's seasoning to taste
1	teaspoon poultry seasoning

Boil chicken in a large pot with a generous amount of water; reserve stock. Debone chicken and return to stock.

In a small saucepan, blend vegetable oil and flour. Cook roux over medium heat, stirring constantly, until roux in the color of a copper penny. Blend roux into stock.

Brown smoked sausage in a large skillet. Drain and add to stock.

Add okra, tomato sauce, puréed tomatoes, onion, celery, green onion and garlic to stock. Add canned broth or water if needed. Season with crab boil, Tabasco, salt and pepper, Italian seasoning, Tony Chachere's seasoning and poultry seasoning. Simmer 1 hour. Adjust seasonings and simmer until vegetables are soft and gumbo is desired consistency. Serve over brown rice with salad and French bread.

Yield: 8 to 10 servings

Soups, Salads and Sandwiches

Mexican Beef and Mushroom Soup

1 pound ground round or sirloin
1 large onion, chopped
½ green or red bell pepper, chopped
1 teaspoon olive oil
2-3 cloves garlic, chopped
1 (14½-ounce) can Mexican tomatoes, mashed
1 (8-ounce) can tomato sauce
2 tablespoons chili powder
1 tablespoon dried basil
1 tablespoon dried oregano
1 tablespoon dried cilantro
1 tablespoon dried thyme

1 tablespoon sugar, brown sugar or equal-measure sugar substitute
2 tablespoons Worcestershire sauce
 salt and pepper to taste
8 ounces mushrooms, chopped
2 carrots, shredded (optional)
2 bay leaves
1 cup port wine
4 cups water
1 (15-ounce) can no-salt-added corn kernels, drained

Sauté ground beef until done; drain and set aside.

In a large pot, sauté onion and bell pepper in olive oil until onion is clear. Add garlic and sauté, but do not allow to burn. Add tomatoes, tomato sauce, chili powder, basil, oregano, cilantro, thyme, sugar, Worcestershire sauce, salt and pepper, mushroom, carrot, bay leaves, wine, water and corn. Simmer about 5 minutes.

Stir in browned meat. Cover and simmer over low heat for 30 to 45 minutes. Soup is best made a day in advance. Serve with cornbread and a salad.

Yield: 10 servings

Brazilian Black Bean Soup

6 cups cold water
1 pound dried black beans
¼ cup olive oil
1 large red onion, chopped
2 large yellow onions, chopped
1 large clove garlic, chopped
3 medium carrots, chopped
2 medium stalks celery, chopped
½ medium bell pepper, chopped
¾ teaspoon dried thyme, crumbled

¾ teaspoon ground coriander
1 large bay leaf
1 (3-inch) strip orange peel, colored part only
½ teaspoon black pepper
parsley
2 quarts canned beef broth
salt and pepper to taste
⅓ cup Madeira wine (optional)
orange slices and parsley for garnish

Bring cold water and beans to a boil in a heavy pan. Remove from heat, cover and let stand 1 hour.

Heat oil in a heavy stockpot over medium-high heat. Add all onions and garlic and sauté 10 to 12 minutes or until lightly browned. Add carrot, celery, bell pepper, thyme, coriander, bay leaf, orange peel and ½ teaspoon black pepper. Sauté 5 minutes.

Drain beans and add to stockpot with vegetables. Add parsley and broth and bring to a simmer. Reduce heat, cover and gently simmer 2½ hours or until beans are mushy, stirring occasionally.

Purée soup in batches in a blender or food processor. Return soup to stockpot and season with salt and pepper to taste. Add wine just before serving. Garnish individual servings with orange slices and a sprinkle of parsley. Soup can be frozen.

Yield: 8 to 10 servings

Soups, Salads and Sandwiches

Cold Zucchini Soup

5 medium zucchini, thinly sliced
1 large yellow onion, sliced
1 large baking potato, peeled and sliced
4 tablespoons butter
3 cups chicken broth

1 pint half-and-half
1 teaspoon sugar
1 teaspoon soy sauce
1½ teaspoons salt
¼ teaspoon white pepper

Combine zucchini, onion, potato and butter in a heavy pot with a lid. Cook slowly, covered, stirring occasionally, until vegetables are very tender. Purée vegetables in a food processor in batches.

Transfer purée to a large bowl. Add broth, half-and-half, sugar, soy sauce, salt and pepper. Chill. Serve cold. Soup can be frozen.

Yield: about 3 quarts

Curried Zucchini and Squash Bisque

1 pound yellow squash, sliced
1 pound zucchini, sliced
1 large onion, chopped
4 tablespoons butter
1½ teaspoons salt
⅛ teaspoon white pepper

1 teaspoon Madras curry powder
1 (32-ounce) carton chicken broth
½ cup half-and-half
½ cup water
sour cream and chopped fresh chives
 (optional)

Sauté squash, zucchini and onion in butter over low heat for about 15 minutes. Add salt, pepper, curry powder and broth and cook, covered, over medium heat for another 15 minutes. Remove from heat and cool about 30 minutes. Stir in half-and-half and water. Purée soup in batches in a blender.

Best served at room temperature or just slightly warm; serving hot reduces the taste of the vegetables. Top with a dollop of sour cream and sprinkle with chives.

Yield: about 2 quarts

CREAMY MUSHROOM SOUP WITH FRESH TARRAGON

1	pound mushrooms, divided	¼	cup red wine
1	quart vegetable or chicken broth	½	cup flour
2	medium yellow onions, finely chopped	1	teaspoon dried tarragon, or 1 tablespoon fresh
4	tablespoons butter	1	cup cream
1	tablespoon chopped garlic		salt and pepper to taste

Chop half the mushrooms in a food processor and thinly slice other half; set aside.

Heat broth in a large pot over medium-high heat.

Sauté chopped mushrooms and onion in butter in a saucepan until they release all liquid. Add garlic and continue to cook 5 minutes. Deglaze saucepan with wine. Gently blend in flour and continue to cook until all lumps are gone and the flour is hot. Slowly add hot broth, whisking vigorously. Bring to a boil.

Meanwhile, sauté sliced mushrooms in a skillet. Add mushrooms to hot soup.

When soup boils, reduce heat to a simmer and cook to desired consistency, or add water or broth if soup is too thick. Add tarragon. Stir in cream. Season with salt and pepper.

Yield: 8 servings

Soups, Salads and Sandwiches

Chunky Gazpacho

1 clove garlic, minced
3-4 tomatoes, peeled and chopped
1 cucumber, peeled and chopped
½ red onion, chopped
1 (4-ounce) jar pimento, drained and chopped
1 (7-ounce) can sliced mushrooms, drained
 freshly ground black pepper to taste
⅛ teaspoon sea salt

2 tablespoons extra virgin olive oil
1 tablespoon white cider vinegar
1 (14-ounce) can artichoke hearts, drained and chopped
 spicy vegetable juice
 Worcestershire sauce to taste
 Tabasco sauce to taste
 seasoned salt to taste

Combine garlic, tomato, cucumber, onion, pimento, mushrooms, black pepper, sea salt, olive oil, vinegar and artichoke hearts in a large glass or plastic container. Add enough vegetable juice to cover contents of soup. Season with Worcestershire sauce, Tabasco sauce and seasoned salt. Chill before serving, preferably overnight.

Yield: 6 to 8 servings

This summer soup is better the next day after the flavors have "married". Three to four days down the road, the soup begins to get watery and loses flavor.

Lentil Soup

1 medium-size white or yellow onion, chopped
1 clove garlic, minced
¼ cup extra virgin olive oil
1 (10-ounce) can mild diced tomatoes with chiles
½ teaspoon celery seed

1 bay leaf
¼ teaspoon dry mustard
1 pound dried lentils
2 quarts chicken broth
 salt and pepper to taste

Sauté onion and garlic in olive oil until tender. Add tomatoes with chiles, celery seed, bay leaf, mustard, lentils, broth and salt and pepper.

Simmer, covered, for 45 to 60 minutes. Serve with a fresh green salad and a slice of hot cornbread to make your meal complete.

Yield: 2½ to 3 quarts

INESTRONE

3 tablespoons extra virgin olive oil
2-3 stalks celery, finely chopped
1 onion, finely chopped
4 ounces bacon, diced (optional)
1 (28-ounce) can peeled plum tomatoes
4 cups hot chicken or vegetable broth
 salt and freshly ground black pepper to taste
1 (14-ounce) can cannelloni beans, drained
1 (14-ounce) can flat green beans, drained

1 medium summer squash, sliced
1 medium zucchini, sliced
1 cup dry elbow macaroni
1 cup fresh or frozen peas
8 ounces green cabbage, shredded
2 tablespoons chopped Italian parsley
¼ cup pesto
¼ cup Parmesan cheese

Heat olive oil in a heavy stock pot. Add celery, onion and bacon and sauté until wilted. Add tomatoes and broth. Heat to a simmer. Season with salt and pepper.

About 1 hour before serving, add all beans, squash, zucchini, macaroni, peas, cabbage and parsley. Garnish individual servings with pesto and Parmesan cheese.

Yield: 6 to 8 servings

QUICK AND EASY TOMATO BASIL SOUP

2 cloves garlic, finely chopped
 olive oil
1 (26-ounce) jar tomato and basil sauce
1 pint half-and-half

1-2 teaspoons dried basil
2 tablespoons shredded Parmesan cheese
 sour cream (optional)
 Parmesan cheese for garnish

Sauté garlic in a saucepan in a little bit of olive oil for a few minutes. Add tomato sauce and half-and-half and whisk until well mixed. Add basil. Heat over low heat until hot, whisking occasionally. Whisk in 2 tablespoons Parmesan cheese.

Serve individual servings with a dollop of sour cream and a sprinkle of Parmesan cheese.

Yield: 4 servings

Hearty Potato Leek Soup

3-4 medium potatoes, peeled
3 cups peeled and cubed potato
1 cup sliced carrot
½ cup sliced celery
¼ cup vegetable oil
3 tablespoons flour
3 cups milk

1-2 leeks, chopped
parsley
salt and pepper to taste
garlic salt to taste
8 ounces bacon, cooked and crumbled
grated Cheddar cheese

Place whole potatoes in a large pot and cover with water. Bring to a boil and cook until tender. Drain and mash thoroughly, using some of the cooking water from the potatoes.

In a large pot, cook cubed potato, carrot and celery in boiling water; do not drain.

Heat oil in a small saucepan over low heat. Stir in flour and cook until roux is smooth and bubbly. Blend roux into vegetable mixture. Add mashed potatoes.

Sauté leeks and add to soup with parsley. Season to taste with salt and pepper and garlic salt. Top individual servings with crumbled bacon and grated cheese.

Yield: 6 to 8 servings

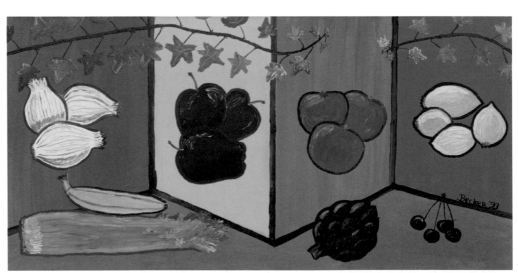

Jim Becker

ROASTED TOMATO SOUP WITH GARLIC

3 pounds plum tomatoes, halved lengthwise
 kosher salt and pepper to taste
6 tablespoons olive oil, divided
3 tablespoons minced garlic
1½ tablespoons finely chopped fresh rosemary, or
 1¼ teaspoons dried
1½ tablespoons finely chopped fresh thyme, or
 1¼ teaspoons dried

¼ teaspoon crushed red pepper flakes, or more
 to taste
1½ quarts chicken broth
6 tablespoons chopped fresh basil
16 (¼-inch thick) baguette slices
2 tablespoons olive oil

Place tomato halves, cut-side up, on a large baking sheet. Sprinkle with salt and pepper and drizzle with 3 tablespoons olive oil. Roast at 400 degrees for 1 hour or until brown and tender. Cool slightly. Transfer tomatoes and any accumulated juices to a food processor. Pulse until slightly chunky.

Heat 3 tablespoons olive oil in a large pot over medium-high heat. Add garlic and sauté 2 minutes or until fragrant. Stir in tomato, rosemary, thyme and pepper flakes. Add broth and bring to a boil. Reduce heat and simmer, uncovered, for 25 minutes or until soup thickens slightly. Remove from heat. Stir in basil and season to taste with salt and pepper.

Meanwhile, preheat broiler. Brush both sides of baguette slices with 2 tablespoons olive oil. Arrange slices on a large baking sheet. Broil 2 minutes on each side or until golden. Serve with soup.

Yield: 4 servings

Can be prepared 1 day ahead and refrigerated. Add basil and season to taste when rewarming over medium-high heat.

Cioppino

1 large onion, chopped
2 cloves garlic, minced
1/3 cup olive oil
1 (28-ounce) can plum tomatoes, undrained
1 1/2 cups dry red wine
1 bay leaf
1/4 teaspoon black pepper

3 tablespoons chopped fresh parsley
1 green bell pepper, chopped
1 (8-ounce) can tomato sauce
1 1/2 cups water
2 teaspoons salt
seafood of choice, such as 1/2 pound firm fish, 1 dozen oysters and 1 pound shrimp

Sauté onion and garlic in olive oil. Add tomatoes, wine, bay leaf, black pepper, parsley, bell pepper, tomato sauce, water and salt. Simmer, covered, for 1 hour. Remove bay leaf. Return to a simmer and add seafood. Cook 5 to 10 minutes or until cooked through. Soup can be frozen.

Yield: 6 servings

Chicken Cheese Soup

1/3 cup chopped bell pepper
1/3 cup chopped celery
1/2 cup chopped green onion
1 stick unsalted butter
1/2 heaping cup flour
2 cups chicken broth

2 cups milk
1 pound processed American cheese loaf, cubed
1/2 pound shredded sharp Cheddar cheese
4 chicken breasts, poached and diced
cayenne pepper to taste

Sauté bell pepper, celery and green onion in butter. Sprinkle flour over vegetables and blend. Slowly stir in broth and milk and blend well. Add cubed and shredded cheese and stir until melted and slightly thickened. Stir in chicken and season with cayenne pepper. If making ahead, freeze until needed and reheat in microwave.

Yield: 4 servings

CRAB AND BRIE SOUP

3 tablespoons butter
⅓ cup chopped green onion
3 tablespoons flour
1 (12-ounce) can fat-free evaporated milk
¾ cup chicken broth

5 ounces Alouette fine herbs crème de Brie, or 4 ounces Brie with rind removed, chopped
¼ teaspoon salt
¼ teaspoon black pepper
⅛ teaspoon nutmeg
1 cup fresh crabmeat, or 1 cup cooked corn

Melt butter over medium heat. Add onion and sauté until just softened. Mix in flour. Slowly stir in milk and broth until blended, adding Brie when half of liquids have been added. Continue to stir and add liquids as Brie melts into mixture. Season with salt, pepper and nutmeg. Add crabmeat. Heat thoroughly and serve.

Yield: 4 servings

CORN AND CRAB CHOWDER

3 tablespoons canola oil
½ cup chopped onion
1 cup chopped celery
½ cup chopped green bell pepper
½ cup chopped red bell pepper
¼ cup all-purpose flour
1 (16-ounce) package frozen sweet whole kernel corn
1 (10-ounce) can diced tomatoes with green chiles

1 tablespoon Worcestershire sauce
2 tablespoons tomato paste
1 teaspoon garlic salt
 salt and pepper to taste
2 cups canned chicken broth
2 cups milk
1 cup half-and-half
1 pound fresh crabmeat
2 green onions, thinly sliced for garnish

Heat canola oil in a large saucepan. Add onion, celery and all bell peppers and cook until wilted; do not brown. Stir in flour until blended. Cook over medium heat for 3 minutes. Add corn, tomatoes with chiles, Worcestershire sauce, tomato paste, garlic salt and salt and pepper. Stir until combined. Add broth, milk and half-and-half.

Bring to a boil over medium heat, stirring until slightly thickened. Add crabmeat. Cover and simmer 1 hour. Adjust seasonings as needed. Sprinkle with green onion just before serving.

Yield: 6 servings

Hot and Sour Lemongrass Soup

1½ pounds small shrimp, peeled and deveined, shells reserved

4 cups water

3 stalks fresh lemongrass, green tops trimmed and reserved, white bulb pounded flat and cut into 1-inch lengths

2 (15-ounce) cans Oriental straw mushrooms, drained (available in Asian markets)

5 lime leaves, fresh or frozen (optional; available in Asian markets)

2 small tomatoes, cut into wedges

1 large green onion, thinly sliced

1½ cups bean sprouts

3 tablespoons plus 1 teaspoon fresh lime juice

¼ teaspoon freshly ground black pepper

¼ cup fish sauce (available in Asian markets)

¼ teaspoon crushed red pepper flakes

½ teaspoon hot Chinese chile oil (available in Asian markets)

Place reserved shrimp shells in a saucepan with 4 cups water. Add reserved lemongrass tops and bring to a boil over high heat. Remove from heat, strain stock and return to saucepan.

Add lemongrass bulbs, mushrooms, lime leaves and tomato wedges to stock. Bring to a boil. Reduce heat and simmer 4 minutes. Add shrimp and simmer 2 minutes or until shrimp are loosely curled and opaque. Remove from heat and stir in green onion, bean sprouts, lime juice, black pepper, fish sauce, pepper flakes and chile oil. Serve immediately.

Yield: 6 servings

Mediterranean Seafood Soup with Saffron, Fennel and Tomatoes

1 teaspoon saffron threads	¾ pound fresh fish, cut into 1-inch chunks
¼ cup olive oil	¾ pound shrimp (optional)
1 tablespoon minced fresh garlic	1 cup peeled and coarsely chopped tomato
⅔ cup minced yellow onion	½ cup white wine
½ cup fennel bulb, thinly sliced	1½ quarts fish or shrimp stock, or bottled clam juice
⅓ cup julienned carrot	1 tablespoon orange zest
2 teaspoons crushed red pepper flakes	salt and pepper to taste
2 teaspoons anise seed	
½ cup chopped fresh Italian parsley	

Pour a bit of hot water over saffron threads in a bowl and allow to steep.

Meanwhile, heat olive oil in a stockpot. Add garlic, onion, fennel and carrot and allow to sweat. Add pepper flakes and anise seed and simmer until vegetables are soft. Add parsley, fish, shrimp and tomato and simmer several minutes.

Stir in wine, stock, saffron with liquid and orange zest. Bring to a full simmer. Season with salt and pepper.

Yield: 4 to 6 servings

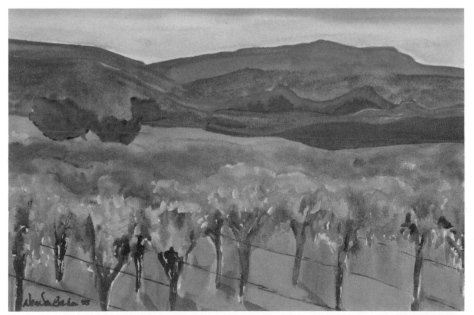

Dee Dee Baker

Soups, Salads and Sandwiches

Oyster Artichoke Soup

1 tablespoon vinegar	1 quart chicken broth
5 medium artichokes, or 3 (10-ounce) cans artichoke hearts, drained	4 ounces lean ham, chopped
1 stick butter	2 teaspoons chopped fresh parsley
1 tablespoon vegetable oil	1 clove garlic, chopped
¼ cup flour	1 tablespoon seasoned salt, or more to taste
1 bunch green onions, chopped	1 teaspoon black pepper
½ cup chopped celery	5 dozen oysters, with liquid

Add vinegar to boiling salted water. Add fresh artichokes and cook over medium heat for 45 to 55 minutes or until tender. Drain and cool. Scrape leaves and chop hearts. If using canned artichoke hearts, drain, chop and set aside.

Melt butter in a large Dutch oven over medium heat. Add oil and flour and cook, stirring constantly, for 5 minutes or until flour is browned. Add green onion and celery and sauté 15 minutes, stirring often. Add reserved artichoke scrapings and hearts, broth, ham, parsley, garlic, seasoned salt and black pepper. Simmer 20 minutes.

In a separate pan, heat oysters in their liquid for 3 minutes or until edges curl. Drain liquid into soup. Chop oysters and add to soup. Simmer 15 minutes longer. Adjust seasonings to taste.

Yield: 10 to 12 servings

Primo Gumbo

¾ cup olive oil
¾ cup flour
3 cups chopped onion
3 cups chopped celery
3 cups chopped red or green bell pepper
2 cloves garlic, chopped
1 bunch green onion, chopped
1 bunch parsley, leaves only
1 pound okra, fresh or frozen, chopped
2 bay leaves
2 tablespoons salt

½ teaspoon dried thyme
½ teaspoon dried rosemary
1 teaspoon brown sugar
1 pound andouille or Cajun sausage, sliced
½ cup Worcestershire sauce
½ cup ketchup
 Tabasco sauce to taste
2 quarts chicken broth or shrimp stock
1 (16-ounce) can tomatoes, chopped
 shrimp, oysters, fish, crabmeat, chicken or ham
 to taste

Make a roux by blending olive oil and flour in a saucepan. Cook, stirring constantly, over medium heat for 30 minutes or until roux is the color of peanut butter. If roux burns, throw it away and start over.

Add 3 cups chopped onion to roux and cook 10 minutes or until onion is clear. Add celery and bell pepper and cook 30 minutes or until tender. (These are the most important steps.)

Add garlic, green onion, parsley and okra, stirring after each addition. Cook 15 minutes or until okra is tender. Water can be added to make stirring easier. Stir in bay leaves, salt, thyme, rosemary and brown sugar.

In a separate pan, brown sausage. Add browned sausage along with a little of the pan drippings to the gumbo for flavor. Cook gumbo another hour. If freezing for future use, cool at this point and freeze in usable portions.

When ready to serve, thaw if needed. Add Worcestershire sauce, ketchup, Tabasco, broth, tomatoes and meat. Serve over a small portion of rice with French bread. Have salt and Tabasco available at the table.

Soups, Salads and Sandwiches

Salmon Chowder

2	tablespoons canola oil		1	cup sliced carrot
2	tablespoons butter		½	teaspoon dried dill
½	cup chopped onion		1	teaspoon salt
½	cup chopped celery		1	teaspoon black pepper
¼	cup chopped green bell pepper		1½	cups milk or half-and-half
1	clove garlic, minced		1	(8½-ounce) can cream style corn
3	tablespoons all-purpose flour		1	(8-ounce) salmon fillet
2	cups chicken broth			olive oil
1	cup diced potato, cut into 1-inch cubes			

Heat canola oil and butter in a large saucepan over medium heat. Add onion, celery and bell pepper and cook until wilted. Add garlic and cook 1 minute. Stir in flour and cook 3 minutes. Stir in broth, potato, carrot, dill, salt, pepper, milk and corn. Bring to a boil. Reduce heat, cover and simmer 30 minutes.

Sauté salmon in olive oil until seared on both sides. Flake salmon and add to soup. Continue to cook over low heat for 30 minutes longer. Adjust seasoning to taste.

Yield: 6 servings

Seafood Chowder

1	teaspoon olive oil		1	cup diced carrot
1	cup chopped onion		½	teaspoon white pepper
1	cup chopped celery		½	teaspoon dried thyme
1	cup diced red bell pepper		2	bay leaves
3	cloves garlic, minced		1½	pounds raw medium shrimp, peeled and deveined
½	cup all-purpose flour			
2	(10½-ounce) cans ready-to-serve chicken broth		2	(12-ounce) cans evaporated skim milk
			1	pound fresh crabmeat, drained and flaked
1½	cups water		2	(8¾-ounce) cans cream-style corn
3	cups peeled and diced red potato		1	teaspoon hot pepper sauce

Coat a Dutch oven with cooking spray. Add oil and place over medium-high heat until hot. Add onion, celery, bell pepper and garlic and cook until tender. Add flour and cook, stirring constantly for 1 minute. Slowly stir in broth, water, potato, carrot, white pepper, thyme and bay leaves. Bring to a boil. Reduce heat and simmer, uncovered and stirring often, for 20 minutes or until potato is tender.

Stir in shrimp, milk, crabmeat, corn and pepper sauce. Cover and simmer, stirring occasionally, for 5 minutes or until shrimp are pink. Remove bay leaves.

Yield: 10 servings

Soups, Salads and Sandwiches

Seafood Gumbo

3 tablespoons flour
2 tablespoons bacon fat or vegetable shortening
1 quart chicken broth
2 large onions, finely chopped
1 green bell pepper, minced
 vegetable oil
3 cups chopped okra, or 20 ounces frozen and
 sliced

1 (28-ounce) can tomatoes, undrained and
 chopped
4 bay leaves
1 tablespoon Creole seasoning
 dash of Louisiana hot pepper sauce
1 tablespoon Worcestershire sauce
2 pounds peeled and deveined raw shrimp
1 pound claw crabmeat

Make a roux by browning flour in a toaster oven, stirring frequently. Slowly heat and stir browned flour and bacon fat in a saucepan. Gradually stir in broth; set aside.

Sauté onion and bell pepper in a separate large saucepan in a small amount of oil. Add okra. Stir in tomatoes with juice. Add broth mixture, bay leaves, Creole seasoning, pepper sauce and Worcestershire sauce. Cook gumbo slowly, watching carefully, for 2 hours.

Add shrimp and crabmeat. Simmer slowly. Adjust seasonings as needed. Gumbo will become darker after adding seafood. Serve over a small mound of cooked rice.

Yield: 6 to 8 servings

Clyde's Tomato Aspic

1 (64-ounce) can tomato juice
½ onion, finely grated
3 tablespoons lemon juice
2 tablespoons vinegar
3 tablespoons Worcestershire sauce
1 tablespoon salt
 several dashes cayenne pepper

1 teaspoon Tabasco sauce
½ cup chopped green onion
4 (¼-ounce) envelopes unflavored gelatin
1 cup cold water
1 cup chopped bell pepper
1 cup finely chopped celery

Combine tomato juice, onion, lemon juice, vinegar, Worcestershire sauce, salt, cayenne pepper, Tabasco and green onion in a saucepan. Bring to a boil. Cool completely.

Dissolve gelatin in 1 cup cold water. Add to cooled tomato mixture. Chill until starting to thicken. Stir in bell pepper and celery. Pour mixture into a large mold or Bundt pan. Chill until firm before unmolding.

Yield: 12 servings

Arugula and Mint Salad

¼ teaspoon fennel seeds
1 tablespoon red wine vinegar
½ tablespoon Dijon mustard
 kosher salt and freshly ground black pepper

2 tablespoons extra virgin olive oil
4 cups curly green leaf lettuce
4 cups young arugula leaves
40 mint leaves

Coarsely grind fennel seeds with a mortar and pestle or spice grinder. Place fennel in a small bowl. Whisk in vinegar and mustard and season with salt and pepper. Gradually whisk in olive oil until dressing is emulsified.

In a large bowl, toss lettuce with arugula and mint. Add dressing and season with salt and pepper. Toss and serve.

Yield: 6 servings

Apple or pear slices and goat cheese can be added.

Soups, Salads and Sandwiches

Summer Melon Salad

1	large cantaloupe, cubed	1	tablespoon chopped chives
2	tablespoons olive oil		salt and pepper to taste
2	teaspoons white wine vinegar		salad greens
5	slices salami, sopressata or prosciutto, julienne		crumbled goat cheese

Combine cantaloupe, olive oil, vinegar, salami, chives and salt and pepper in a bowl and toss. Serve atop a handful of salad greens and sprinkle with goat cheese. Finish with a coarse grind of black pepper.

Yield: 4 to 6 servings

Melon Salad

1	cup pine nuts	3	limes, juiced
1	head butter lettuce	1/3	cup chopped fresh mint
1	cantaloupe melon	1/3	cup crumbled feta cheese
1	honeydew melon		

Toast pine nuts in a skillet over low heat, stirring often and watching carefully; set aside.

Separate lettuce leaves, wash and chill. Cut melons into bite-size pieces. Store melons in separate zip-top plastic bags so flavors do not blend. Chill.

Two hours before serving, divide lime juice and mint between 2 bags. Seal and chill.

To assemble, spoon a serving of honeydew and cantaloupe on a lettuce leaf. Top with feta and pine nuts.

Yield: 10 to 12 servings

MANDARIN SALAD

TOPPING
3 tablespoons sugar

½ cup sliced almonds

DRESSING
2 tablespoons balsamic vinegar
¼ cup vegetable oil
1 tablespoon chopped fresh parsley
2 tablespoons sugar

½ teaspoon salt
 dash of black pepper
 dash of Tabasco

SALAD
½ head iceberg lettuce or spinach, torn
½ head romaine lettuce, torn
1 cup chopped celery

1 cup chopped green onion
1 (11-ounce) can Mandarin oranges, drained

Heat sugar in a small pan until melted. Add almonds and stir until coated. Cool and store in an airtight container.

Mix all dressing ingredients and chill until serving time.

To assemble salad, layer lettuces. Add celery, green onion and oranges. Top with almonds. Whisk dressing with a fork until emulsified and pour over salad.

Yield: 6 servings

Cathy Crockett

CRANBERRY SALAD

1 pound fresh cranberries, chopped in a food
 processor
1½ cups sugar
2 cups red grapes, halved and seeded

1 (8-ounce) can pineapple tidbits, drained
½ cup chopped pecans
1 cup whipped cream

Mix chopped cranberries and sugar and place in a colander. Place colander in a bowl and refrigerate overnight to drain.

The next day, transfer cranberries to a bowl, discarding juice. Add grapes, pineapple and pecans. Fold in whipped cream.

Yield: 8 servings

RICE AND BLACK BEAN SALAD

3 cups cooked rice, room temperature
1 (16-ounce) can black beans, rinsed and drained
1 medium-size red bell pepper, minced
1 medium-size green bell pepper, minced
4 green onions, minced
¼ cup minced fresh cilantro

⅓ cup peanut oil
¼ cup fresh lime juice
 salt and freshly ground black pepper to taste
 lettuce leaves
2 avocados, peeled and sliced
1 mango or papaya, peeled, seeded and diced

Combine rice, beans, all bell peppers, onion and cilantro in a large bowl.

Mix peanut oil and lime juice in a small bowl. Pour mixture over salad and toss to coat. Season with salt and pepper. Cover bowl and refrigerate up to 1 day.

When ready to serve, line a large bowl with lettuce. Mount salad in the center. Garnish with avocado and mango or papaya and serve.

Yield: 8 to 10 servings

Mardi Gras Salad
and Poppy Seed Dressing

POPPY SEED DRESSING

½-¾ cup sugar
1 teaspoon dry mustard
1 teaspoon salt
⅓ cup cider vinegar

1 tablespoon grated onion
1 cup vegetable oil
1 tablespoon poppy seeds

SALAD

3 bunches broccoli, stems removed, separated into florets
1 bunch green onion, green and white parts, chopped
½ cup red grapes, halved and seeded
½ cup seedless green grapes, halved

½ cup raisins
½ cup golden raisins
2 red apples, unpeeled and chopped
2 green apples, unpeeled and chopped
 bacon bits
2 packages slivered almonds, toasted

Combine all dressing ingredients and mix well, whisking in oil slowly. Refrigerate until needed.

To assemble salad, combine broccoli florets, green onion, all grapes and raisins in a bowl. When ready to serve, add all apples, bacon bits and almonds. Toss salad with dressing and serve.

Yield: 8 to 10 servings

Cold Rice Salad

1½ cups cooked and cooled white rice
chopped raw vegetables, such as carrot, celery, green and red onion, ripe and stuffed olives, parsley and green bell pepper

tarragon
oil
vinegar
salt and pepper to taste

Mix cooled rice with chopped raw vegetables, tarragon, oil and vinegar. Season with salt and pepper. Chill well before serving.

Good summer dish to serve with cold suppers. May be made a day ahead.

Indonesian Rice Salad

SALAD
2 cups cooked brown rice
½ cup raisins
2 green onions, chopped
¼ cup toasted sesame seeds
½ cup thinly sliced water chestnuts
1 cup fresh bean sprouts

¼ cup toasted cashews
1 green bell pepper, chopped
1 stalk celery, chopped
chopped fresh parsley
salt and pepper to taste

DRESSING
⅔ cup orange juice
⅓ cup vegetable oil
juice of 1 lemon
3 tablespoons soy sauce

2 tablespoons dry sherry
1 clove garlic, minced
1 teaspoon grated fresh ginger

Combine all salad ingredients in a bowl.

Mix all dressing ingredients and pour over salad. Toss until mixed and chill until ready to serve.

Yield: 6 to 8 servings

Gimelli Chicken and Cranberry Salad

¼ cup pine nuts

4 ounces asparagus

1¼ cups dry gimelli, or other short, twisted pasta,
 cooked and drained

¼ cup frozen corn, thawed

10 ounces chicken, poached and ½-inch cubed

½ cup dried cranberries

 juice and zest of ½ orange

2 tablespoons apple cider vinegar

 rosemary to taste

 kosher salt and ground white pepper to taste

6 tablespoons honey

3 tablespoons Dijon mustard

½ cup olive oil

Toast pine nuts at 350 degrees for 10 minutes; set aside.

Blanch asparagus to desired doneness; drain and cool. Cut cooled asparagus on the diagonal into 1-inch pieces and place in a large bowl. Add drained pasta, corn, chicken, cranberries and orange zest. Mix well.

In a separate bowl, mix orange juice, vinegar, rosemary, salt and pepper, honey, mustard and olive oil. Drizzle over salad and toss to combine. Top with toasted pine nuts.

Yield: 8 servings

Soups, Salads and Sandwiches

Chicken Pasta Salad

3 pounds chicken tenders
1 medium onion, quartered
 salt and pepper to taste
6-7 ounces dry angel hair pasta

2-3 (14-ounce) cans chicken broth
1 pint cherry tomatoes, halved
2 (14-ounce) cans artichoke hearts, quartered
4-5 green onions, chopped

MARINADE

⅔ cup canola oil
6 tablespoons red wine vinegar
6 tablespoons lemon juice

2 teaspoons sugar
1 tablespoon seasoned salt
1 tablespoon basil

Cook chicken with quartered onion and salt and pepper in boiling water. Cool and cut into bite-size pieces.

Break pasta into thirds and cook according to package directions in chicken broth, adding water if needed for volume; drain. In a large bowl, mix chicken, pasta, tomatoes, artichoke hearts and green onions.

Combine all marinade ingredients and pour over salad. Mix thoroughly and marinate overnight. Serve hot or cold.

Yield: 8 to 10 servings

Marcia's Pasta Salad

PARMESAN DRESSING

1 egg	¼ cup red wine vinegar
1 cup vegetable oil	1 teaspoon freshly ground black pepper
½ cup freshly grated Parmesan cheese	½ teaspoon garlic salt

SALAD

8 ounces corkscrew noodles, cooked and drained

1 (4-ounce) can chopped green chiles

1 (10-ounce) bag frozen artichoke hearts, thawed

8 ounces mozzarella cheese, cubed

4-6 boneless, skinless chicken breasts, cooked and chopped, or may substitute ham

12 ounces fresh spinach

To make dressing, place egg in a blender. With motor running, slowly add oil until emulsified. Add Parmesan cheese, vinegar, pepper and garlic salt and blend.

Mix drained noodles, chiles, artichoke hearts, mozzarella cheese and chicken with dressing. Salad is best if prepared 8 hours to a day ahead. Add spinach just before serving to prevent wilting.

Yield: 6 to 8 servings

Chicken and Spinach Tortellini

3 cups cooked and chopped chicken breast

2 Granny Smith apples, peeled and chopped

4 green onions, chopped

½ cup sliced ripe olives

½ cup mayonnaise

1 (9-ounce) package cheese tortellini

1 bunch spinach, washed and drained

½ cup sunflower seeds

1 (8-ounce) bottle Italian salad dressing, or as needed

Combine chicken, apple, green onion, olives and mayonnaise and mix well. Refrigerate overnight.

The next day, cook tortellini according to package directions; drain. Add tortellini, spinach and sunflower seeds to chicken mixture. Just before serving, add Italian dressing to taste.

Yield: 4 servings

Soups, Salads and Sandwiches

Shrimp, Orzo and Feta Salad

1	tablespoon kosher salt	1	cup minced green onion, white and green parts
	extra virgin olive oil	1	cup chopped fresh dill
12	ounces dry orzo pasta	1	cup chopped fresh Italian parsley
½	cup freshly squeezed lemon juice	1	cucumber, seeded and diced (optional)
½	cup olive oil	½	cup finely diced red onion
2	teaspoons kosher salt	2	teaspoons kosher salt
1	teaspoon freshly ground black pepper	1	teaspoon freshly ground black pepper
2	pounds shrimp, peeled and deveined	12	ounces coarsely crumbled or diced feta

Add 1 tablespoon salt and a splash of olive oil to a large pot of water and bring to a boil. Add orzo and simmer 9 to 11 minutes, stirring occasionally, until cooked al dente; drain and transfer to a large bowl.

Whisk together lemon juice, ½ cup olive oil, 2 teaspoons salt and black pepper. Pour mixture over hot orzo and stir well.

Meanwhile, place shrimp in a medium bowl. Drizzle with olive oil and sprinkle with salt and pepper. Toss to combine and spread in a single layer on a baking sheet. Bake at 400 degrees for 5 to 6 minutes or until shrimp are cooked through; do not overcook.

Add cooked shrimp to orzo along with green onion, dill, parsley, cucumber, red onion, 2 teaspoon salt and 1 teaspoon pepper. Toss well. Carefully stir in feta cheese. Set aside at room temperature for 1 hour to allow the flavors to blend, or refrigerate overnight. If refrigerated, taste and adjust seasonings and bring to room temperature before serving.

Yield: 6 servings

Vashon Island Orzo Salad
with Lime Vinaigrette

DRESSING
¼	cup fresh lime juice
2	tablespoons balsamic vinegar
¾	cup extra virgin olive oil

Creole mustard to taste
horseradish to taste
1 (2-ounce) jar capers

SALAD
2 cups dry orzo pasta
¾ cup kalamata olives
1 cup diced sweet onion
minced garlic to taste
½ cup chopped Italian parsley
¾ cup chopped red bell pepper

½ cup chopped celery
1 cup chopped tomato
fresh basil, chiffonade
2 cups cooked leftover salmon, broken into pieces
sea salt and freshly ground black pepper to taste

Whisk together lime juice and vinegar in a small bowl. Gradually whisk in olive oil. Season with mustard and horseradish. Stir in capers. Set aside.

Cook orzo in a large pot of boiling salted water until al dente, stirring occasionally. Drain and rinse under cold water, drain well. Transfer to a large mixing bowl and cool.

Add olives, onion, garlic, parsley, bell pepper, celery, tomato, basil and salmon to orzo. Pour dressing over salad and season with salt and pepper. Let stand at room temperature up to 2 hours. Stir before serving.

Yield: 6 to 8 servings

Proportions are estimated. Use your imagination when adding ingredients. Cooked chicken, pork tenderloin, shrimp, duck or crabmeat can be substituted for the salmon.

Soups, Salads and Sandwiches

Greek Pasta Salad

¼ cup olive oil
3 tablespoons lemon juice
2 tablespoons Greek seasoning
3 tablespoons mayonnaise
1 bunch green onions, sliced

1 red bell pepper, chopped
1 (2¼-ounce) can ripe olives
1 (7-ounce) package vermicelli pasta, cooked, rinsed and drained
grape tomatoes

Combine all ingredients except grape tomatoes in a large bowl. Mix well. If salad is dry, add more olive oil. Just before serving, add tomatoes.

Yield: 6 servings

Grilled chicken or boiled shrimp, as well as feta and/or purple onion slices can be added just before serving.

Yield: 6 servings

Curried Chicken Salad

3 cups cooked and chopped chicken breast
1 cup halved seedless red grapes
1 cup peeled and diced apple
¼ cup diced pineapple
2 tablespoons currants (optional)
6 tablespoons mayonnaise
2 teaspoons honey

1 teaspoon curry powder
1 teaspoon fresh lemon juice
¼ teaspoon salt
¼ teaspoon freshly ground black pepper
2 tablespoons sliced toasted almonds, or ⅓ cup walnuts

Combine chicken, grapes, apple, pineapple and currants in a large bowl.

In a separate bowl, whisk together mayonnaise, honey, curry powder, lemon juice, salt and pepper. Pour mixture over chicken salad and gently toss to coat. Cover and chill. Garnish with nuts to serve

Yield: 4 servings

Regan's Chicken Salad

6 medium or 4 large chicken breasts	¾ cup mayonnaise
4 tablespoons butter	1 teaspoon dried tarragon
3 cubes chicken bouillon	black pepper to taste
¾ cup sour cream	

Cover chicken with cold water in a large pot. Add butter and bouillon and bring to a boil. Reduce heat and simmer until chicken is very tender. Cool and remove skin and bones. Shred chicken by hand into small, bite-size pieces; do not chop or you will ruin the texture of the finished product.

Whisk together sour cream and mayonnaise. Fold mixture into chicken, mixing well. If too dry, add a little more sour cream. Season with tarragon and lots of pepper, but do not salt at this point (the chicken has absorbed salt from the bouillon). Refrigerate at least 3 hours.

If mixture is too thick from absorbing dressing, add more sour cream or mayonnaise at this point. Season with salt as needed.

Makes a very good sandwich or stuffed tomato, and can't be beat as a snack on crackers. Wonderful for a cocktail party in a hollowed-out bread or cabbage, served with thinly sliced French bread.

Lemon-Ginger Chicken Salad

½ cup mayonnaise	½ teaspoon salt
¼ cup sour cream	2 cups cooked and cubed chicken
1 teaspoon sugar, or ½ packet sugar substitute	1 cup halved seedless green grapes
½ teaspoon lemon zest	1 cup thinly sliced celery
1 tablespoon lemon juice	1 (4- or 6-ounce) package slivered almonds
½ teaspoon ground ginger	

Mix mayonnaise, sour cream, sugar, lemon zest and juice, ginger and salt in a medium mixing bowl. Add chicken, grapes and celery and toss well until evenly coated. Cover and chill at least 2 hours.

Serve salad over sliced cantaloupe, honeydew or strawberries on lettuce leaves sprinkled with almonds on top.

Yield: 4 servings

West Indies Salad

SALAD

2 pounds jumbo lump crabmeat, rinsed in a colander with cold water, picked for shells

1 large onion, finely chopped, sweet onion variety preferred

1 (4- to 6-ounce) jar capers, drained

1 (14-ounce) bag frozen artichoke quarters, cooked according to package directions, or one (14-ounce) can, drained and quartered (optional)

DRESSING

4 tablespoons chopped fresh parsley, or 2 tablespoons dried

½ cup extra virgin olive oil, or ¼ cup olive oil and ¼ cup pepper oil

½ cup distilled vinegar, or more to taste

2 tablespoons Worcestershire sauce

½ teaspoon Tabasco sauce salt and pepper to taste

Combine crabmeat, onion, capers and artichoke in a gallon-size zip-top bag.

Mix all dressing ingredients in a 2-cup glass measuring cup, stirring well. Pour dressing over salad in bag. Seal well and place in a dish in case bag leaks. Refrigerate several hours, turning bag several times to coat.

Drain and serve over a bed of crisp lettuce leaves. Garnish with red bell pepper slices, grape tomatoes and olives.

Yield: 4 to 6 servings

Crab Salad with Asparagus, Avocado and Lime

VINAIGRETTE

3	tablespoons lime juice
2	teaspoons lime zest
4½	teaspoons rice wine vinegar
1½	teaspoons honey

1½	teaspoons grated fresh ginger
3	tablespoons olive oil
3	tablespoons peanut oil
	salt and freshly ground pepper to taste

SALAD

1	pound asparagus, ends trimmed
1	pound fresh lump or jumbo lump crabmeat
2	heads Bibb lettuce, torn

2	ripe avocados, halved, pitted and peeled
1	ruby red grapefruit, peeled and cut into sections

Whisk together lime juice and zest, vinegar, honey and ginger. Whisk in oils. Season with salt and pepper; set aside.

For salad, cook asparagus in a pot of boiling water for about 5 minutes. Drain and plunge into an ice water bath until cold; drain. Toss asparagus with 3 tablespoons vinaigrette.

Toss crabmeat with 3 tablespoons vinaigrette; set aside. In a large bowl, toss lettuce with 3 tablespoons vinaigrette.

Divide dressed lettuce among 4 chilled large plates. Arrange an avocado half on top of lettuce and drizzle with some vinaigrette. Arrange a bundle of asparagus next to each avocado half. Divide crabmeat among salads over the avocado and asparagus. Garnish with grapefruit sections and serve.

Yield: 4 servings

Tropical Pork Tenderloin Salad

PORK
2 teaspoons salt
½ teaspoon black pepper
1 teaspoon ground cumin
1 teaspoon chili powder

1 teaspoon cinnamon
2 pork tenderloins
2 tablespoons olive oil

GLAZE
1 cup dark brown sugar
2 tablespoons minced garlic

1 tablespoon Tabasco sauce

VINAIGRETTE
3 tablespoons fresh lime juice
1 tablespoon fresh orange juice
1 tablespoon Dijon mustard
1 teaspoon curry powder, toasted

½ teaspoon salt
¼ teaspoon black pepper
½ cup olive oil

SALAD
3 naval oranges
2 ripe, firm California avocados
5 ounces baby spinach, trimmed (6 cups leaves)

4 cups thinly sliced napa cabbage
1 red bell pepper, cut lengthwise into strips
½ cup golden raisins

Mix salt, pepper, cumin, chili powder and cinnamon. Rub mixture over pork.

Heat olive oil in an ovenproof 12-inch heavy skillet over medium-high heat until just starting to smoke. Add pork to skillet and brown, turning, for about 4 minutes total. Leave pork in skillet.

Stir together all glaze ingredients and pat on top of each tenderloin.

Transfer pork in skillet to oven and bake at 350 degrees for 20 minutes or until a meat thermometer inserted diagonally in center of tenderloins registers 140 degrees. Remove from heat and let stand in skillet for 10 minutes; temperature will rise to about 155 degrees while standing. Cut pork at a 45-degree angle into ½-inch slices.

While pork roasts, prepare vinaigrette. Whisk together lime juice, orange juice, mustard, curry powder, salt and pepper. Whisk in oil in a steady stream until emulsified.

Cut peel, including white pith, from oranges with a sharp knife. Cut oranges crosswise into ¼-inch thick slices.

Cut avocados in half, remove pit and peel. Cut avocado halves diagonally into ¼-inch slices.

Combine spinach, cabbage, bell pepper and raisins in a large bowl. Toss salad with about ¼ cup vinaigrette.

To assemble salad, line individual salad plates with dressed salad. Arrange sliced pork, oranges and avocados in rows on top. Drizzle extra vinaigrette over orange and avocado slices. Pour any skillet juices over pork slices.

To toast curry powder, stir in a dry heavy skillet over medium heat until fragrant and a shade or 2 darker.

Yield: 6 to 8 servings

Kit Fields

Soups, Salads and Sandwiches

Salad Niçoise

FRENCH VINAIGRETTE DRESSING

⅔ cup olive oil
1 tablespoon lemon juice
2 tablespoons wine vinegar
2 tablespoons Dijon mustard

1 clove garlic, finely minced
 salt and freshly ground pepper to taste
1 tablespoon chopped fresh basil, parsley
 and/or dill

SALAD

8 new potatoes
1 tablespoon minced green onion
8 ounces fresh green beans
2 heads Boston or Bibb lettuce, separated into
 leaves
4 ripe tomatoes, quartered, or 12 cherry
 tomatoes, halved

2 (6-ounce) cans tuna in olive oil, drained and
 flaked, or albacore tuna
⅓ cup niçoise or Greek olives
3 tablespoons capers
3 tablespoons dry vermouth
 salt and pepper to taste
1 (2-ounce) tin rolled anchovies (optional)
3 hard-boiled eggs, peeled and halved

Combine all dressing ingredients in a screw-top jar and shake well to blend. Refrigerate until ready to use.

Steam new potatoes until tender. Cool, then peel and slice and toss with minced green onion; set aside.

Blanch green beans in boiling salted water for 3 to 5 minutes. Plunge into an ice water bath until cooled; drain and set aside.

To assemble salad, toss lettuce with 2 tablespoons dressing and place on a round platter. Arrange potato slices in a ring over lettuce. Arrange beans and tomatoes in a decorative pattern on top. Place flaked tuna in a mound in the center. Sprinkle olives and capers around tuna. Drizzle with vermouth and season with salt and pepper. Place rolled anchovies on top of egg halves and arrange around tuna. Spoon dressing over entire salad. Serve immediately.

Yield: 6 servings

Artichoke and Avocado Salad

DRESSING
1	packet dry garlic and herb salad dressing mix
½	cup walnut oil
¼	cup balsamic vinegar

3	tablespoons water
½	teaspoon sugar or sugar substitute

SALAD
1	large tomato, peeled and cut into bite-size chunks
¼	cup minced Vidalia onion
4	stuffed olives, sliced
2	hearts of palm, cut into ½-inch slices

5	artichoke hearts, halved
1	ripe avocado, peeled and cut into bite-size chunks at serving time
¼	cup crumbled feta cheese
	garlic salt and black pepper to taste

Combine dressing mix with walnut oil, vinegar and water as directed on dressing package. Stir in sugar.

For salad, combine tomato, onion, olives, hearts of palm and artichoke in a large bowl and toss well. Refrigerate if preparing ahead.

Just before serving, peel avocado and cut into bite-size chunks. Add avocado and feta to salad along with desired amount of dressing. Season with garlic salt and pepper. Toss and serve immediately.

Yield: 2 servings

Salad ingredients can be doubled or tripled; the amount of dressing will be adequate even if salad amount is tripled.

Great Salad

3	heads romaine lettuce, washed and torn
2	heads green lettuce, washed and torn
¼	cup extra virgin first cold pressed olive oil or to taste
	juice of 2 lemons or to taste

1	tablespoon garlic salt or to taste
1	red bell pepper, chopped
1	orange bell pepper, chopped
1	(16-ounce) can hearts of palm, drained and chopped

Combine lettuces in a large bowl and toss with olive oil, using enough oil to make the greens glisten, but using a light touch so lettuce is not drenched in oil. Sprinkle with lemon juice and toss. Season with garlic salt to taste. Place bell peppers and hearts of palm on top and serve.

Sarah's Avocado Salad

1-2 cloves garlic
6 large or 8 medium avocados
1 large lemon, halved
 salt and white pepper to taste

⅓-½ cup canola oil, or as needed
1 extra large or 2 medium heads iceberg
 lettuce, washed and torn

Rub garlic cloves on the inside surface of a wooden salad bowl, or press cloves and add to salad for a stronger garlic taste.

Peel avocados and cut into large cubes. Add to salad bowl and squeeze lemon juice over top. Toss avocados well. Add salt and pepper and canola oil and toss.

When ready to serve, add lettuce and toss.

Yield: 8 to 12 servings

Everyone raves about this salad and it goes with most any meal you might serve.

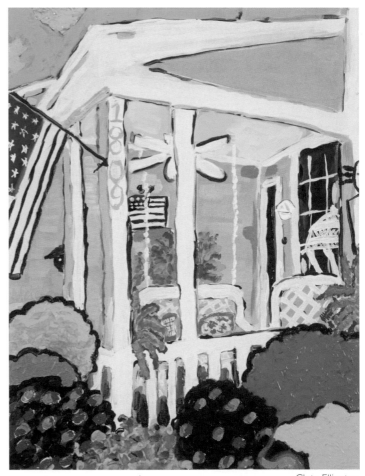

Cleta Ellington

Cauliflower and Broccoli Salad

1 head cauliflower, broken into bite-size florets	1 bunch green onions, sliced
1 head broccoli, broken into bite-size florets	1 cup mayonnaise
1 (4-ounce) can chopped ripe olives	sugar to taste
1 pound bacon, cooked and crumbled	juice of 1 lemon
1 pound fresh mushrooms, sliced	½ cup shaved Parmesan cheese

Blanch cauliflower and broccoli, drain and cool. Combine blanched vegetables with olives, bacon, mushrooms and green onion in a large salad bowl.

In a separate bowl, mix mayonnaise, sugar, lemon juice and cheese. Add mixture to salad and toss. Chill several hours before serving.

Yield: 10 to 12 servings

Blue Corn Salad

2¾ cups white shoepeg corn	2½ ounces arugula, chopped
1 pint cherry tomatoes, halved	1 cup blue cheese, crumbled
4 stalks celery, chopped	2 tablespoons balsamic vinegar
½ red onion, chopped	⅓ cup olive oil

Combine corn, tomatoes, celery, onion and arugula in a bowl. Top with blue cheese, reserving some cheese for garnish.

Mix vinegar and olive oil in a separate bowl. Pour mixture over salad and toss. Garnish with reserved cheese. Salad can be made a day in advance.

Yield: 6 to 8 servings

Orange and Cucumber Salad

1 cucumber, peeled and sliced	juice of ½ lemon
1 large orange, peeled and sliced	olive oil to taste
½ large red onion, thinly sliced	kosher salt to taste
½ cup chopped fresh mint leaves	

Combine cucumber, orange and onion in a salad bowl. Add mint, lemon juice, olive oil and salt and toss to mix. Chill.

Serve with Paella (see page 241).

Yield: 4 servings

Thai Cucumber Salad

1 cup sugar	1 jalapeño pepper, seeded and thinly sliced
½ cup vinegar	¼ large onion, sliced
salt to taste	2 tablespoons chopped cilantro
2 cucumbers, peeled and sliced	

Combine sugar, vinegar and salt in a saucepan and bring to a boil. Allow to cool.

Place cucumbers, jalapeño, onion and cilantro in a salad bowl. Pour cooled mixture over top and refrigerate 1 hour. Serve well chilled.

Yield: 4 servings

Pete's Potato Salad

3-4 medium potatoes
 freshly ground black pepper
½ bell pepper, chopped
3-4 stalks celery, chopped

1-2 tablespoons cubed sweet pickle
4 hard-boiled eggs, chopped
2 tablespoons mayonnaise
1 tablespoon prepared mustard

Cook potatoes in boiling salted water until fork tender. Drain and cube when cool enough to handle. Place potatoes in a salad bowl. Season with black pepper.

Add bell pepper, celery, pickle and egg to potatoes. Fold in mayonnaise and mustard.

Yield: 6 to 8 servings

Creamy Coleslaw

1 cup mayonnaise
4 tablespoons milk
2 tablespoons white vinegar
1 teaspoon sugar
1 (16-ounce) package coleslaw mix

1 green bell pepper, diced
1 tablespoon minced mild onion (optional)
 salt and pepper to taste
⅛ teaspoon white pepper

Combine mayonnaise, milk, vinegar and sugar in a small bowl. Let dressing stand 5 minutes.

Place coleslaw mix, bell pepper and onion in a large bowl. Pour dressing over top and season with salt and black and white pepper. Toss until evenly coated. Cover and refrigerate at least 1 hour. Stir before serving.

Yield: 8 servings

Soups, Salads and Sandwiches

Ann Allin's Slaw

1	large head cabbage, shredded		1	teaspoon salt
2	large onions, sliced		1	teaspoon dry mustard
¾	cup sugar		1	cup vinegar
1	teaspoon celery seed		1	cup salad oil

Place cabbage and onion in a salad bowl.

Combine sugar, celery seed, salt, mustard and vinegar in a saucepan. Bring to a full boil, then remove from heat and stir in oil. Pour hot mixture over vegetables. Refrigerate until thoroughly chilled.

Yield: 8 servings

New Orleans Olive Salad

SALAD

1	(10-ounce) jar salad olives, drained and chopped		2	stalks celery, chopped
½	cup drained and finely chopped marinated artichoke hearts		¼	cup chopped ripe olives
			½	cup red bell pepper, cut into ½-inch strips
½	cup chopped cauliflower florets		1	small carrot, cut into 1-inch strips

DRESSING

1	cup olive oil		3	cloves garlic, chopped
3	tablespoons lemon juice		1	tablespoon chopped green onion
8	anchovy fillets		3	tablespoons dried oregano
½	teaspoon black pepper			

Chop salad vegetables, one at a time, in a food processor; pulse quickly so that vegetables are chunky, not pulverized. Combine all salad ingredients in a large bowl.

Mix all dressing ingredients in a food processor. Pour dressing over salad. Refrigerate 24 hours before serving. Salad will keep for several weeks.

Use this salad as a substitute for the Italian olive salad mix in Mini Muffalettas (page 121).

Creamy Citrus Dressing

1 egg	2 teaspoons lemon zest
2 tablespoons lemon juice	1 tablespoon orange zest
1/3 cup orange juice	1 cup heavy cream, whipped
1 cup sugar	

Beat egg in a large measuring cup. Stir in lemon and orange juices, sugar and lemon and orange zests. Microwave dressing on medium power, stirring every few seconds, until mixture thickens. Refrigerate until ready to use; mixture will thicken as it cools.

When ready to serve, fold in whipped cream. Serve with fresh fruits as a dip, or mix together for a salad.

Yield: about 1 pint

Eggless Caesar Salad Dressing

¾ cup mayonnaise, do not use light	3-4 tablespoons fresh lemon juice
¼ teaspoon Tabasco sauce	½ cup freshly grated Parmesan cheese
3 cloves garlic, or to taste	¼ cup olive oil
½ teaspoon freshly ground black pepper	dash of Worcestershire sauce
1 teaspoon Dijon mustard	2 anchovy fillets (optional)

Purée all ingredients in a food processor. Refrigerate overnight.

Toss dressing with romaine lettuce and top with croutons and shaved Parmesan cheese.

Yield: about 1 pint

Soups, Salads and Sandwiches

Hot Bacon Dressing

the ONLY dressing for a REAL spinach salad

4-6 slices bacon, diced	1 teaspoon dry mustard
3 tablespoons diced onion	½ cup vinegar
2 tablespoons flour	½ teaspoon salt
½ cup sugar	1½ cups water
1 egg, beaten	

Place diced bacon in a cold skillet. Cook slowly until crisp. Add onion to skillet and sauté. Remove bacon and onion with a slotted spoon to a paper towel, leaving bacon drippings in skillet.

Combine flour and sugar in a small bowl. Add egg, mustard, vinegar, salt and water and mix until smooth. Pour mixture into bacon drippings and heat, stirring constantly, until thickened. Return bacon and onion to skillet and heat through.

Pour dressing over raw baby spinach. Add sliced raw mushrooms and sliced and quartered hard-boiled eggs.

Dressing can be made ahead and refrigerated for up to 2 days. Warm before using.

Yield: about 1 pint

Kum-Back Salad Dressing

5 cloves garlic, grated or pressed	1½ tablespoons Worcestershire sauce
½ cup ketchup	juice of 1 lemon
1½ cups chili sauce	1 teaspoon dry mustard
1 cup vegetable or canola oil	1 cup best quality mayonnaise
1 tablespoon paprika	2 teaspoons sugar
1 teaspoon black pepper	2 tablespoons chopped fresh parsley
2 tablespoons water	5 anchovy fillets, finely minced

Combine all ingredients in a blender or food processor. Mix well. Refrigerate.

Yield: about 1 quart, 32 servings

Thousand Island Salad Dressing

1 cup cottage cheese	Tabasco to taste
2 cups mayonnaise	Worcestershire sauce to taste
½ cup freshly grated Parmesan cheese	onion juice to taste (optional)
4 hard-boiled eggs, peeled and chopped	1 tablespoon prepared horseradish
5 tablespoons chili sauce	

Combine all ingredients in a bowl and mix with a fork. Store in refrigerator up to 1 week; do not freeze or microwave.

Mini Muffalettas

2 (12-ounce) packages party white dinner rolls	8 ounces provolone cheese, sliced
8 ounces Virginia ham, thinly sliced	1 (16-ounce) jar Italian olive salad mix
4 ounces Genoa salami, thinly sliced	2 tablespoons unsalted butter, melted
4 ounces smoked turkey, thinly sliced	sesame seeds

Slice each package of dinner rolls in half horizontally; do not separate rolls. Layer ham, salami, turkey and cheese on bottom half of rolls, dividing evenly between 2 packages.

Drain olive salad mix and pulse briefly in a food processor. Spoon or spread salad mix over meat and cheese layers. Replace top half of rolls.

Wrap each large sandwich in foil and bake at 425 degrees for 20 minutes. Fold away top of foil. Lightly brush top of sandwiches with butter and sprinkle with sesame seeds. Return to oven and bake, uncovered, for 5 minutes or until rolls are lightly browned.

Run a knife through original divisions on top of rolls to make finger sandwiches. Serve hot.

Yield: 4 to 6 servings

Ham and Turkey Hot Rolls

1 foil pan frozen yeast rolls, thawed in refrigerator

4 tablespoons unsalted butter, softened

1 tablespoon Creole mustard

1 tablespoon finely grated yellow onion

1 teaspoon poppy seeds

4 ounces thinly shaved Virginia ham

4 ounces thinly shaved smoked turkey

4 ounces freshly shredded Swiss cheese

Slice package of rolls in half horizontally; do not separate rolls. Combine butter, mustard, onion and poppy seeds in a small bowl. Spread mixture over each cut side of rolls. Place bottom half back in foil pan.

Layer ham, turkey and cheese on bottom half of rolls. Place top half of rolls.

Bake at 400 degrees for 10 to 15 minutes or until rolls are browned. Run a knife through the original divisions on top of rolls. Separate into finger sandwiches. Serve hot or warm.

Yield: 4 servings

Boo's Tomato Party Sandwiches

1 envelope dry ranch dressing mix

2 (8-ounce) packages cream cheese, softened

½ cup mayonnaise, or as needed

1 teaspoon dried dill

8 loaves sliced white bread

sliced small garden or roma tomatoes

lemon pepper for garnish

Blend dressing mix, cream cheese, mayonnaise and dill to a spreading consistency, using more mayonnaise if needed.

Use a cookie cutter or glass to cut out rounds from the bread slices. Spread cream cheese mixture on rounds. At this point, rounds can be layered on wax paper or plastic wrap, sealed in an airtight container and frozen.

When ready to serve, thaw if needed. Top each round with a tomato slice and sprinkle lightly with lemon pepper.

Yield: 200 small sandwiches

Pulled Chicken Sandwiches

2	cups cider vinegar	2	teaspoons kosher salt
1½	cups water	1	teaspoon freshly ground black pepper
1	cup dry white wine	½	teaspoon cayenne pepper
⅓	cup vegetable oil	1	(3½-pound) rotisserie chicken
3	tablespoons Worcestershire sauce	4	hamburger buns, split
2	tablespoons dry mustard	1	cup prepared coleslaw
1	tablespoon sweet paprika		

Combine vinegar, water, wine, vegetable oil, Worcestershire sauce, mustard, paprika, salt, black pepper and cayenne in a medium saucepan. Bring to a boil over high heat. Cook 30 minutes or until sauce reduces to 1¼ cups. Remove from heat.

Meanwhile, remove meat from chicken and shred; discard skin and bones. Add chicken meat to warm sauce and cook until heated through, stirring gently. Pile pulled chicken on bottom halves of buns and drizzle with extra sauce. Top with coleslaw and replace bun tops. Serve immediately.

Yield: 4 servings

Soups, Salads and Sandwiches

SPINACH SANDWICHES

2 (10-ounce) packages frozen chopped spinach, thawed and squeezed dry
2 tablespoons sour cream
2 tablespoons mayonnaise
1 (8-ounce) can water chestnuts, drained and chopped
2 tablespoons Worcestershire sauce
2 tablespoons lemon juice
1 small bunch green onions, finely chopped
 dash of Tabasco sauce (optional)
 thinly sliced bread

Mix together all ingredients except bread, adding more sour cream or mayonnaise if a creamier consistency is desired. Spread mixture over bread slices.

Yield: 1½ cups filling, enough for 12 sandwiches

Mildred Nungester Wolfe

Bob Thompson

*"The discovery of a new
dish does more for human happiness
than the discovery of a star."*

~Brillot-Savarin

"Dinner is served." Surely these are among the loveliest words in our language. Dinner will indeed be a delight if you adopt the following entrees into your culinary repertoire. The variety of offerings here is wide, and the gastronomical delight suggested by each recipe is irresistible.

Chicken lovers will enjoy Charlie's Chicken (aka Parmesan Chicken). Ann Allin served this dish at her and Presiding Bishop Allin's home in New York. Their visitors from around the world loved it. Or perhaps you will be attracted to Chicken Paradise, so good that although it serves six, it serves only four "when Uncle Harry comes for dinner."

The array of "red meat" dishes should please all. They include the basic beef roast, the flavorful kind that slices well and lasts all weekend. Then there are the luscious dishes of pork, veal, lamb, and even that epicurean red meat, wild duck.

No Deep South cookbook could be complete without those culinary gifts from our rivers and seas: trout, catfish, oysters, salmon and shrimp. Luscious concoctions with our own seafood are abundant in these pages. And if your tastes run to south Louisiana, the Cajun Shrimp and Crawfish dish should excite you, as well as the taste of Mexico that lies among these recipes. Bon Appetit!

ENTRÉES

Beef Tenderloin

1 (3½- to 5-pound) beef tenderloin, trimmed
 with silver skin removed
 Kitchen Bouquet
 Worcestershire sauce

cracked black pepper
Cavender's no-salt seasoning
garlic salt

MUSHROOMS

2 pounds fresh mushrooms, sliced
2 tablespoons butter

1-2 dashes Worcestershire sauce
½-1 cup port wine

HORSERADISH SAUCE

1 cup mayonnaise
2 tablespoons prepared horseradish

 dash of Tabasco sauce
1 teaspoon Worcestershire sauce

Place beef tenderloin in a foil-lined roasting pan. Pour a generous amount of Kitchen Bouquet over beef and rub around entire surface. Pour a liberal amount of Worcestershire sauce over beef as well. Season beef generously with cracked pepper, no-salt seasoning and garlic salt. Fold in thin end so thickness of tenderloin is about even. Bring to room temperature, or let stand at room temperature for up to 8 hours. Beef can be seasoned the night before and refrigerated overnight, but it must be brought to room temperature before going into the oven.

Bake tenderloin at 450 degrees for 20 to 30 minutes. Remove from oven and place on a serving platter. Loosely tent with foil; do not seal and do not slice the beef. Let stand about 45 minutes before slicing into small pieces. Reserve any gravy for mushrooms.

To prepare mushrooms, pour reserved pan gravy into a deep pot. Add mushrooms, butter, Worcestershire sauce and wine. Heat until cooked down. Serve with tenderloin.

Combine all sauce ingredients and serve with tenderloin.

Ellen Langford

Yield: 8 servings

Mama Bear's Friday Night Roast

1 (5-pound) rump roast
10-12 cloves garlic, peeled

salt and freshly ground black pepper to taste
seasoned salt to taste

GRAVY
2 tablespoons flour
 water or beef broth

salt and pepper to taste

Cut deep slits with a knife into roast. Stuff a garlic clove into each slit. Generously season with salt and pepper and seasoned salt. Brown roast in a cast iron skillet, fat-side down first, then brown on all sides.

Place roast in a roasting pan Roast at 350 degrees for 15 minutes per pound of meat for medium-rare, or 20 minutes per pound for well done: rare: 130-140 degrees, medium: 140-160 degrees, well done: 150 to 170 degrees.

To make gravy, pour off all but 2 tablespoons drippings from pan into a measuring cup, reserving drippings in measuring cup. Blend flour into 2 tablespoons drippings remaining in pan. Cook and stir until brown and thickened. Add hot water or broth to drippings in measuring cup to equal 1 cup in volume. Stir drippings mixture into flour. Cook and stir until thickened. Season with salt and pepper.

Yield: 6 to 8 servings

Mama would have Lilla cook this roast every Friday night so we would have something to eat for the rest of the weekend. Sunday night sandwiches were always great. Monday night, if there was any left over, there would be roast beef hash over toast points with boiled potatoes and leftover gravy with green peas.

Rosemary Shish-ka-Bobs on Creamy Rice

MARINADE

1	cup good red wine
1	cup canola oil
2	tablespoons ketchup
¼	cup red wine vinegar
1	tablespoon Worcestershire sauce

1	tablespoon chopped fresh rosemary
1	tablespoon sugar
1	teaspoon salt
1	teaspoon freshly ground black pepper

SHISH-KA-BOBS

2½-3	pounds beef sirloin, cut into 2-inch cubes (about 24 pieces)
12	medium mushrooms
1	red bell pepper, cut into 2-inch squares (12 pieces)

1	green bell pepper, cut into 2-inch squares (12 pieces)
12	shallots, peeled and parboiled 5 to 7 minutes
12	(8-inch) woody switches rosemary, leaves removed and reserved, or wooden skewers soaked in water 30 minutes

CREAMY RICE

3⅓	cups chicken broth
1½	cups dry converted rice
2	tablespoons butter
½	teaspoon salt

¼	teaspoon white pepper
½	teaspoon finely chopped fresh rosemary
½-1	cup cream

Combine all marinade ingredients.

Place beef cubes in a plastic zip-top bag. Add enough marinade to cover. Place mushrooms, bell peppers and shallots in a separate bag and add remaining marinade. Marinate beef and vegetables in refrigerator at least 3 to 4 hours.

Starting and ending with a beef cube, thread beef and vegetables, in an alternating pattern, onto rosemary skewers. Grill or broil 2 to 4 minutes per side, depending on desired degree of doneness. Baste with marinade as skewers are turned.

For rice, bring broth to a boil in a saucepan. Add rice and butter. Cover and cook 20 to 25 minutes. Add salt, pepper, rosemary and enough cream to coat rice but not be soupy. Keep warm.

To serve, spoon rice onto warm plates. Top each with 1 or 2 skewers of beef and garnish with a small sprig of rosemary.

How to Cook a Steak in an Iron Skillet

Bring steak to room temperature. Heat iron skillet in a 500 degree oven until red hot. Season a steak on both sides with Cavender's seasoning, freshly ground black pepper and Worcestershire sauce. Let stand to absorb seasonings.

Remove hot skillet from oven and put on stovetop over high heat. Sear steak for 30 seconds on each side. Place skillet with steak in oven and bake at 500 degrees for 2 minutes. Turn steak and cook 2 minutes longer. Remove steak from pan and let stand about 5 minutes. The steak will be cooked medium-rare.

Richard Kelso

Braised Brisket

1	tablespoon black peppercorns	4	cups beef broth, plus more if needed
2	teaspoons fennel seeds	1	(28-ounce) can whole tomatoes
1	teaspoon crushed red pepper flakes	1	tablespoon chopped fresh rosemary
4	pounds beef brisket	1	tablespoon chopped fresh oregano
	kosher salt	2	Vidalia onions, quartered
3	tablespoons vegetable oil	6	cloves garlic, peeled
4-6	slices bacon, diced	6	sprigs fresh parsley for garnish
¼	cup dry red wine		

Crush or grind peppercorns, fennel seeds and pepper flakes using the bottom of a heavy pan or a spice grinder. Press spice mixture into brisket and season with salt; set aside.

Heat oil in a large, heavy Dutch oven or roasting pan over medium-high heat. Add brisket and cook 5 minutes on both sides or until browned. Transfer to a platter and set aside. Add bacon to pan and cook 3 minutes. Deglaze pan with wine, scraping up any brown bits from bottom of pan with a wooden spoon. Continue to cook until reduced by half.

Return brisket to pan. Add 4 cups broth, tomatoes, rosemary, oregano, onion and garlic. Place pan in oven and bake at 500 degrees, stirring vegetables occasionally, for 20 minutes or until a meat thermometer inserted in the thickest part of the brisket registers 130 degrees.

Add more beef broth as needed to come halfway up the side of the brisket. Reduce oven temperature to 300 degrees. Braise brisket, turning every 30 minutes, for 2 hours or until thickest part of brisket registers 170 degrees.

Remove brisket from braising liquid and wrap in foil. Skim off any visible fat. Using a handheld blender, purée braising liquid with vegetables until smooth. Or, after liquid cools to a safe temperature, purée in small quantities in a food processor and return to pan. Adjust seasonings of sauce as needed.

Thinly slice brisket across the grain. Serve with sauce and garnish with parsley sprigs.

Yield: 6 servings

Stuffed Peppers

2 pounds ground chuck
 salt and pepper to taste
1 pound sausage
1 large onion, chopped
1 (28-ounce) can diced tomatoes, undrained

1 teaspoon minced garlic, or to taste
2 tablespoons Worcestershire sauce
2 cups cooked rice
12 red, yellow or green bell peppers

Season ground meat with salt and pepper. Brown meat in a skillet; drain. Transfer browned meat to a Dutch oven. In same skillet, brown sausage. Chop and drain and add to Dutch oven. Add onion to skillet drippings and sauté. Add onion to meat in Dutch oven.

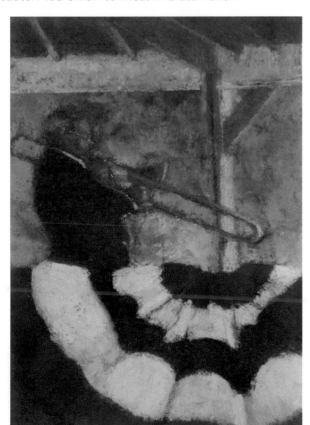

Stir in tomatoes, garlic and Worcestershire sauce. Add water if needed. Cook about 25 minutes. Add rice to mixture.

Cut off top of peppers and clean out seeds and membranes. Stuff meat mixture into peppers. If desired, peppers can be frozen in plastic freezer bags at this point; thaw before baking. Place peppers in a baking pan.

Bake at 350 degrees for 30 minutes or until bubbly.

Yield: 12 servings

Laurel Friedman

GRILLED FLANK STEAK WITH CILANTRO PESTO

2½ pounds flank steak
½ cup olive oil
¼ cup red wine vinegar
½ teaspoon salt
½ teaspoon black pepper

1 teaspoon minced garlic
2 teaspoons chili powder
1 teaspoon sugar
½ cup finely minced onion

Combine all ingredients and marinate overnight.

To cook, remove steak from marinade, discarding marinade. Grill or broil steak to desired degree of doneness. Slice steak on the diagonal. Drizzle steak slices with Cilantro Pesto (recipe below). Delicious served with corn and black beans or use in tortillas for steak tacos.

Yield: 6 to 8 servings

CILANTRO PESTO

¾ cup toasted pumpkin seeds or pine nuts
2 (4½-ounce) cans chopped mild chiles, drained
¾ cup freshly grated Parmesan cheese
¼ cup chopped fresh parsley

⅓ cup chopped fresh cilantro
1½ teaspoons minced garlic
½ teaspoon salt
¼ cup canola oil

Combine all ingredients in a food processor and blend.

GRILLADES AND GRITS

Great for a brunch...this makes a large amount

4	pounds beef or veal rounds, sliced ½-inch thick	½	teaspoon dried tarragon (optional)	
½	cup bacon drippings	½-¾	teaspoon dried thyme	
½	cup flour	1	cup water, heated	
1	cup chopped onion	1	cup good red wine	
2	cups chopped green onion	1	tablespoon salt	
¾	cup chopped celery	½	teaspoon black pepper	
1½	cups chopped green bell pepper	2	bay leaves	
2	cloves garlic, minced	½	teaspoon Tabasco sauce	
2	cups chopped tomatoes	2	tablespoons Worcestershire sauce	
		3	tablespoons chopped fresh parsley	

Pound meat slices with a mallet to ¼-inch thick. Brown meat in 4 tablespoons bacon drippings in a skillet. Remove to a warm plate. At this point, you may add another ¼ cup bacon drippings to skillet and blend in flour to make a dark roux.

Add all onions, celery, bell pepper and garlic and sauté until limp. Add tomatoes, tarragon and thyme and cook 3 minutes. Add hot water and wine and stir well. Return meat to skillet. Stir in salt, pepper, bay leaves, Tabasco and Worcestershire sauce. Reduce heat and simmer, covered, for about 2 hours for beef, or 1 hour for veal. Grillades should be tender.

Remove bay leaves and stir in parsley. Cool and refrigerate overnight. Add more liquid, as needed, when reheating.

Serve with plain grits, cheese grits or other variations. One variation is to add goat cheese and thyme to the cooked grits. Serve with a green salad and French bread or oven-baked French toast and fruit. Recipe may easily be halved.

Yield: 12 to 14 servings

If not making a roux, you may add a can of mushroom soup and a can of original stewed tomatoes instead of the fresh tomatoes and following these steps:

Brown meat as above and remove from pot. Sauté vegetables in bacon drippings. Add tarragon and thyme and cook 3 minutes. Stir in soup, stewed tomatoes, water, wine and seasonings. Return meat to pot by layering it on the bottom of pot. Cover and bake at 325 degrees for 1 hour. Stir, add more water or broth if needed, and return to oven. Bake until tender. Mix a little flour and water and add to pot to thicken the gravy. Follow above instructions for refrigerating overnight and serving the next day.

DEVILED CHICKEN

¼	cup Dijon mustard		salt and pepper to taste
2	tablespoons white wine or cider vinegar	1½	cups fresh bread crumbs
8-10	chicken breast tenderloins	¼	cup canola oil

Combine mustard and vinegar in a large bowl. Add chicken and turn to coat evenly with mustard mixture. Marinate in refrigerator for 30 minutes.

Place bread crumbs in a large plastic bag. Remove chicken from marinade and place 3 to 4 strips at a time in bag with crumbs. Seal and shake to coat with crumbs. Place coated chicken on a foil-lined baking sheet. Spoon a small amount of canola oil over each chicken strip.

Bake at 400 degrees for 15 to 20 minutes or until brown.

Yield: 4 servings

Boneless chicken breasts, cut into strips, may be used instead of the chicken tenderloins.

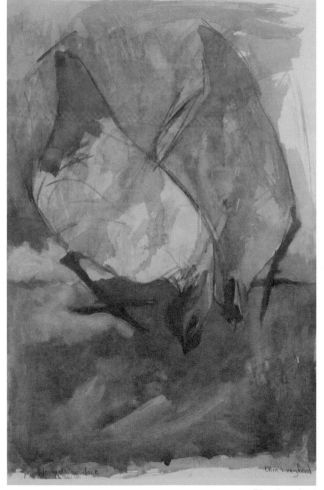

Ellen Langford

CHICKEN AND DUMPLINGS

(or the real reason I get invited to visit my children)

CHICKEN

6-8	chicken breasts with skin and bone		1	stick butter
4	cups cold water		1	quart chicken broth
2-3	carrots, coarsely chopped		3-5	cubes low sodium chicken bouillon
1	yellow onion, with skin		1½	teaspoons freshly ground black pepper
2-3	stalks celery, coarsely chopped			

DUMPLINGS

¼	cup vegetable shortening	¼-⅓	cup ice water
1½	cups self-rising flour		

Combine all chicken ingredients in a large heavy pot. Bring to a boil. Reduce heat to medium-low and simmer at least 45 minutes; exact time will vary depending on type and size of chicken. If using regular chicken with bones and skin, add only 4 cubes bouillon. If using boneless chicken, use 6 cubes. Use low sodium bouillon or the broth will be too salty. The chicken must be cooked until falling apart. Add more water while cooking, if needed; make sure there is enough water to cover chicken. I like to let the chicken rest in the broth for about 30 minutes after I've turned off the heat.

When done, remove chicken from broth, reserving broth. When cool enough to handle, shred chicken into large, bite-size pieces. Do not cut! Shred the meat; set aside.

Strain broth into another large heavy pot and return to heat. Bring to a rapid boil.

Meanwhile, begin to make the dumplings. Cut shortening into flour until mixture reaches a crumb-like texture. Using a fork, stir in ¼ cup ice water. Stirring as gently as possible, combine until mixture forms a ball, using more water or flour as needed. The dough should be the same texture as biscuit dough. Roll out on a lightly floured board until very thin. Cut into strips about ¾-inch wide and 1 to 2 inches long.

When broth has come to a rapid boil, drop a few dumplings at a time into boiling broth, stirring gently. When all dumplings are in the pot, reduce heat to low. Cover and simmer 5 minutes, checking often as dumplings will stick easily.

Stir chicken into broth and allow to simmer until heated through. The dumplings will fall apart and be torn into smaller pieces by the stirring. That is OK. It thickens the broth. Just don't get too carried away when you stir! The end result should be thick but not soupy.

Yield: 6 to 8 servings

MEDITERRANEAN CHICKEN

1	head garlic, finely puréed	½	cup capers with a bit of the juice
¼	cup dried oregano	6	bay leaves
	coarse salt and freshly ground pepper to taste	4	(2½-pound) chickens, quartered, or 10-12 chicken breasts
½	cup red wine vinegar		
½	cup olive oil	½	cup brown sugar
1	cup prunes	1	cup white wine
½	cup pitted Spanish green olives	¼	cup chopped fresh Italian parsley

Combine garlic, oregano, salt and pepper, vinegar, olive oil, prunes, olives, capers and bay leaves in a large bowl and mix well. Add chicken. Cover and marinate in refrigerator overnight.

When ready to bake, remove chicken from marinade and arrange in a single layer on 1 or 2 shallow baking pans. Pour marinade over chicken. Sprinkle chicken with brown sugar and pour wine around chicken in pan.

Bake at 350 degrees for 50 to 60 minutes, basting frequently with pan juices, or until chicken juices run clear rather than pink when pricked with a fork in the thickest part of the thigh.

Transfer chicken, prunes, olives and capers to a serving platter. Sprinkle generously with parsley. Pass remaining pan juices in a sauceboat on the side.

Yield: 10 to 12 servings

Chicken, Sausage and Ham Jambalaya

¼ cup canola oil

2 cups smoked ham, cut into 1-inch dice

2 cups smoked kielbasa sausage, cut into 1-inch rounds

2 cups boneless chicken breast, cut into bite-size pieces

3 tablespoons Paul Prudhomme poultry seasoning

1 tablespoon seafood seasoning

2 bay leaves

1 cup chopped onion

1 cup chopped celery

1 cup chopped green bell pepper

2 cloves garlic, minced

1 (8-ounce) can tomato sauce

1 (15-ounce) can petite dice tomatoes

3 cups canned chicken broth

1½ cups uncooked white rice

Heat canola oil in a 4-quart saucepan. Add ham and sausage and cook, stirring frequently, until meat starts to brown. Remove from pan and add chicken to pan. Cook 5 minutes or until chicken is brown. Add poultry seasoning, seafood seasoning, bay leaves, onion, celery, bell pepper and garlic. Cook 6 minutes or until vegetables are tender.

Add sausage and ham back to pan. Stir in tomato sauce, tomatoes, broth, and rice. Bring to a boil, stirring occasionally. Reduce heat and simmer, covered, over low heat for 30 minutes or until rice is tender. Remove bay leaves. Remove from heat and let stand 10 minutes before serving.

Yield: 8 servings

Artichoke Chicken

3	sticks butter, divided	¾	teaspoon white pepper
I	pound fresh mushrooms, sliced	I	tablespoon Worcestershire sauce
¾	cup flour	8	cups cooked and cubed chicken
3	cups whole milk, scalded	4	(14-ounce) cans artichoke hearts, quartered, or 2 packages frozen
2	cups heavy cream		
I	cup dry sherry	2	cups freshly grated Parmesan cheese
2	teaspoons salt		

Melt 4 tablespoons butter in a skillet. Add mushrooms and sauté.

Melt remaining 2½ sticks butter in a large saucepan. Blend in flour and let cook I minute. Slowly add hot milk and cook and stir to make a white sauce; cool. Stir in cream. Add sherry, salt, pepper and Worcestershire sauce.

Place chicken, artichoke and mushrooms in a 10x13-inch casserole dish. Pour sauce over the top. Sprinkle with cheese. Cover and refrigerate overnight; bring to room temperature before baking.

Bake at 350 degrees for 30 to 40 minutes or until hot, browned and bubbly. Serve over rice.

Yield: 16 servings

Casserole can be divided into 2 smaller dishes if desired.

ANYTHING CHICKEN

*2 pounds chicken tenders or boneless, skinless
 chicken breast, chopped*
5 bay leaves

I tablespoon chopped fresh cilantro
2 cups chicken broth

Place chicken and bay leaves in a baking dish. Sprinkle with cilantro. Pour broth over the top. Cover dish with foil

Bake at 375 degrees for 20 minutes. Stir and tent foil over the top. Bake 10 minutes longer. Drain, reserving broth for another use, if desired. If drier chicken is desired, return chicken to oven and bake 5 minutes longer.

Use chicken in pasta salad, or shred for chicken salad, chicken spaghetti or any other recipe that calls for basic chicken.

Chicken Annu

2 medium onions, chopped
2 cups good chicken broth, divided
4 cups tomato sauce
1 (10-ounce) box currants
1 tablespoon dried thyme

1 tablespoon curry powder
2 tablespoons Worcestershire sauce
 salt and pepper to taste
5 cups cooked and chopped chicken

In a 5-quart saucepan, sauté onion in some of the chicken broth until softened. Add remaining broth, tomato sauce, currants, thyme, curry powder and Worcestershire sauce to saucepan.

Simmer, uncovered, for 15 minutes. Season with salt and pepper. Add chicken and cook until thoroughly heated. Serve over hot rice.

Yield: 8 to 10 servings

Easy Sautéed Chicken

3 whole boneless, skinless chicken breasts
 salt and pepper to taste
 flour as needed
1 tablespoon unsalted butter
½ cup diced onion
6 cloves garlic, chopped

½ cup dry white wine
1 tablespoon lemon juice
2 tomatoes, peeled, seeded and finely chopped
½ cup chicken broth
6 fresh basil leaves, shredded

Cut chicken breasts in half *horizontally* removing cartilage connecting the 2 halves. Season with salt and pepper and dredge chicken in flour. Sauté chicken in a skillet in butter for 8 minutes on each side, turning only once. Remove from skillet and keep warm.

Add onion and garlic to skillet and sauté until onion is translucent. Deglaze pan with wine and lemon juice. Add tomatoes and broth and cook to combine flavors and reduce sauce to desired consistency.

Add basil to sauce. Return chicken to skillet and reheat. Adjust seasonings. Serve on a bed of rice along with a portion of the sauce.

Yield: 6 servings

Entrées

CHICKEN WELLINGTON

1	pound mushrooms, finely chopped	¼	cup beef broth
¼	cup chopped green onion	½	cup finely chopped cooked ham
4	tablespoons butter	2	tablespoons chopped fresh parsley
½	teaspoon salt	6-12	boneless, skinless chicken breasts
¼	teaspoon dried marjoram	2-3	tablespoons butter
2	teaspoons flour	1	(17-ounce) box puff pastry
	dash of black pepper		

Sauté mushrooms and onion in 4 tablespoons butter in a saucepan until liquid evaporates. Stir in salt, marjoram, flour, pepper and broth. Cook, stirring constantly, until mixture comes to a boil and thickens. Remove from heat and stir in ham and parsley.

Brown chicken in 2 to 3 tablespoons butter. Keep moist, but do not cook completely; cool.

Divide each pastry sheet into 6 equal squares. Roll out each square until large enough to wrap chicken completely.

Place chicken in center of pastry. Spoon 2 to 3 tablespoons of mushroom pâté on top of chicken. Wrap pastry completely around chicken and seal edges closed. Place pastry, seam-side down, on a baking sheet.

Bake at 400 degrees for 20 minutes or until pastry is lightly browned.

Yield: 12 servings

If using less than 12 breasts, extra pâté may be frozen.

COQ AU VIN

(Chicken Stewed in Red Wine)

¼	pound salt pork, cut into small pieces		1	red or yellow bell pepper, diced
3	tablespoons olive oil		1	bay leaf
2	large onions, diced		1	cup chopped fresh thyme
1½	pounds shallots, peeled and left whole		1	cup chopped fresh basil
8	cloves garlic, chopped		1	(750 ml) bottle red wine
2	chicken, cut into pieces, skinned if desired		1	quart chicken broth
1	pound whole mushrooms		2	tablespoons flour
8	ounces carrots, sliced			

Heat salt pork and olive oil in a large iron pot. Add onion, shallots and garlic in pot. Add chicken, mushrooms, carrot, bell pepper, bay leaf, thyme and basil. Cover contents of pot with wine, reserving one-fourth of bottle. Use broth as needed to help cover contents.

Bring to a boil. Immediately reduce heat and simmer, covered, for 1 hour. Mix flour with remaining wine and stir into mixture and cook until thickened. Serve over white rice or alone with a side of green peas.

Yield: 8 servings

Best prepared a day ahead.

CHARLIE'S CHICKEN

4-6 pieces chicken, skin removed
 salt and pepper to taste
1 (16-ounce) container sour cream

2 tablespoons Dijon mustard
¼ cup Parmesan cheese

TOPPING
bread crumbs
Parmesan cheese

Melted butter

Place chicken in a casserole dish and season with salt and pepper. Mix sour cream, mustard and Parmesan cheese together. Spread mixture over chicken.

Top with bread crumbs and a little Parmesan cheese. Drizzle with butter.

Bake at 350 degrees for 45 minutes or until bubbly and golden on top. Serve over hot rice.

Yield: 6 servings

This recipe can easily be doubled.

For variety, mix a 10¾-ounce can of cream of mushroom soup and a 4-ounce can of mushrooms in with the sour cream.

This recipe was given to me by Ann Allin when she and Bishop Allin lived in New York. Ann made this dish for their visitors from around the world. She called it Parmesan Chicken, but we began calling it Charlie's Chicken because our son Charlie always requested it. It is now a staple in his kitchen repertoire.

French Quarter Chicken

6	boneless, skinless chicken breasts	1	cup finely chopped shallots or green onion, divided
	salt and pepper to taste	1	teaspoon finely chopped garlic
¼	cup slivered almonds	1	cup sliced fresh mushrooms
1	teaspoon garlic powder	3	tablespoons finely chopped fresh parsley
2	cups fine day-old bread crumbs	¼	cup olive oil
1	cup vegetable oil	1	(15-ounce) can tomato sauce with tomato bits
1⅓	cups finely chopped celery	2	cups water
½	cup finely chopped bell pepper		

Season chicken with salt and pepper and refrigerate 15 minutes. Spread out fillets and sprinkle with almonds and ½ cup shallots. Fold or roll fillets around seasoning. Mix garlic powder with bread crumbs and mix thoroughly. Roll fillets in bread crumb mixture until well-coated. Deep fry in hot vegetable oil until golden brown; drain and transfer chicken to a deep casserole dish.

Sauté celery, bell pepper, ½ cup shallots, garlic, mushrooms and parsley in olive oil over medium heat for 5 to 10 minutes or until tender. Add tomato sauce and water and simmer, stirring frequently, for 10 minutes. Pour sautéed mixture over chicken.

Bake at 375 degrees for 1 hour. Serve over steaming rice.

Yield: 6 servings

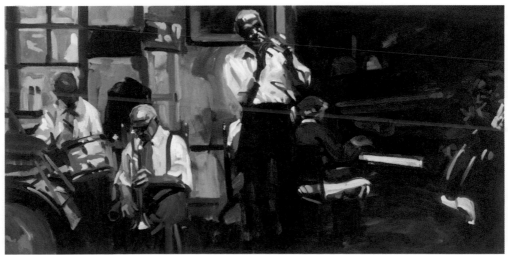

Baxter Knowlton

Garlic Lime Chicken

6	boneless, skinless chicken breasts		½	teaspoon onion powder
1	teaspoon salt		½	teaspoon dried thyme
1	teaspoon black pepper		2	tablespoons butter
¼	teaspoon cayenne pepper		2	tablespoons olive oil
¼	teaspoon paprika		½	cup chicken broth
1	teaspoon garlic powder		¼	cup lime juice

Leave chicken breasts whole, or butterfly breasts and pound flat so they cook extra fast. Or, cut breasts into strips.

Mix salt, black pepper, cayenne pepper, paprika, garlic powder, onion powder and thyme in a bowl. Sprinkle mixture over both sides of chicken breasts.

Heat butter and olive oil in a skillet over medium-high heat. Add chicken and sauté 5 minutes on each side or until browned and no longer pink in the center. Remove chicken and add broth and lime juice to skillet, scraping up any browned bits from the bottom of the pan. Cook until sauce is slightly reduced. Add chicken back to skillet and coat with sauce.

Yield: 6 servings

Melissa Neville

Monroe's Chicken Thighs with Rice

6-8 chicken thighs, skin on
 Tony Chachere's Creole seasoning
1 tablespoon olive oil
1 medium-size yellow onion, thinly sliced
3-4 large cloves garlic, chopped

¼ cup dry Marsala wine
1 cup uncooked rice
2 cups chicken broth
1 tablespoon salt

Season chicken thighs with Creole seasoning. Heat olive oil in a Dutch oven over high heat until hot. Place chicken, skin-side down, in hot oil and sauté 4 to 5 minutes or until skin is crisp. Turn chicken and sauté 1 minute on other side. Remove from pan and set aside on a plate.

Add onion to Dutch oven. Cook, stirring occasionally, until onion starts to caramelized. Add garlic and cook 1 minute, stirring constantly. Deglaze pan with wine, stirring constantly.

Stir in rice. Add broth and salt and bring to a boil. Add chicken, skin-side up, along with any accumulated chicken juices. Cover pan and reduce heat. Simmer until all liquid has been absorbed.

Yield: 4 to 6 servings

Melissa Neville

CHICKEN CHALOUPAS

4	cups poached and cubed chicken breast	1	bunch green onions, chopped
2	cups sour cream	2	cups shredded sharp Cheddar cheese
2	(10½-ounce) cans cream of chicken soup	1	(2¼-ounce) can chopped black olives
1	(10-ounce) can diced tomatoes with green chiles	2	(16-ounce) packages small flour tortillas
		2	cups shredded Monterey Jack cheese

Combine chicken, sour cream, soup, tomatoes with chiles, onion, Cheddar cheese and olives in a large bowl. Fill tortillas with mixture and roll jelly-roll fashion. Place rolls, seam-side down, in an ungreased baking dish. Sprinkle Monterey Jack cheese on top.

Bake at 350 degrees for 30 to 40 minutes. Remove from oven and let stand 10 minutes before serving. Serve with hot or mild salsa and rice on the side.

Yield: 6 to 8 servings

PERFECT POACHED CHICKEN

6 chicken breasts, with bone and skin
2 onions with skin, quartered
2 carrots, cut into chunks
2 stalks celery with leaves, cut into chunks
½ cup white wine
¼ cup whole black peppercorns
fresh parsley

Combine all ingredients in a large saucepan. Cover contents of pan with water and bring to a boil. Reduce heat and simmer, covered, for 10 to 15 minutes. Turn off heat, leave cover on and let stand 30 to 40 minutes, allowing hot liquid to finish cooking process.

When poaching several batches, remove chicken and repeat process using same cooking liquid.

When cool, remove skin from chicken and debone. Discard bones and skin. Reserve broth.

Sour Cream Chicken Enchiladas

6 boneless, skinless chicken breasts
1 medium onion, chopped
2 cloves garlic, chopped
2 tablespoons olive oil
2 (4-ounce) cans green chiles, drained

½ (1¼-ounce) package taco seasoning
2 (10½-ounce) cans cream of chicken soup
1 (16-ounce) container sour cream
¾-1 cup chicken broth
1½ cups shredded Cheddar cheese
12 (soft taco size) flour tortillas

Cook chicken in a small amount of water until done. Drain and cut into bite-sized pieces.

Sauté onion and garlic in olive oil until transparent. Add green chiles, taco seasoning, soup, sour cream and broth. Spread a thin layer of sauce over the bottom of a 9x13-inch glass baking dish, reserving ¾ cup of sauce for topping.

Mix chicken with remainder of sauce. Spoon 3 tablespoons chicken mixture and 3 tablespoons cheese down the center of each tortilla. Roll up and place side by side, seam-side down, in a baking dish. Spread reserved sauce over top.

Cover dish with foil and bake at 325 degrees for 45 minutes.

Yield: 6 generous servings

CHICKEN PARADISE

CHICKEN

6	boneless chicken breasts
	salt and pepper to taste
	butter for rubbing chicken

1	cup chopped celery
1	cup chopped carrot
½	cup chopped white onion

SAUCE PARADISE

4	tablespoons unsalted butter
¼	cup white flour
2	cups double-strength veal or chicken broth
½	cup Madeira wine

2	tablespoons red currant jelly
2	cups seedless grapes
8	ounces fresh mushrooms, sliced

Sprinkle chicken breasts with salt and pepper and rub with butter. Combine celery, carrot and onion and spread over the bottom of a greased roasting pan. Place chicken on vegetables. Roast at 325 degrees for 30 minutes.

Meanwhile, prepare sauce. Melt butter in a saucepan. Blend in flour, stirring until smooth. Add broth and cook, stirring constantly, until slightly thickened. Add wine and jelly and stir until jelly is melted. Add grapes and mushrooms.

When done baking, remove chicken from pan and place in a deep casserole dish; discard vegetables in pan. Pour sauce over chicken. Bake 15 minutes longer.

Yield: 6 servings

CRAB CAKES

1	pound lump crabmeat	3	tablespoons lemon juice
2	shallots, minced	1	cup bread crumbs
	salt and pepper to taste		mayonnaise
2	egg yolks		

Lightly mix together all ingredients, using enough mayonnaise to hold mixture together. Form into small cakes. Sauté in butter until golden brown. Serve with Lemon Caper Sauce (recipe below) or Basil Tartar Sauce (recipe below).

LEMON CAPER SAUCE

1 stick butter, melted
 juice of 2 lemons

capers to taste

Combine all ingredients.

BASIL TARTAR SAUCE

½ cup packed fresh basil
½ cup mayonnaise
1 tablespoon sour cream
1 teaspoon lemon juice
1 teaspoon minced garlic
 salt and pepper to taste
 dash of Tabasco sauce

Combine all tartar sauce ingredients in a food processor and pulse until well blended.

Darryl Anderson

Entrées

CRAB CAKES WITH LEMON RÉMOULADE

2 tablespoons butter
1 large red bell pepper, finely chopped
½ medium onion, finely chopped
1 cup finely crushed saltine cracker crumbs
½ cup mayonnaise
1 egg, lightly beaten
2 teaspoons Old Bay seasoning
2 teaspoons Worcestershire sauce

¾ teaspoon dry mustard
¼ teaspoon Tabasco sauce
1 pound fresh lump crabmeat, drained and picked over
1 tablespoon butter, divided
1 tablespoon vegetable oil, divided
 mixed baby greens, lemon wedges and parsley sprigs for garnish

Melt 2 tablespoons butter in a large nonstick skillet over medium heat. Add bell pepper and onion and sauté 10 minutes or until tender. Remove from heat and stir in cracker crumbs, mayonnaise, egg, Old Bay seasoning, Worcestershire sauce, mustard and Tabasco. Gently stir in crabmeat; handle the crabmeat as little as possible to keep lumps intact. Shape mixture into 8 patties, or 24 small patties for appetizers. Cover and chill at least 1 hour, or up to 24 hours.

Heat ½ tablespoon butter with ½ tablespoon oil in a large skillet over medium-high heat. Add 4 crab cakes and cook 4 to 5 minutes on each side or until golden; drain on paper towels. Repeat with remaining butter, oil and crab cakes. Serve with Lemon Rémoulade (recipe below) and garnish as desired.

LEMON RÉMOULADE
2 cups mayonnaise
¼ cup Creole mustard
2 cloves garlic, pressed
2 tablespoons chopped fresh parsley

1 tablespoon fresh lemon juice
2 teaspoons paprika
¾ teaspoon cayenne pepper

Whisk together all ingredients until blended. Cover and chill 30 minutes or up to 3 days.

CRABMEAT JUSTINE

4	tablespoons butter		Tabasco sauce to taste
1	cup fresh lump crabmeat	½	teaspoon lemon juice
1	hard-cooked egg, grated	4	slices bread, toasted
2	tablespoons sherry	1½	cups hollandaise sauce

Melt butter in a saucepan. Mix in crabmeat, egg, sherry, Tabasco and lemon juice. Cook until thoroughly heated.

Place a slice of toast in each of 4 individual casserole dishes. Spoon crabmeat mixture over toast and top with hollandaise sauce. Brown under the broiler.

Yield: 4 servings

See Microwave Hollandaise, page 247

See Microwave Hollandaise, page 247

CRABMEAT RAVIGOTE

½	cup mayonnaise	⅛	teaspoon dried tarragon
1	teaspoon cider vinegar	1	shake white pepper
1	tablespoon Creole mustard	⅛	teaspoon salt
1	tablespoon buttermilk		Tabasco sauce to taste
1	green onion, finely chopped	1	tablespoon small capers
2	sprigs Italian parsley, chopped	1	pound jumbo lump crabmeat
½	teaspoon dried dill		

Combine all ingredients except crabmeat and mix with a wire whisk. Carefully toss crabmeat with sauce. Let stand for 1 hour before serving.

Yield: 4 servings

Seafood au Gratin

2 tablespoons unsalted butter
2 tablespoons flour
½ teaspoon salt
½ teaspoon black pepper
1 teaspoon Worcestershire sauce
 Tabasco sauce to taste
1 cup whole milk, heated
1 cup shredded sharp Cheddar cheese

1 bunch green onions, finely sliced or chopped
1 tablespoon finely chopped fresh parsley
2 cups fresh jumbo lump crabmeat, steamed shrimp or boiled lobster, or combination
2-3 cups shredded sharp Cheddar cheese
1-2 cups freshly shredded or grated Parmesan cheese
 paprika to taste

Prepare a cheese sauce by melting butter in a skillet. Blend in flour, salt, pepper, Worcestershire sauce and Tabasco. Slowly add hot milk and stir until smooth and thickened. Add 1 cup Cheddar cheese and simmer, stirring constantly until melted. Stir in green onion and parsley until well blended. If too thick, thin sauce with extra milk.

Layer seafood, sauce, 2-3 cups Cheddar cheese and Parmesan cheese in a greased baking dish, ending with cheeses. Sprinkle with paprika.

Bake at 350 to 375 degrees until hot, bubbly and slightly browned on top.

Yield: 4 servings

May also be served in a pastry shell or baked potato.

Bayou Crawfish
with Fried Green Tomatoes

CRAWFISH SAUCE

2	tablespoons chopped shallot	½	cup white wine
2	tablespoons olive oil	1½	teaspoons salt
1	cup peeled and chopped tomato	¼	teaspoon cayenne pepper
1	pound Louisiana crawfish tails	2	cups cream, heated
3	tablespoons chopped fresh basil	¼	cup sliced green onion

FRIED GREEN TOMATOES

1	egg	1	cup flour
½	cup milk	2	cups bread crumbs
2-3	large Creole tomatoes, peeled and sliced		vegetable oil for frying
	Creole seasoning to taste		

Sauté shallot in olive oil in a large saucepan for 2 minutes. Add tomato and sauté 4 minutes. Add crawfish and basil and sauté 2 minutes longer. Add wine and cook until liquid is reduced by half. Add salt, cayenne pepper and warm cream. Stir in green onions and remove from heat.

To prepare tomatoes, beat egg with milk in a bowl. Season tomato slices with Creole seasoning. Dredge in flour, then dip in egg mixture and coat with bread crumbs.

Heat vegetable oil to 350 degrees in a large deep skillet. Add tomato slices and fry 4 minutes or until golden brown.

To serve, place 1 or 2 fried tomato slices on each serving plate. Pour crawfish sauce over tomato slices. Serve with a green salad and crisp French bread.

Yield: 4 to 6 servings

CRAWFISH ÉTOUFFÉE

6	tablespoons butter		dash of Tabasco sauce
1	large onion, finely chopped	½	teaspoon dried basil
½	bell pepper, finely chopped	½	teaspoon dried thyme
1	stalk celery, finely chopped (optional)	¼ -½	cup water
2-3	cloves garlic, minced	3	tablespoons brandy, cognac or sherry
1	tablespoon flour	1-2	tablespoons tomato paste (optional)
1	teaspoon lemon juice, or more if needed	1	pound crawfish tails and fat, Louisiana
	salt to taste		crawfish preferred
	cayenne pepper to taste	1	bunch green onions, finely chopped
1-2	teaspoons Worcestershire sauce		finely chopped fresh parsley

Melt butter in an iron skillet or Dutch oven. Add onion, bell pepper and celery and sauté until vegetables are wilted. Add garlic and sauté; do not burn. Stir in flour and cook 5 minutes.

Add lemon juice, salt, cayenne pepper, Worcestershire sauce, Tabasco, basil, thyme, water, liquor and tomato paste. Simmer about 15 minutes.

Add crawfish and simmer 5 minutes longer. Add green onion and parsley just before serving. Serve over rice.

Yield: 4 to 6 servings

CRAWFISH PIE

1	large onion, finely chopped	¼	cup minced fresh parsley
¼	cup minced green onion	½	cup seasoned bread crumbs
2	cloves garlic, minced	1	teaspoon salt
½	bell pepper, chopped	½	teaspoon cayenne pepper
2	stalks celery, chopped	½	teaspoon black pepper
1	stick butter	1	egg, beaten
1	(10¾-ounce) can cream of celery soup	½	cup milk
4	tablespoons tomato sauce	2	deep dish pie crust, unbaked
1	pound Louisiana crawfish, half chopped and half left whole		

Sauté all onions, garlic, bell pepper and celery in butter. Add soup, tomato sauce, crawfish and parsley and cook 10 minutes.

Stir in bread crumbs, salt, cayenne pepper, black pepper, egg and milk. Spoon into 1 unbaked pie crust. Top with second crust and seal. At this point, pie can be frozen.

Bake at 350 degrees for 45 to 60 minutes.

Yield: 6 servings

Bay St. Louis Fish Stew with Mississippi Aïoli

2	teaspoons butter	2	pounds cobia or catfish, or other firm-fleshed
2	teaspoons olive oil		white fish, cut into 1½-inch chunks
1	small leek, white part only, thinly sliced	½	teaspoon dried thyme
1	small onion, chopped	1	cup chicken broth
2	teaspoons finely chopped garlic	1	bunch fresh spinach, stemmed, washed and
	salt and pepper to taste		spun dry
¼	pound ham, diced	2	teaspoons finely chopped garlic
4	ounces mushrooms, sliced	1	tablespoon chopped fresh parsley, or other
2	teaspoons butter		fresh herbs
4-5	dashes Worcestershire sauce		juice of ½ lemon, or more to taste

Melt butter with olive oil over medium-high heat in a deep skillet. Add leek, onion and 2 teaspoons garlic and cook and stir 2 to 3 minutes or until softened. Season lightly with salt and pepper while cooking.

Add ham and cook, stirring, for 2 to 3 minutes or until ham begins to release its own juices and starts to brown on the edges.

Add mushrooms, 2 teaspoons butter and Worcestershire sauce and cook 1 to 2 minutes or until butter melts and mushrooms are coated with pan juices and begin to soften.

Add fish and thyme and increase heat. Cook, stirring gently, for 2 to 3 minutes or until fish start to brown.

Add broth and bring to a boil; liquid level should be just below the top of the other ingredients. Reduce heat to a simmer, cover and cook 2 to 10 minutes, depending on type of fish, or until fish is cooked but not flaky.

Stir in spinach and a pinch of salt and cook until spinach wilts. Simmer, covered, for about 2 to 3 minutes. Uncover and add 2 teaspoons garlic, parsley and lemon juice. Stir and remove from heat. Adjust seasonings and let stand at least 5 minutes before serving. Serve on deep plates or in wide-mouth bowls with dollops of Mississippi Aïoli. Accompany with crusty bread or rolls and a salad.

Yield: 4 servings

MISSISSIPPI AÏOLI

¾ cup mayonnaise
2 tablespoons sour cream or yogurt
2-3 cloves garlic, minced
1 tablespoon chopped fresh herbs

juice of ½ lemon, or to taste
salt and pepper to taste
garlic powder to taste
Tabasco to taste

Mix together mayonnaise, sour cream, garlic and fresh herbs with a fork or whisk. Season to taste with lemon juice, salt and pepper, garlic powder and Tabasco.

South Carolina
Low Country Catfish Stew

1 pound salt pork, sliced
1 pound onions, sliced
2½ pounds potatoes, peeled and sliced
1 (10¾-ounce) can tomato soup
2 soup cans water

½ cup ketchup
Tabasco sauce to taste
salt and black pepper to taste
3 pounds dressed catfish, cut into serving pieces

Fry salt pork in a large oval roaster with a cover; remove salt pork and drain on paper towel; reserve pan drippings. Add onion and potato to drippings and sauté until tender. Cover roaster to help steam vegetables. Pour off grease and mix in soup, water and ketchup. Add Tabasco and salt and pepper. Cut salt pork, if desired, into 1 inch pieces and return to roaster. Simmer at least 1 hour to allow flavors to blend.

About 45 minutes before ready to eat, add fish. Do not stir after fish pieces are added to stew. Serve over hot rice.

Yield: 6 to 8 servings

Creole Baked Fish

1	stick butter	2	tablespoons chopped fresh parsley, plus extra for garnish
¼	cup flour	2	bay leaves
1	(16-ounce) can tomatoes	¼	lemon, cut into pieces
½	(6-ounce) can tomato paste	1	teaspoon chili powder
6	green onions, chopped		black pepper to taste
½	cup chopped green bell pepper	1½-2	pounds any ocean fish fillets, such as speckled trout, red snapper, etc.
1	cup chopped celery		
1	clove garlic, minced		

Melt butter in a large skillet. Add flour and stir over medium heat until well blended. Add tomatoes, tomato paste, onion, bell pepper, celery, garlic, 2 tablespoons parsley, bay leaves, lemon, chili powder and plenty of black pepper. Cook and stir 7 minutes. Add enough water to make a sauce and simmer 20 minutes, stirring occasionally and adding more water if needed. Remove bay leaves and lemon pieces from sauce.

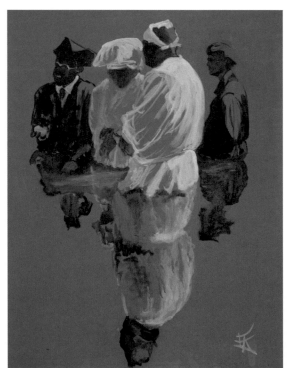

Emma Lytle

Place fish fillets in a single layer in a greased baking dish. Cover fish with sauce. Bake at 350 degrees for 20 minutes or until fish flakes easily with a fork. Transfer fish to a heated serving dish. Cover with sauce and garnish with parsley.

Yield: 4 to 6 servings

LEBLANC'S WONDERFUL REDFISH

6 redfish or trout fillets
 salt and pepper to taste
1 stick butter, melted

3 tablespoons white Worcestershire sauce
 (marinade for chicken)
½ cup Italian bread crumbs, plain or seasoned
1-2 lemons, thinly cut into 12 slices
2 tablespoons capers (optional)

Season fish with salt and pepper. Mix melted butter with Worcestershire sauce. Coat fish on both sides with butter mixture and place in a 9x13-inch glass baking dish.

Bake at 400 degrees for 20 minutes. Remove from oven and sprinkle bread crumbs over fish. Top each fillet with a couple lemon slices, capers and broil until top is nicely browned.

Yield: 6 servings

This is SO easy and delicious!

ANN'S CATFISH

2 tablespoons mayonnaise
1 tablespoon lemon juice
 garlic salt to taste
 freshly ground black pepper to taste

 paprika to taste
2 catfish or tilapia fillets
 Parmesan cheese to taste

Mix mayonnaise, lemon juice, garlic salt, pepper and paprika. Spread mixture over fish fillets on a baking sheet. Sprinkle liberally with Parmesan cheese.

Broil 8 to 10 minutes.

Yield: 2 servings

REDFISH WITH ARTICHOKES AND MUSHROOMS

FISH FILLETS

	juice of ½ lemon, strained
4	(6- to 8-ounce) redfish fillets
1	cup flour
1	tablespoon kosher salt

¼	teaspoon white pepper
3	eggs, beaten
4	tablespoons butter
1	(16-ounce) bag fresh spinach, sautéed

SAUCE

⅓	cup dry white wine
4	artichoke bottoms, chopped
2	cups sliced white mushrooms
2	tablespoons chopped green onion
¼	teaspoon chopped garlic

½	teaspoon chopped shallot
3	tablespoons capers
½	cup fresh lemon juice
1½	sticks unsalted butter

Sprinkle lemon juice over fish fillets. Combine flour, salt and pepper in a large bowl. Dredge fillets in seasoned flour, shaking off excess. Dip fillets in beaten egg, then dredge again in seasoned flour and shake off excess.

Melt butter in a large, heavy skillet over medium-high heat. Sauté fish in butter for 3 minutes on each side or until cooked through. Remove fillets from pan and keep warm.

To make sauce, whisk wine into pan drippings in skillet. Bring to a boil and cook until wine is reduced by two-thirds. Reduce heat to medium and add artichoke, mushrooms, onion, garlic, shallot, capers and lemon juice. Cook until mushrooms are soft. Reduce heat to low and add butter, 1 tablespoon at a time, shaking the skillet until butter has blended in completely.

To serve, place a bed of sautéed spinach on each of 4 warm serving plates. Top each with a fillet and spoon sauce over fish.

Yield: 4 servings

REDFISH JANICE

SAUCE

1 tablespoon butter	4 whole peppercorns
2 tablespoons minced shallots	2 whole cloves
½ cup chicken broth	1 (10¾-ounce) can cream of celery soup
½ cup white vermouth	2 tablespoons fresh lemon juice
1 bay leaf	⅓ cup heavy cream
1 clove garlic, whole	⅛ teaspoon cayenne pepper, or more to taste

FISH

2 pounds fresh redfish fillets	salt and pepper to taste
11 tablespoons butter, melted	1 tablespoon paprika
½ cup fresh lime juice	1 lime, sliced
1 tablespoon fines herbes	

For sauce, melt butter in a 2-quart saucepan. Add shallots and sauté over low heat until translucent. Increase to medium heat and add broth, vermouth, bay leaf, whole garlic clove, peppercorns and cloves. Cook until reduced by half. Remove and discard bay leaf, garlic, peppercorns and cloves.

Stir in soup and lemon juice and cook until reduced by half. Reduce heat to low, add cream and cayenne pepper and cook to gradually reduce sauce. When sauce reaches desired consistency, remove from heat. Refrigerate if not using immediately.

To prepare fish, arrange fillets in a greased fish basket designed for grilling. Mix butter with lime juice and fines herbes and drizzle over both sides of the fish, reserving some of mixture for basting. Sprinkle with salt and pepper and paprika.

Place fish basket 5 to 6 inches from heat source and grill 8 to 10 minutes on each side, depending on thickness of fillets; do not overcook. Baste, occasionally, with butter sauce.

When done cooking, remove fish from grill. Warm sauce if needed. Place a liberal portion of sauce on the bottom of individual serving plates. Top each with a portion of fish. Garnish with a slice of lime and serve.

Yield: 4 to 6 servings

Speckled Trout Casserole

TROUT

6 trout fillets
4 tablespoons butter

⅓ cup Sauterne or other dry white wine
½ tablespoon (scant) chopped fresh basil

SAUCE

4 tablespoons butter
8 ounces fresh mushrooms, sliced
½ cup chopped bell pepper
2 (10¾-ounce) cans cream of celery soup
⅓ cup Sauterne
1 cup shredded Swiss cheese

2-3 pounds shrimp, peeled and deveined
4 tablespoons butter
2 tablespoons basil
 salt to taste
 Parmesan cheese
6 tablespoons sherry

Sauté trout fillets in butter, Sauterne and basil; do not cook completely. Transfer fillets to a greased 9x13-inch casserole dish or individual casserole dishes.

To make sauce, melt 4 tablespoons butter in a skillet. Add mushrooms and sauté. Add bell pepper and sauté until tender. Stir in soup, Sauterne and Swiss cheese. Cook until bubbly.

Meanwhile, in a separate skillet, sauté shrimp in 4 tablespoons butter. Stir in basil and salt. Add shrimp to other skillet when sauce bubbles. Adjust seasoning as needed. Pour sauce over trout fillets. Sprinkle generously with Parmesan cheese. Add sherry to casserole dish.

Bake at 450 degrees for 15 minutes. If needed or desired, finish trout under the broiler. Serve with rice.

Yield: 6 servings

Oysters Mosca

½ cup olive oil
4 tablespoons butter, melted
 juice of 1 lemon
1 clove garlic, crushed
2 teaspoons Worcestershire sauce

2 tablespoons dry white wine
⅔ cup chopped fresh parsley
1 cup bread crumbs
¾ cup Parmesan cheese
3 dozen oysters, drained on paper towels

Combine olive oil, melted butter, lemon juice, garlic, Worcestershire sauce and wine in a bowl.

In a separate bowl, mix parsley, bread crumbs and cheese.

Layer oysters, oil mixture and bread crumb mixture in a baking dish. Repeat layers once.

Bake at 450 degrees for 10 to 15 minutes or until oysters begin to curl.

Yield: 4 to 6 servings

Thirty years ago, a New Orleans neighbor shared this recipe. It's been a favorite ever since. It's one of those that needs just a good salad and plenty of French bread for dipping in the juice.

SCALLOPED OYSTERS

1 stick butter	Tabasco sauce to taste
1 sleeve crackers, coarsely crumbled	black pepper to taste
1 pint oysters, ¼ cup oyster liquor reserved	¼ cup chopped fresh parsley
¾ cup light cream or milk	¼ cup sliced green onion, with tops
½ teaspoon Worcestershire sauce	¼ cup Parmesan cheese
½ teaspoon salt	

Melt butter with cracker crumbs in the microwave and mix to coat evenly. Spread half of crumb mixture in a 1½-quart casserole dish.

Drain oysters, reserving ¼ cup liquor; check for shell. Arrange oysters over crumbs in dish in a single layer.

Combine oyster liquor, cream, Worcestershire sauce, salt and Tabasco sauce and pour over oysters. Season with black pepper and extra salt. Top with parsley, green onion and Parmesan cheese. Sprinkle remaining crumb mixture over oysters.

Bake at 350 degrees for 40 minutes or until bubbling and crumbs are lightly browned.

Yield: 4 servings

Salmon Fillets

1½-2 pounds salmon fillet
mayonnaise
dill to taste

lemon pepper to taste
lemon juice to taste

Coat both sides of salmon with a thin layer of mayonnaise. Sprinkle with dill and lemon pepper. Place fish in a casserole dish.

Bake at 425 to 450 degrees for 10 minutes per inch of fish, usually around 13 minutes. Squeeze lemon juice over fish before serving.

Yield: 6 servings

Salmon and Vegetables in Foil

4 (6-ounce) salmon fillets
4 teaspoons fresh lemon juice
2 teaspoons minced fresh ginger (optional)
4 teaspoons fresh dill, basil or thyme
 salt and pepper to taste
2 tablespoons extra virgin olive oil

2 red potatoes, boiled and sliced
1 cup snow peas, blanched 30 seconds
2 carrots, thinly sliced and blanched 1 minute
¼ small zucchini, sliced
 chopped parsley for garnish

Cut 4 sheets of aluminum foil. Place a fillet on each sheet, slightly off center. Sprinkle each with lemon juice, ½ teaspoon ginger, 1 teaspoon fresh herbs and salt and pepper. Drizzle with olive oil. Divide potatoes, snow peas, carrot and zucchini among foil sheets. Fold foil over to form a rectangle and crimp all edges tightly. If preparing ahead, stop here and refrigerate; increase baking time by 5 minutes.

Bake on a baking sheet at 400 degrees for 15 minutes or until fish is just cooked through. Garnish with parsley.

Yield: 4 servings

Alternative vegetables include peas, corn and asparagus.

Artichoke and Shrimp

1	stick butter	1	cup light cream
½	cup flour	8	ounces fresh mushrooms
½	cup chopped green onion	¼	cup sherry
1	teaspoon salt	½	cup Parmesan cheese, plus extra for topping
1	tablespoon Worcestershire sauce	3	pounds raw peeled shrimp
1	teaspoon paprika	2	(14-ounce) cans artichoke hearts, drained, or frozen
1	cup milk		

Melt butter in a 3-quart dish. Stir in flour and cook about 1 to 2 minutes. Add green onion, salt, Worcestershire sauce, paprika, milk, cream, mushrooms and sherry. Mix in ½ cup Parmesan cheese last. Cook sauce briefly.

Mix shrimp with artichokes in a baking dish. Pour sauce over top and mix well. Sprinkle extra Parmesan cheese on top.

Bake at 350 degrees for 30 to 45 minutes. Serve over toast points, rice or pasta.

Yield: 6-8 servings as entrée; 10-12 over rice or pasta.

Barbeque Shrimp

4-5	tablespoons butter, melted	2	tablespoons paprika
2	tablespoons barbeque seasoning	3	tablespoons Worcestershire sauce
2	tablespoons garlic salt	¾	teaspoon cayenne pepper
¾	teaspoon salt		dash of Tabasco sauce
¾	teaspoon black pepper	4-5	pounds jumbo shrimp

Combine all ingredients except shrimp in a baking dish. Stir well until dissolved. Add shrimp to mixture and stir well.

Bake at 350 degrees for 15 to 20 minutes or until shrimp are done; shrimp will pull away from the shell. Be sure to not overcook shrimp or they will be tough.

Yield: 6 servings

GRILLED BARBEQUE SHRIMP

2	tablespoons paprika		3	sticks butter, melted
2	tablespoons garlic salt			Worcestershire sauce to taste
1	tablespoon cayenne pepper			juice of 10 lemons
2	tablespoons dry barbeque seasoning		5	pounds extra large or jumbo peeled shrimp

Combine paprika, garlic salt, cayenne pepper and barbeque seasoning and mix with melted butter. Stir in Worcestershire sauce and lemon juice. Add shrimp to mixture and marinate 30 to 60 minutes; the butter will congeal.

Prepare a charcoal fire with smoking chips and allow fire to burn to medium heat. Have a container of water nearby just in case coals flame up when grilling shrimp.

Place shrimp on grill. Cover and cook about 5 minutes, watching to be sure fire does not burn shrimp. Turn and cook another 3 to 5 minutes. If desired, baste shrimp with marinade after turning. Be careful not to overcook or undercook shrimp.

Yield: 5 to 6 servings

GRILLED SHRIMP

1-2 pounds raw medium shrimp, peeled and deveined	Tony Chachere's Creole seasoning
	olive oil

Soak 8 bamboo skewers in cold water for at least 30 minutes. Prepare a charcoal or gas grill.

Drain shrimp well and thread onto skewers. Sprinkle both sides of shrimp with Creole seasoning; the more seasoning, the hotter the shrimp. Drizzle olive oil over both sides of shrimp and let stand 3 to 4 minutes.

Meanwhile, close lid and vents of heating grill so fire will smoke for a few minutes. Place shrimp skewers on grill and close lid. Cook 3 minutes. Turn shrimp and cook 2 to 3 minutes longer. Serve hot or cold.

Yield: 4 servings

CAJUN SHRIMP AND CRAWFISH CASSEROLE

2	pounds large shrimp		2-2½	tablespoons Tony Chachere's Creole seasoning
2	cups uncooked rice		1	(10¾-ounce) can cream of mushroom soup
1	stick butter		1	cup sour cream
1	cup chopped white onion		1	cup chopped green onion
1	cup chopped celery		8	ounces fresh mushrooms, sliced
1	cup chopped bell pepper		1-2	sleeves round butter crackers, crushed and buttered
1	pound Louisiana crawfish			paprika

Peel shrimp. If large, shrimp can be butterflied.

Cook rice in 4 cups salted water.

Melt butter in a skillet. Add white onion, celery and bell pepper and sauté until about half done. Add shrimp and crawfish and cook only until shrimp turns pink.

Add Creole seasoning, soup, sour cream, green onion and mushrooms. Mix well. Add cooked rice and stir. Transfer mixture to a glass casserole dish. Top with buttered cracker crumbs and sprinkle with paprika.

Bake at 350 degrees until hot and bubbly.

Yield: 8 servings

CURRIED SHRIMP

4 tablespoons butter
4 large onions, minced
2 apples, finely chopped
¾ cup water
2 teaspoons Madras curry
½ cup sifted flour

3 cups chicken broth, heated
¾ cup heavy cream, warmed
1 teaspoon salt
⅛ teaspoon white pepper
juice of ½ lemon, or to taste
2½ pounds shrimp

CONDIMENTS

Major Grey's chutney
sliced banana
grated coconut
cooked and crumbled bacon
peanuts

toasted slivered almonds
chopped chives
chopped green onion
chopped green bell pepper
raisins soaked in cognac

Melt butter in a large heavy saucepan. Add onion, apple and ¾ cup water and cook over medium heat until water has boiled away and onion and apple are soft. If needed, add more water while cooking. Stir in curry and cook about 10 minutes. Stir in flour and cook until smooth. Cook 3 minutes longer. Stir in hot broth and bring to a boil. Reduce heat and simmer 10 to 15 minutes, stirring occasionally. At this point, sauce can be refrigerated until needed.

Stir in warm cream, salt, pepper and lemon juice. Add shrimp and bring to a boil. Reduce heat and simmer 5 minutes, no longer. Serve over rice with condiments on the side.

Yield: 8 servings

This mixture should be creamy, not soupy. To thicken, mix 1 tablespoon cornstarch with 1 tablespoon cold water in a small bowl. Add to hot mixture and bring to a boil. Repeat as needed until desired consistency is reached.

Nun Better Jambalaya

2	pounds shrimp, peeled		2	cups converted rice
1	pound bulk sausage		1	(11-ounce) can French onion soup
1	bunch green onions, chopped		1	(11-ounce) can beef consommé
1	stick butter		1	(10-ounce) can diced tomatoes with green
2	bay leaves			chiles

Add all ingredients to an ovenproof pot and cover. Bake at 350 degrees for 1½ hours, stirring after 1 hour.

Yield: 6 to 8 servings

When stirring at 1 hour, you will think it's not going to be ready in 30 minutes. Don't worry; it will. Also, when you need to double this recipe, don't actually double it. Make 2 separate recipes.

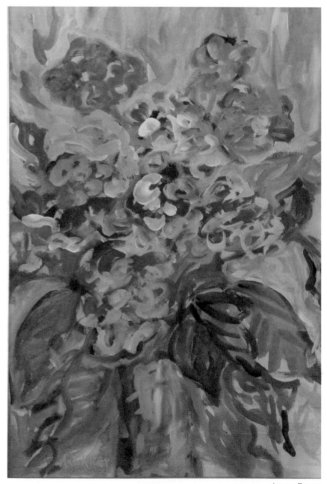

Anne Perry

Shrimp and Ham Jambalaya

2	onions, chopped		½	teaspoon dried thyme
4	tablespoons butter		3	cloves, ground
1	(14½-ounce) can whole tomatoes		1	pound boiled ham, diced
½	(6-ounce) can tomato paste		3	cups cooked rice
4	cloves garlic, minced			salt and pepper to taste
2	stalks celery, chopped			cayenne pepper to taste
¼	bell pepper, chopped		2	pounds shrimp peeled and deveined
1	teaspoon chopped fresh parsley			

Sauté onion in butter for 5 minutes. Add tomatoes and tomato paste and cook 5 minutes, stirring constantly. Add garlic, celery, bell pepper, parsley, thyme and cloves and cook 30 minutes, stirring frequently.

Stir in ham and cook 5 minutes. Stir in rice and season with salt and pepper and cayenne pepper. Simmer 30 minutes, stirring often. Stir in shrimp and cook until shrimp are pink.

Yield: 8 servings

Ship Island Shrimp

1 stick butter
1 bunch green onions, chopped
juice of 1 lemon
generous amount of garlic salt
salt and pepper to taste
3-4 dashes Tabasco sauce

Worcestershire sauce to taste
½ cup ketchup
4-6 teaspoons light dry sherry
chopped fresh parsley
2 pounds raw shrimp

Heat butter in a skillet. Add green onion and sauté until softened. Stir in lemon juice, garlic salt, salt and pepper, Tabasco, Worcestershire sauce, ketchup, sherry and parsley. Simmer 5 minutes.

Add shrimp and simmer until shrimp are pink; do not overcook. Serve over grits.

Yield: 4 servings

Shrimp and Feta with Roasted Tomatoes

5 large tomatoes, cut into eighths
2 tablespoons olive oil
1 tablespoon minced garlic
¾ teaspoon sea salt
¾ teaspoon freshly ground black pepper

1½ pounds medium shrimp, peeled and deveined
¼ cup chopped fresh parsley
2 tablespoons fresh lemon juice
1 cup crumbled feta cheese

Place tomatoes in a large baking dish. Spoon olive oil and garlic over tomatoes and sprinkle with salt and pepper. Toss to mix. Roast at 450 degrees on top rack of oven for 20 minutes.

Add shrimp, parsley and lemon juice to tomatoes and stir. Sprinkle with feta. Bake 10 minutes longer or until shrimp are cooked. Serve with crusty bread.

Yield: 8 servings

Stir-Fry Shrimp and Peppers

2 pounds raw shrimp
minced fresh garlic
chopped green onion
butter
olive oil
2 yellow bell peppers, chopped
2 red bell peppers, chopped

2 green bell peppers, chopped
1 pound fresh mushrooms, chopped
Creole seasoning
seasoned salt
Worcestershire sauce
1 cup dry rice, cooked, or angel hair pasta

Stir-fry shrimp with garlic and green onion in butter and olive oil.

In a separate skillet, sauté all bell peppers and mushrooms until tender. Add shrimp to skillet along with Creole seasoning, seasoned salt and Worcestershire sauce. Cook 2 minutes.

Serve shrimp mixture with cooked rice or pasta.

Yield: 4 servings

Mrs. Bronson's Sausage Stuffed Leg of Lamb

1 (16-ounce) roll of spicy or mild sausage
1 (4- to 5-pound) boneless leg of lamb

1 tablespoon salt
1 tablespoon freshly ground black pepper

Freeze sausage roll 30 minutes to firm up sausage. Carefully remove elastic netting from lamb, keeping netting intact to reuse. Trim excess fat from inside and remove skin from outside, leaving a layer of fat intact. Place sausage roll inside leg where the bones used to be. Roll lamb into leg shape and secure with kitchen string. Slip netting back onto lamb to help keep shape. Mix salt and pepper and rub onto outside of lamb. Place in a roasting pan.

Roast at 250 degrees for 25 to 30 minutes per pound or until lamb is done and sausage is cooked. Let stand 10 to 15 minutes and test for doneness before carving into ½-inch slices.

Yield: 6 to 8 servings

RACK OF LAMB WITH MUSTARD CRUST

3	tablespoons Creole mustard		1	tablespoon chopped fresh rosemary
3	tablespoons Dijon mustard		1	teaspoon freshly ground black pepper
2	tablespoons fresh lemon juice		½	teaspoon kosher salt
1	tablespoon soy sauce		2	cloves garlic, minced
1	tablespoon extra virgin olive oil		1	(2-pound) rack of lamb, fat trimmed

Whisk together both mustards, lemon juice, soy sauce, olive oil, rosemary, pepper, salt and garlic. Coat lamb generously with paste mixture. Place lamb, rack-side down, in a lightly greased shallow roasting pan.

Roast at 400 degrees for 30 minutes or until a meat thermometer registers 145 degrees for medium-rare, 45 minutes or 160 degrees for medium or 170 degrees for well done. Remove from oven and tent lightly with foil. Allow to stand 10 to 15 minutes; lamb temperature will continue to rise 5 to 10 degrees, so you may want to remove from oven at 145 degrees for medium. Slice through rack and between ribs.

Yield: 4 servings

Sauce may be made ahead of time as it can be stored in refrigerator for several weeks. If sauce is too thick, add more lemon juice or mustard as needed. Sauce is also good with pork.

RACK OF LAMB

2 racks of lamb
 fresh lemon juice
 rosemary
 minced garlic

garlic salt
seasoned salt
Cavender's Greek seasoning
seasonings of choice

Place lamb in a large plastic zip-top bag. Add lemon juice, rosemary, garlic, garlic salt, seasoned salt, Greek seasoning or any seasonings of choice. Marinate in refrigerator for several hours or preferably overnight.

To roast, place lamb in a roasting pan. Bake at 475 degrees for 15 minutes. Reduce oven temperature to 375 degrees and roast 10 minutes longer. Remove from oven and let rest 10 minutes before serving. Serve with mint jelly or béarnaise sauce.

Yield: about 4 servings

In general, plan 4 to 5 ribs per serving, so note number of ribs when purchasing racks.

Louise's Lamb and Lima Bean Ragoût

1½ pounds lamb or beef, cubed
3 medium onions, sliced from stem down into ½-inch slivers
1 clove garlic, chopped
2 (10-ounce) packages frozen lima beans, thawed, or 2½ cups fresh

1 (28-ounce) can tomatoes, or 1½ pounds fresh, chopped
1 teaspoon salt
½ teaspoon freshly ground black pepper
2½ cups hot water, or as needed
2 cubes beef bouillon, dissolved in hot water
cooked rice

Braise meat in a skillet until well browned. Add onion and garlic to meat and cook until onion is softened and browned. Add lima beans. Cover and cook 15 minutes over medium heat. Stir lightly and add tomatoes, salt and pepper and cook 30 minutes; tomatoes will turn brown.

Add hot water and dissolved bouillon and cook about 20 minutes longer. Serve hot over hot rice.

Yield: 4 servings

Ragoût keeps well in the refrigerator and is even better the next day.

DELTA SUPPER

3 tablespoons oil
1 pound smoked sausage, cut into 1-inch thick
 slices
1 large green bell pepper, sliced into strips
1 large red bell pepper, sliced into strips
1 large onion, sliced into wedges
2 (12-ounce) cans black-eyed peas, undrained

1 (14½-ounce) can diced tomatoes with
 green chiles
1 cup self-rising cornmeal mix
¼ teaspoon cayenne pepper
⅔ cup milk
1 egg, beaten
1 large jalapeño pepper, chopped, for garnish

Heat oil in a large skillet over medium heat. Add sausage and brown. Add all bell peppers and onion and cook, stirring occasionally, until vegetables are tender. Add peas and tomatoes. Reduce heat to low and simmer 5 minutes. Pour mixture into a greased 3-quart baking dish.

In a small bowl, combine cornmeal mix, cayenne pepper, milk and egg and stir until smooth. Pour mixture over casserole. Bake at 400 degrees for 25 to 30 minutes or until golden brown.

Yield: 8 servings

Recipe can be halved with good results.

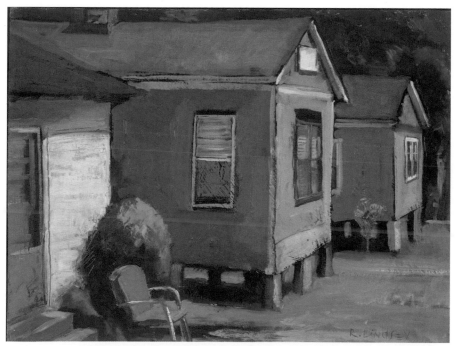

Ron Lindsay

Roast Pork Loin

¾ teaspoon paprika
¾ teaspoon garlic powder
½ teaspoon onion powder
½ teaspoon dried oregano
½ teaspoon salt

½ teaspoon black pepper
I (3-pound) pork loin on the bone
¾ cup orange juice
¾ cup white wine

Combine paprika, garlic powder, onion powder, oregano, salt and pepper in a small bowl. Rub mixture over pork. Place pork in a small heavy roasting pan or skillet.

Roast at 450 degrees for 10 minutes. Reduce oven temperature to 350 degrees. Pour orange juice and wine around (not over) the pork. Roast about I to 1½ hours or until pan juices run clear and a meat thermometer registers 160 degrees for medium doneness. Remove pork from oven and let rest in pan for 15 minutes.

Remove pork from pan. Reduce pan juices to ⅓ cup. Thinly slice pork and place on a serving platter. Spoon pan juices over pork.

Yield: 4 servings

Jackie's Pineapple Salsa (page 19) or Mango Salsa (page 19) would be a good accompaniment.

Marinated Pork Tenderloin

2	(1- to 1¼-pound) pork tenderloins	2-3	cloves garlic, minced
	Cavender's Greek seasoning	2	sticks butter, melted
	Pick-A-Peppa sauce		juice and zest of 1 lemon

Rub tenderloins with Greek seasoning, Pick-A-Peppa sauce and garlic, covering well. Place in a plastic zip-top bag and marinate overnight.

Prepare a basting sauce by mixing butter with lemon juice and zest. Add Greek seasoning to taste.

To grill, build a fire on one side of the grill. When red hot, sear meat on all sides directly over heat. Move tenderloins off to the side to cook over indirect heat. Baste with butter sauce while cooking. Cook to desired degree of doneness, about 45 minutes for medium-rare. Remove from grill to a roasting pan and pour any remaining basting sauce over the top. Slice and serve with pan juices.

To roast, sear tenderloins on all sides in a heavy skillet on stovetop. Place in a roasting pan and bake at 350 degrees for 25 to 30 minutes or to desired degree of doneness; 160 to 165 degrees for medium-rare. Baste several times during cooking with basting sauce.

Yield: 6 to 8 servings

Delicious as an entrée or with party rolls as an appetizer.

Roast Pork Tenderloins with Blackberry Sauce or Blueberry Onion Sauce

2 tablespoons canola oil	½ teaspoon salt
1 tablespoon Dijon mustard	½ teaspoon freshly ground black pepper
1 tablespoon red wine vinegar	1 teaspoon paprika
1 tablespoon Worcestershire sauce	2 (1½-pound) pork tenderloins
1 tablespoon soy sauce	

Combine canola oil, mustard, vinegar, Worcestershire sauce, soy sauce, salt, pepper and paprika. Rub mixture onto tenderloins and marinate in refrigerator at least 4 hours or overnight.

To roast, sear tenderloins in a skillet. Transfer to a roasting pan. Bake at 350 degrees for 30 to 45 minutes or until a meat thermometer reaches 160 to 165 degrees.

To grill, sear tenderloins over hot coals, then move off to side of grill and cook over indirect heat until a meat thermometer reaches 160 to 165 degrees.

To serve, carve meat into ½-inch thick slices. Serve with Blackberry Sauce (recipe below) or Blueberry Onion Sauce (recipe below).

BLACKBERRY SAUCE

1 (10- to 12-ounce) jar seedless blackberry jam	1 tablespoon grated fresh ginger
2 tablespoons seasoned rice wine vinegar	½ teaspoon salt
¼ cup ketchup	black pepper to taste
¼ cup honey	hot pepper sauce to taste
¼ cup light brown sugar	fresh blackberries for garnish

Whisk together all ingredients in a saucepan and bring to a boil. Reduce heat and simmer 20 minutes. Sauce can be made ahead and refrigerated; warm to serve. Garnish meat and sauce with fresh berries.

Yield: about 2 cups

BLUEBERRY ONION SAUCE

2	tablespoons butter	¼	cup port or Madeira wine
2	medium onions, thinly sliced	2	tablespoons balsamic vinegar
½	teaspoon salt	1	cup fresh or frozen blueberries
¼	teaspoon black pepper	1	cup halved cherry or grape tomatoes
2	tablespoons sugar		

Melt butter in a saucepan. Add onion, salt and pepper and sauté 10 minutes or until golden. Add sugar and cook and stir 3 minutes. Add wine, vinegar and blueberries and bring to a boil. Add tomatoes and simmer, uncovered, until tomatoes are soft and sauce reaches desired consistency.

Yield: about 1½ cups

ℱABULOUS ℬBQ ℘ORK

1	(3- to 5-pound) pork butt roast	several cloves garlic, smashed
1	(12-ounce) can beer	1½ cups favorite barbeque sauce, divided
1	onion, coarsely chopped	

Combine all ingredients except barbeque sauce in a plastic zip-top bag and marinate overnight in refrigerator.

The next morning, drain roast and place in a crock pot. Pour ¾ cup barbeque sauce over roast. Cook about 8 hours on low or until tender but still in large pieces.

Transfer to a cutting board and carve into medium slices. Discard juice from crock pot (I know it's hard; it smells so good, but just trust me!) Return pork to crock pot and add remaining ¾ cup barbeque sauce. Heat until warm.

Yield: 6 to 8 servings, depending on size of roast

Stuffed Pork Tenderloin with Apricot Jalapeño Sauce

STUFFING
2 shallots, chopped
2 tablespoons butter
¼ cup golden raisins

¼ cup pine nuts, lightly toasted
1 cup cooked rice, basmati preferred

PORK
3 tablespoons butter
1 clove garlic, minced

1 (10-ounce) package frozen spinach, thawed
 and squeezed dry
1 (2- to 2½-pound) pork tenderloin,
 or 2 smaller

For stuffing, sauté shallot in butter until tender. Mix with raisins, pine nuts and cooked rice. Stuffing can be made ahead.

To prepare pork, melt butter in garlic until soft but not browned. Add spinach; cook a few minutes to evaporate most of the liquid.

Butterfly pork tenderloins, being careful not to cut completely through the meat. Spread spinach mixture evenly over inside of meat. Top with stuffing. Roll pork carefully and tie off with kitchen string so pork will hold its shape during cooking. This can be done ahead and refrigerated until ready to bake.

Bake at 400 degrees for 20 minutes per pound or until a meat thermometer registers 160 to 165 degrees. Remove from oven and let rest 10 minutes before removing string. Cut into slices and serve with Apricot Jalapeño Sauce (recipe follows).

Yield: 6 to 8 servings, depending on size of tenderloins

APRICOT JALAPEÑO SAUCE

4　ounces dried apricots, diced
1　(16-ounce) can apricots, drained
¾　cup bourbon
4　jalapeño peppers, or to taste, seeded
　　and finely diced

1　tablespoon grated onion
¼　teaspoon dried red pepper flakes
　　(optional, but adds an interesting color)
　　juice and zest of 1 lime

Combine dried and canned apricots with bourbon in a saucepan. Bring to a boil. Reduce heat to low and simmer 30 minutes; cool. Process cooled apricots and pan juice in a food processor with jalapeño pepper, onion, pepper flakes and lime juice and zest. If too thick, add a dash of bourbon. Can be made ahead and refrigerated. Serve warm.

Yield: 2 cups

Brazos Valley Wild Duck on Linguini

6　ducks, breasted and filleted
2　sticks butter
1　tablespoon garlic salt
1½　teaspoons nutmeg
⅔　cup sherry
1　pound fresh mushrooms, sliced

3　tablespoons Worcestershire sauce
　　seasoned salt to taste
　　black pepper to taste
1　tablespoon flour
1-2　teaspoons Kitchen Bouquet (optional)

Cut duck breasts into bite size pieces. Melt butter in a skillet. Add duck and cook until golden brown. Stir in garlic salt, nutmeg, sherry, mushrooms and Worcestershire sauce. Simmer 20 minutes.

Season to taste with seasoned salt and pepper. Mix flour with a bit of cold water to make a slurry. Add flour mixture to skillet to thicken as desired. Stir in Kitchen Bouquet for a darker sauce. Serve over linguini.

Yield: 6 servings

Veal with a Rainbow of Peppers

1 pound veal, cut into thin strips
 flour to coat veal
2 tablespoons salad oil
½ green bell pepper, cut into thin strips
½ red bell pepper, cut into thin strips
½ yellow bell pepper, cut into thin strips
1 clove garlic, minced

1 onion, thinly sliced
8 ounces fresh mushrooms, sliced
 salt and pepper to taste
¾ cup tomato sauce or fresh or canned diced
 tomatoes
¾ cup water
½ teaspoon dried basil

Toss veal with flour until coated; shake off excess. Heat oil in a skillet over high heat. Add veal and sauté until browned. This may be done in batches, adding more oil if needed.

Reduce heat and add all bell peppers, garlic, onion and mushrooms and sauté 5 minutes. Season with salt and pepper. Stir in tomato sauce, water and basil. Cover and simmer 20 minutes or until veal is tender. Serve over rice with a salad and good bread for a complete meal!

Yield: 4 servings

Recipe can easily be doubled or tripled. Freezes well if made ahead.

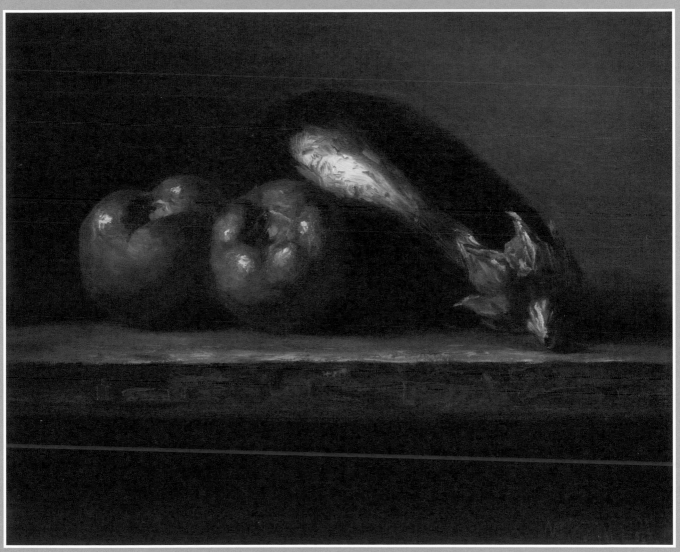

Lucy Mazzaferro

"Asparagus inspires gentle thoughts."

~Charles Lamb

And so do fresh green peas that whisper "Spring!" With the bounty of fresh vegetables now available in all seasons to the shopper and chef, we can vary our diets to an extent unbelievable in the days of Charles Lamb. That English essayist would be astounded at the plenty in our markets. Of course, we still depend on that staple of his time, the noble potato. Among the recipes in this section, however, you will find a new appreciation of the sweet potato—three mouthwatering concoctions in fact.

In the Deep South, another of our staples is the versatile tomato. We can't wait for those round red summer delicacies necessary for the essential BLT, salads, aspic and gazpacho, but we love them year-round too in casseroles and for grilling and roasting. This marvelous gift from nature never fails us. You'll find no less than five recipes for tomatoes in these pages, all deserving a Brava!

Interestingly, these recipes offer both the contemporary and the venerable. For example, the one for Eggplant Casserole is one hundred years old, while just a page or two over are tasty treats from two of Jackson's fine restaurants: Bravo's Grilled Portabella Mushrooms and Char's Spinach Au Gratin. And of course *All Things Good* could not leave out those side dishes that have complemented our meals for a long time, those casseroles of baked fruits and melting spoon bread, southern culinary favorites.

Root vegetables are not overlooked either, and in addition to several savory selections for carrots, you will find a ravishing Roast Root Vegetable Purée using both Yukon Gold and sweet potatoes, plus carrots, parsnips, turnips, fennel bulb and celery. This is a comfort food supreme and a delicious treat on a frosty Friday night.

Nutritionists who admonish us to eat more and more vegetables will find themselves preaching to the choir if we tempt the palates of our families and friends with all these tantalizing dishes, literally from Artichokes to Zucchinis. We agree with John Milton who warned, "Accuse not nature, she hath done her part;/ Do thou but thine."

Vegetables

Artichoke Pie

2 (9-ounce) cans artichoke hearts, or
 2 (9-ounce) packages frozen artichoke
 hearts
4 tablespoons butter
½ cup chopped onion
1 tablespoon flour
½ cup half-and-half
½ cup sour cream

4 eggs, beaten
 salt and pepper to taste
¼ teaspoon ground nutmeg
2 teaspoons minced fresh parsley
1 (9-inch) store-bought pie crust, unbaked
½ cup shredded Cheddar cheese
½ cup shredded Swiss cheese
¼ cup freshly grated Parmigiano-Reggiano cheese

If using frozen artichokes, cook according to package directions. Set artichokes aside.

Melt butter in a large skillet over medium heat. Add onion and cook 5 minutes or until tender but not brown. Blend in flour. Stir in half-and-half and cook 3 to 5 minutes or until blended.

Combine sour cream, egg, salt and pepper, nutmeg and parsley in a small bowl. Add sautéed onion.

Place a layer of artichokes in the bottom of the pie crust. Sprinkle with Cheddar cheese. Add another layer of artichoke hearts and top with Swiss cheese. Pour egg mixture over layers. Sprinkle with Parmigiano-Reggiano cheese.

Bake at 350 degrees for 45 minutes. Cut into wedges.

Yield: 4 to 6 servings

Asparagus Italia

2	bunches fresh asparagus		paprika
6	tablespoons extra virgin olive oil	½	cup Parmesan cheese
3	tablespoons lemon juice		

Break off tough ends of asparagus spears. Parboil asparagus in salted water for 3 to 4 minutes. Drain in a colander and rinse with cold water. Place spears in a single layer in a greased glass baking dish.

Drizzle olive oil and lemon juice over asparagus. Sprinkle with paprika and Parmesan cheese.

Bake at 400 degrees for 10 to 15 minutes. If preparing ahead, reheat asparagus briefly under a broiler before serving.

Yield: 6 servings

Brussels Sprouts and Cauliflower with Walnut Butter

1½	pounds fresh Brussels sprouts	5	tablespoons butter
1	large head cauliflower, broken into florets	½	cup coarsely chopped walnuts

Trim Brussels sprouts and cut an "x" into the stem end of each. Rinse with cold water. Place sprouts and cauliflower florets in a steaming basket. Place vegetables over a pot filled with 1 inch of simmering water. Cover pot and steam 8 minutes or until crisp-tender.

Melt butter in a large heavy saucepan or Dutch oven over medium heat. Add walnuts and sauté 5 minutes or until walnuts begin to brown. Add vegetables and toss well until coated. Transfer to a warmed dish and serve.

Yield: 12 servings

Dijon Asparagus

asparagus spears, trimmed
1 tablespoon whipped butter

1 tablespoon Dijon mustard
juice of 1 lemon

Cook asparagus until tender.

Melt butter in a shallow skillet. Add mustard and lemon juice and mix well. Add asparagus and toss until well coated.

Glorified Cabbage

1 medium head cabbage
2 eggs, beaten
1 tablespoon butter, melted
½ cup light cream

⅛ teaspoon paprika
salt
Parmesan cheese

Discard outer leaves of head of cabbage. Quarter cabbage and finely shred. Cook cabbage in boiling salted water for 5 minutes; drain well.

Combine eggs, butter, cream and paprika and mix well. Spread half of cabbage in a greased baking dish. Season with salt. Spread remaining cabbage in dish. Pour egg mixture over cabbage.

Bake at 325 degrees for 20 to 25 minutes or until top is lightly browned and mixture is slightly thickened; do not overcook. Remove and sprinkle liberally with Parmesan cheese. Return to oven and bake 5 to 10 minutes longer or until cheese is melted.

Yield: 6 servings

Celery Casserole

4 cups coarsely chopped celery
4 tablespoons butter
3 tablespoons flour
½ cup heavy cream

1 (10¾-ounce) can cream of celery soup
¼ cup slivered almonds
½ cup sliced water chestnuts
 buttered bread crumbs

Cook celery in a small amount of water until crisp-tender. Drain, reserving water for sauce.

To make a white sauce, melt butter in a saucepan. Blend in flour. Add about ½ cup reserved cooking water and cream. Stir in soup. Add cooked celery, almonds and water chestnuts. If sauce is too thick, add a little milk. Pour sauce into a casserole dish. Top with buttered bread crumbs.

Bake at 350 degrees for 25 minutes or until bubbly.

Yield: 4 to 6 servings

Easy Black Beans

½ green bell pepper, chopped
1 onion, chopped
2 tablespoons olive oil
2 tomatoes, peeled and chopped
2 cloves garlic, chopped
2 (16-ounce) cans black beans, drained

1 (2-ounce) jar pimentos
½ teaspoon vinegar
1 tablespoon sugar
1 bay leaf
 sour cream for garnish

Sauté bell pepper and onion in olive oil. Add tomato and garlic. Stir in beans, pimentos, vinegar, sugar and bay leaf. Simmer about 20 minutes. Remove bay leaf.

Serve over rice. Garnish with sour cream.

Yield: 6 servings

Cuban Black Beans

1	(16-ounce) package black beans	1	pound beef sausage links
¼	cup olive oil	½	cup honey mustard
1	onion, chopped	½	cup honey
1	green bell pepper, chopped	2	tablespoons white wine
2	cloves garlic, minced		saffron rice
1	teaspoon ground cumin		grated sharp Cheddar cheese
2	teaspoons salt		sour cream
1	tablespoon red wine vinegar		green onions

Soak beans in water for several hours or overnight.

Rinse beans after soaking, drain and place in a large pot. Add enough water to cover and bring to a boil. Transfer beans to a crock pot. Add olive oil, onion, bell pepper, garlic, cumin and salt. Cook on high for several hours or until tender. Stir in red wine vinegar. Beans are best if cooked the day before, refrigerated overnight and reheated just before serving.

Cut sausage links in half and brown in a skillet. Add honey mustard, honey and wine to skillet and simmer 20 to 30 minutes.

Serve beans with sausage over saffron rice. Top with cheese, sour cream and green onions.

Yield: 8 servings

Cowboy Baked Beans

1 pound ground round, cooked and crumbled
6 slices bacon, cooked and crumbled
1 bell pepper, chopped
1 onion, chopped
1 (3-pound) can baked beans
⅔ cup barbecue sauce
½ cup ketchup
1 tablespoon yellow mustard
1 tablespoon Worcestershire sauce
½ cup brown sugar
2 tablespoons pancake syrup
2 tablespoons honey
 salt and pepper to taste

Combine all ingredients and place in a greased 9x13-inch glass baking dish. Cover with foil. Bake at 350 degrees for 20 minutes. Uncover and bake 10 to 15 minutes longer.

Yield: 10 to 12 servings

Ground venison can be substituted for the beef.

Festive Green Beans

1 cup coarsely chopped walnuts
¾ cup olive oil
⅓ cup red wine vinegar
1 tablespoon chopped fresh dill
1 clove garlic
 salt and pepper to taste
2 pounds fresh or frozen whole green beans
1 small red onion, sliced
4 ounces feta cheese, crumbled

Bake walnuts at 350 degrees on a baking sheet, stirring occasionally, for 5 to 8 minutes or until toasted. Cool.

Combine olive oil, vinegar, dill, garlic and salt and pepper in a small bowl.

For fresh beans, trim ends. Leave beans whole or cut in half. Cook beans in boiling water until crisp-tender. Cook frozen beans according to package directions. Plunge cooked beans in an ice bath to stop cooking; drain.

Combine beans, onion, feta and toasted walnuts in a large bowl. Stir to mix well. Cover and chill several hours. Pour oil mixture over beans. Marinate for at least 1 hour before serving.

Yield: 6 servings

Vegetables

Holiday Green Beans

1½ cups brown sugar
1 tablespoon dry mustard

3 (16-ounce) cans whole green beans, rinsed and drained
Bacon, chopped into small pieces

Combine brown sugar and mustard and sprinkle over beans. Toss to coat beans. Gently stir in bacon. Transfer to a casserole dish.

Bake at 325 degrees for 30 minutes, stirring occasionally.

Yield: 8 to 10 servings

Recipe can be prepared ahead and baked before serving.

Green Bean Casserole

1½ pounds fresh Blue Lake thin green beans, snapped
 cayenne pepper to taste
2½ tablespoons butter
2 tablespoons flour
1 teaspoon sugar

½ teaspoon salt
1 pint sour cream
8 ounces fresh mushrooms
1 small onion, grated
¼ cup chicken broth
 shredded Swiss cheese

Cook green beans in boiling salted water seasoned generously with cayenne pepper. If available, add any seasoning of leftover country ham or salt pork to cooking water. Drain and set aside.

To make a sauce, melt butter in a saucepan. Blend in flour. Add sugar, salt, sour cream, mushrooms, onion and broth. Bring to a boil.

Arrange beans in a casserole dish. Pour sauce over beans. Top with cheese. Bake at 375 degrees for 20 to 30 minutes or until bubbly.

Yield: 4 to 6 servings

RED CABBAGE

1	large head red cabbage, cored	1	tablespoon butter	
1	tablespoon butter	2	(14-ounce) cans beef broth	
1¼	teaspoons caraway seeds	¼	cup vinegar	
1	tablespoon flour	1	tablespoon sugar	
1	teaspoon salt			

Slice cabbage into thin strips. Grease bottom and sides of a Dutch oven with 1 tablespoon butter. Layer cabbage in Dutch oven, with alternating layers of caraway seeds, flour, salt and 1 tablespoon dots butter.

Pour broth over layers. Simmer 1½ hours, stirring frequently. Add vinegar and sugar just before serving.

Ellen Langford

OFFBEAT CARROTS

6	carrots, diced	½	teaspoon salt
½	cup mayonnaise	¼	teaspoon black pepper
2	tablespoons horseradish	½	cup buttered bread crumbs
2	tablespoons grated onion		

Cook carrots in water; drain. Transfer carrots to a 1½-quart baking dish.

Combine mayonnaise, horseradish, onion, salt and pepper. Stir mixture into carrots. Top with bread crumbs.

Bake at 300 degrees for 15 to 20 minutes.

Yield: 3 to 4 servings

GLAZED CARROTS

1	pound carrots, sliced	1	tablespoon unsalted butter
½	cup water	1	teaspoon sugar
1	cup apricot nectar	1	teaspoon salt
1	tablespoon freshly squeezed lemon juice	1	tablespoon cornstarch
½	teaspoon lemon zest		

Cook carrots in ½ cup water in a covered saucepan for 10 minutes or until just tender; drain.

Combine apricot nectar, lemon juice, lemon zest, butter, sugar, salt and cornstarch in a saucepan. Cook until sauce is clear and thickened. Add carrots and heat until ready to serve.

Yield: 4 servings

Corn Casserole

1 stick butter
2 eggs
1 (6-ounce) package Mexican cornbread mix
1 (16-ounce) can whole kernel corn, drained
 with liquid reserved
1 (16-ounce) can cream-style corn

reserved corn liquid with water added
 to equal 1 cup
½ cup milk
1 cup sour cream
1 onion, chopped
¼ teaspoon Creole seasoning
 shredded cheese (optional)

Melt butter in a casserole dish. Mix eggs, cornbread mix, whole kernel corn, cream-style corn, corn liquid, milk, sour cream, onion and seasoning. Pour batter into casserole dish. Top with shredded cheese, if desired.

Bake at 350 degrees for 45 to 50 minutes.

Yield: 6 servings

Crunchy Corn Casserole

¼ cup sliced green onion
¾ cup thinly sliced celery
1 tablespoon butter
2 eggs, slightly beaten
⅓ cup milk

½ teaspoon dried oregano
¼ teaspoon salt
1 (16-ounce) can cream-style corn
1½ cups shredded Cheddar cheese
½ (10-ounce) bag corn chips

Sauté onion and celery in butter in a skillet. In a bowl, combine egg, milk, oregano, salt and corn. Stir in sautéed vegetables.

In a casserole dish, alternate layers of corn mixture and cheese. Top with corn chips. Bake, uncovered, at 325 degrees for 40 minutes.

Yield: 6 to 8 servings

EGGPLANT CASSEROLE

1 large eggplant, peeled and coarsely diced
3 tablespoons flour
½ cup milk
1 (14-ounce) can diced tomatoes, drained
2 tablespoons ketchup
2 tablespoons butter, melted

1 teaspoon sugar
2 eggs, beaten
1 medium onion, chopped
3 tablespoons cracker crumbs (about 5 crackers)
 Parmesan or Cheddar cheese

Cook eggplant in boiling salted water until tender; drain.

Combine flour and milk in a bowl. Add tomatoes, ketchup, butter, sugar, egg and onion. Pour mixture over eggplant and stir to mix. Pour into a greased casserole dish. Top with cracker crumbs.

Bake at 325 degrees for 1 hour. Sprinkle cheese on top for last 15 minutes of baking.

Yield: 6 servings

This recipe is one hundred years old.

SMOTHERED EGGPLANT PARMESAN

1 large eggplant, peeled and cut into ¾-inch chunks
2 large onions, coarsely chopped
1 bell pepper, coarsely chopped
1 stick butter, melted

3 large tomatoes, coarsely chopped
2 cloves garlic, minced
1 tablespoon salt
½ teaspoon Tabasco
 freshly grated Parmesan cheese

Soak eggplant in cold salted water; drain.

Sauté onion and bell pepper in butter. Add tomato and garlic and cook slowly for 20 minutes. Add eggplant, salt and Tabasco. Steam 30 minutes. Top with cheese.

Yield: 4 servings

Bravo! Portabello Mushrooms

When grilling season is upon us, many customers ask us how we make the BRAVO! grilled portabello mushrooms. The procedure is simple, but the key is NOT TO MARINATE THE MUSHROOMS. Portabellos are rich, beefy-flavored mushrooms that can easily become bitter and stringent if allowed to soak up a vinaigrette by sitting for a long time in a marinade. Therefore, the secret to the BRAVO! grilled portabello mushrooms is to toss the mushroom in balsamic vinaigrette right before placing it on the grill - NO SOONER!

Pour balsamic vinaigrette (recipe below) into a bowl and toss in a portabello mushroom cap. Turn it over a couple of times to coat both sides and then pop it on a medium heat grill. Do not baste; just turn it over after 4 or 5 minutes. Another 4 minutes on the flip side and it should be perfect. Test for doneness by stabbing with a fork. If done, it will be soft all the way through and will not resist the pressure of the fork. Serve immediately as a side item or the main course. Great as a sandwich on focaccia or ciabatta bread with roasted peppers, fontina or goat cheese and basil pesto.

BALSAMIC VINAIGRETTE

½	cup balsamic vinegar	2	teaspoons dry Italian seasoning
1	tablespoon Dijon mustard		salt and pepper to taste
1	teaspoon minced garlic	¾	cup olive oil
2	tablespoons sugar		

Combine all vinaigrette ingredients except oil in a food processor. Start machine and slowly drizzle in olive oil until fully incorporated. If too thick, drizzle in a bit of cool water.

1979 New Year's Black-Eyed Peas

2	pounds dry black-eyed peas	¼	cup olive oil
12	cups water	1	tablespoon Worcestershire sauce
	leftover ham bone	2	tablespoons vinegar
2	tablespoons salt	1	medium onion, chopped
½	tablespoon black pepper	½	teaspoon chopped garlic
1½	tablespoons sugar		butter for sautéing

Rinse peas and pick through. Soak peas in 12 cups water overnight; drain.

Place ham bone in a pot. Cover with water and boil 1 to 2 hours. Cool and skim fat off broth. Pick ham from bone. Reserve broth and ham, dispose of bone.

In a large saucepan, mix drained peas with salt, pepper, sugar, olive oil, Worcestershire sauce, vinegar, 4 cups reserved broth and ham. Sauté onion and garlic in butter and add to peas.

Bring peas to a boil. Reduce heat to a simmer and cook 10 to 15 minutes or until peas are slightly tender, stirring frequently and adding water as needed.

Refrigerate overnight. Reheat and serve hot with rice and cornbread.

Yield: 8 servings

Boursin Cheese Potatoes

3 pounds red potatoes, unpeeled and thinly
 sliced
 salt and pepper to taste

2 cups heavy cream
5 ounces Boursin cheese with herbs
 chopped fresh parsley

Sprinkle potato slices with salt and pepper. Spread potato slices in a casserole dish. Heat cream with cheese and pour mixture over potato slices.

Bake at 400 degrees for 1 hour. Garnish with parsley.

Escalloped Potatoes with Goat Cheese and Herbes de Provence

1½ cups heavy cream
1½ cups chicken broth
1 cup dry white wine
⅔ cup finely chopped shallots
2 teaspoons minced garlic

1 tablespoon herbes de Provence
1 teaspoon salt
½ teaspoon white pepper
1 (10- to 11-ounce) log goat cheese, divided
4 pounds russet potatoes, peeled and sliced

Combine cream, broth, wine, shallots, garlic, herbes de Provence, salt, pepper and half the goat cheese in a saucepan. Bring to a simmer.

Arrange potato slices in a greased 9x13-inch baking dish. Pour hot cream sauce over the top. Cover with foil.

Bake at 400 degrees for 20 minutes. Uncover and bake 20 to 25 minutes longer. Dot with remaining goat cheese and bake 5 minutes more. Remove from oven and let stand 15 minutes before serving.

Yield: 8 servings

Char's Creamed Spinach au Gratin

3	pounds frozen chopped spinach	¼	cup dry onion soup mix
1	quart water	8	ounces Parmesan cheese, shredded
1	pinch of salt	½	teaspoon ground nutmeg
2	medium onions, finely chopped	¾	tablespoon garlic salt
1	stick butter	½	teaspoon Tabasco sauce
¼	cup flour	½	cup shredded mozzarella cheese
1	quart half-and-half	½	cup shredded Cheddar cheese

Cook spinach in 1 quart water with a pinch of salt for 15 to 20 minutes. Drain well and press out excess moisture. Transfer spinach to a casserole dish.

Sauté onion in butter for 5 minutes or until translucent. Blend in flour. Add half-and-half, soup mix, Parmesan cheese, nutmeg, garlic salt and Tabasco sauce. Cook over medium heat until hot. Pour mixture over spinach. Top with mozzarella and Cheddar cheeses.

Bake, uncovered, at 350 degrees until bubbly and cheese is melted.

Yield: 6 to 8 servings

SPINACH AND ARTICHOKE CASSEROLE

2 (10-ounce) packages frozen chopped spinach
1 (3-ounce) package cream cheese
2 tablespoons fresh lemon juice
2 sticks butter
1 teaspoon garlic salt

1 (14-ounce) can artichoke hearts, drained and halved
1 (8-ounce) can sliced water chestnuts (optional)
 seasoned bread crumbs

Cook spinach; drain well and place in a mixing bowl. Combine cream cheese, lemon juice, butter and garlic salt and heat until melted. Pour melted mixture over spinach and stir until blended.

Line a greased casserole dish with artichoke hearts. Scatter water chestnuts on top, if using. Spoon spinach mixture over artichokes and sprinkle with bread crumbs.

Bake at 325 degrees for 20 minutes.

One package frozen artichoke hearts, or fresh artichokes, steamed with hearts cleaned and leaves scraped, can be used in place of canned.

Yield: 8 servings

Squash and Cherry Tomatoes in Basil Butter

⅓	cup fresh basil leaves	4	green onions
4	tablespoons unsalted butter, slightly softened	2	pounds yellow squash, thinly sliced
2-3	cloves garlic	6	ounces cherry or grape tomatoes, halved

Combine basil leaves, butter, garlic and onions in a food processor. Process until blended but not completely smooth.

Melt butter mixture in a large skillet over medium-high heat. Add squash and sauté 2 to 3 minutes. Add tomatoes and cook just until tomatoes are heated through. The squash should be crisp-tender and the tomatoes should keep their shape and not be mushy. Serve immediately.

Yield: 6 servings

Stuffed Squash

6	small yellow squash	I	egg, beaten
I	tablespoon butter	I	tablespoon chopped chives
½	cup shredded Cheddar cheese		salt and pepper to taste
¼	cup bread crumbs or crushed butter crackers		paprika

Cook whole squash in boiling water for 10 minutes; drain and cool slightly. Halve squash lengthwise and scoop out centers into a mixing bowl; set squash shells aside.

Add butter, Cheddar cheese, bread crumbs, egg and chives to squash centers. Season with salt and pepper and mix. Spoon mixture into squash shells. Sprinkle with paprika and place on a baking sheet.

Bake at 350 degrees for 20 minutes.

Yield: 6 servings

Linda's Squash Casserole

2 pounds yellow squash, sliced
1 (10½-ounce) cream of chicken soup
1 cup sour cream
1 carrot, shredded
 salt and pepper to taste
1 yellow onion, grated

1 stick butter
1 green bell pepper, chopped (optional)
1 (4-ounce) can mushrooms, drained
1 (2-ounce) jar pimentos, rinsed and drained
1 (8-ounce) package herb stuffing mix
 melted butter

Cook squash until tender; drain. Mix squash with soup, sour cream, carrot, salt and pepper, onion, 1 stick butter, bell pepper, mushrooms, pimentos and half the stuffing mix. Spoon mixture into a greased casserole dish.

Sprinkle remaining stuffing on top and drizzle with melted butter. Bake, uncovered, at 350 degrees for 30 minutes.

Yield: 8 to 10 servings

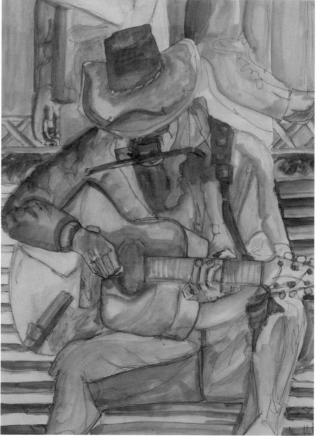

Alan Paul

Vegetables

Squash-Corn Surprise

3½ cups fresh corn, cut off the cob
4 tablespoons butter
1 tablespoon sugar
1 teaspoon salt
3½ cups thinly sliced yellow squash
1 small onion, minced
½ cup sour cream

1 egg, beaten
1 teaspoon salt
¼ teaspoon dried dill
1 teaspoon white pepper
3 tablespoons butter, melted
 bread crumbs mixed with Parmesan cheese

Sauté corn in butter until tender. Mix in sugar and 1 teaspoon salt; set aside.

Cook squash and onion in simmering water until tender; drain. Chop half of squash mixture slightly in a food processor. Return chopped mixture to remaining squash mixture. Add sour cream, egg, 1 teaspoon salt, dill, pepper, butter and corn mixture. Spoon into a greased 2-quart casserole dish. Sprinkle bread crumbs and Parmesan cheese on top.

Bake, uncovered, at 350 degrees for 45 minutes.

Yield: 12 servings

Brandied Sweet Potatoes

3-4 oranges
¼ cup brown sugar
½ cup brandy
¼ cup light cream

4 tablespoons butter
1 teaspoon salt
4 cups cooked and mashed sweet potatoes
brown sugar for topping (optional)

Grate oranges to yield 1 tablespoon zest; set aside. Peel oranges. Cut 1 orange crosswise into slices. Chop remaining oranges into small pieces to yield 2 cups drained fruit. Sprinkle chopped orange with ¼ cup brown sugar and set aside.

Combine orange zest with brandy, cream, butter and salt and heat until melted. Add mixture to sweet potatoes and heat until well blended. Drain sweetened oranges and add to sweet potato mixture. Spoon mixture into a well-greased 1½-quart casserole dish. Top with orange slices and sprinkle with extra brown sugar, if desired.

Bake, uncovered, at 350 degrees for 35 to 40 minutes.

Yield: 8 servings

Casserole may be prepared in advance and refrigerated until ready to bake.

Oven-Roasted Sweet Potatoes and Onions

4 medium-size sweet potatoes, peeled and cut into 2-inch pieces
2 medium Vidalia or other sweet onions, cut into 1-inch pieces

2 tablespoons extra virgin olive oil
¾ teaspoon garlic pepper blend
½ teaspoon salt

Combine all ingredients and spoon into a 9x13-inch baking dish. Bake at 425 degrees for 35 minutes or until tender, stirring occasionally.

Yield: 6 servings

Can add Brussels sprouts, whole garlic cloves, parsnips, carrots or any other root vegetable.

Vegetables

Sweet Potato Leek Gratin

6	ounces country ham, diced into ¼-inch pieces	2	cups heavy cream
2	tablespoons butter	2-2½	pounds sweet potatoes, sliced ⅛- to ¼-inch thick
2	tablespoons olive oil	3	tablespoons chopped fresh thyme, or 1 teaspoon dried
2	leeks, thinly sliced		salt and freshly ground pepper to taste
2	cloves garlic, chopped		

Sauté ham in butter and olive oil. Add leeks and garlic and sauté over low heat until vegetables start to sweat, but do not brown. Add cream and simmer 5 minutes.

Arrange a single layer of overlapping potato slices in a greased 2-quart baking dish. Sprinkle with thyme and season lightly with salt and pepper. Spoon a layer of cream mixture on top. Repeat layers, pressing down with the back of a spoon so potatoes are covered with cream.

Bake at 350 degrees for 50 to 60 minutes. Remove from oven and let stand 5 minutes before serving. If baked in advance, when ready to serve, reheat at 300 degrees until bubbly.

Yield: 6 servings

Chula Homa Tomato Pie

1 prepared pie crust
1 cup chopped fresh basil
1 cup minced green onion
½ cup minced parsley
 mayonnaise for layering

5-6 ripe tomatoes, sliced
1½ cups shredded Cheddar cheese, divided
⅛ teaspoon black pepper
¼ teaspoon paprika
¼ cup mayonnaise

Bake pie crust at 350 degrees until lightly browned; cool.

Combine basil, green onion and parsley; set aside.

Spread mayonnaise on cooled crust. Layer with half of tomato slices and another layer of mayonnaise. Sprinkle with half of herb mixture and ½ cup Cheddar cheese. Add a second layer of tomato slices and sprinkle with black pepper, paprika and remaining herb mixture.

Mix remaining 1 cup cheese with ¼ cup mayonnaise and spread on top. Bake at 400 degrees for 5 minutes. Reduce to 350 degrees and bake 20 to 30 minutes longer.

Yield: 6 to 8 servings

Marinated Tomatoes

8 tomatoes, cut into 1-inch cubes
2 (14-ounce) cans artichoke hearts, drained and
 quartered (optional)
⅓ cup chopped fresh chives
⅓ cup minced parsley

¾ cup canola oil
⅓ cup tarragon vinegar
¾ teaspoon thyme leaves
1¼ teaspoons salt
¼ teaspoon black pepper

Combine tomato, artichoke, chives and parsley in a large zip-top plastic bag. Whisk together oil, vinegar, thyme, salt and pepper in a bowl and pour over vegetables. Marinate in refrigerator 12 hours or overnight.

Yield: 5 to 6 servings

A favorite summer supper. Add boiled shrimp to recipe and serve with your best toasted pimento cheese sandwich.

Green Tomato Casserole

2½	pounds green tomatoes, peeled and sliced	1	tablespoon chopped fresh thyme
1	scant teaspoon sugar	1	tablespoon chopped fresh basil
1	scant teaspoon salt		bread crumbs for topping
½	teaspoon black pepper		butter for topping

Layer tomato slices in a greased casserole dish, sprinkling each layer with sugar, salt, pepper, thyme and basil. Top with bread crumbs and dot with butter.

Bake, uncovered, at 350 degrees for 45 to 60 minutes.

Yield: 4 servings

If desired, 3 green onions, sliced, can be sprinkled on the first layer of tomatoes.

Grilled Stuffed Tomatoes

4	large tomatoes or mushrooms	1	pound raw shrimp, peeled, deveined and chopped, or lump crabmeat, picked over
1	(8-ounce) package herb stuffing mix		

Start a charcoal or gas grill and bring to medium heat.

Cut tomatoes in half and scoop out seeds and ribs, leaving a ¼-inch thick shell. If using mushrooms, remove stems from caps.

Prepare stuffing mix according to package instructions. Mix in seafood. Spoon mixture, slightly over-filling, into tomato shells or mushroom caps.

Reduce grill to low heat and allow to smoke. Place stuffed vegetables on a wire cooking screen over low heat. Cook 15 to 20 minutes. Or bake at 350 degrees for same amount of time.

Yield: 8 servings

Tomatoes Rockefeller

2 (10-ounce) packages frozen spinach
1 tablespoon minced onion
1 cloves garlic, crushed
1 stick butter, melted
1 teaspoon MSG
½ cup Parmesan cheese
2 eggs

½ cup dry bread crumbs
¼ teaspoon cayenne pepper
½ teaspoon black pepper
 salt to taste
6 tomatoes
 garlic salt to taste
 Parmesan cheese for topping

Cook frozen spinach long enough to thaw; do not cook until done. Drain well and place in a mixing bowl. Add onion, garlic, butter, MSG, ½ cup Parmesan cheese, eggs, bread crumbs, cayenne pepper, black pepper and salt and mix well.

Halve tomatoes and sprinkle with garlic salt. Place halves, cut-side up, in a greased baking dish. Top each half with spinach mixture.

Bake at 350 degrees for 15 minutes or until heated through. Sprinkle with extra Parmesan cheese.

Yield: 6 servings

Roasted Root Vegetable Purée

2 pounds root vegetables, peeled and quartered, such as carrots, parsnips, turnips, Yukon gold potatoes, sweet potatoes, fennel bulb or celery
¼ cup olive oil

 fresh herbs to taste, such as rosemary, thyme or chives
2 tablespoons butter
¾ cup milk or half-and-half
 salt and pepper to taste

Toss vegetables with olive oil and fresh herbs and spread on a baking sheet. Roast at 400 degrees for 45 minutes or until vegetables are soft and cooked through, stirring several times while roasting to assure even cooking.

Transfer roasted vegetables to a food processor with butter and milk. Purée until smooth. Season with salt and pepper.

Yield: about 4 cups

Ami's Purée Freneuse

(White Turnips)

2 cups milk
1 cup uncooked white rice
½ teaspoon salt
2 tablespoons butter
2-3 large cloves garlic, mashed
¼ teaspoon fresh thyme

3-4 white turnips, peeled and roughly chopped
 salt and pepper to taste
4 tablespoons butter
¼-⅓ cup heavy cream, or as needed for
 consistency

Bring milk to a simmer in a heavy saucepan. Add rice, ½ teaspoon salt, 2 tablespoons butter, garlic and thyme. Cook 10 to 12 minutes or until rice is tender. Stir in turnips, adding more milk if needed. Cover and simmer 10 to 15 minutes or until turnips are tender, stirring occasionally. Liquid should be almost all absorbed.

Transfer mixture to a food processor and purée. Return to saucepan and season with salt and pepper. Stir in 4 tablespoons butter and cream.

Yield: 4 to 6 servings

Shredded Zucchini

3 large zucchini, shredded
½ teaspoon salt
3 tablespoons olive oil
1 red onion, finely chopped

4-6 large cloves garlic, thinly sliced
½ cup coarsely chopped fresh basil
 salt and pepper to taste

Combine zucchini and salt and let stand in a colander for 1 hour.

Heat olive oil in a skillet. Add onion and garlic and sauté until soft and translucent. Stir in basil and zucchini and sauté 2 to 3 minutes, stirring constantly until all is coated with oil. Season with salt and pepper and serve immediately.

Yield: 4 servings

CRANAPPLE CRUNCH

2	cups cranberries	1½	cups regular oatmeal
3	cups chopped tart apple	½	cup chopped pecans
1½	cups granulated sugar	1	stick butter
½	cup light brown sugar		

Combine cranberries, apple, both sugars, oatmeal and pecans. Transfer to a baking dish and top with slices of butter. Bake at 300 degrees for 1 hour.

Yield: 10 to 12 servings

SAUTÉED SPECIAL APPLES

| 1 | stick butter | ½ | cup brown sugar |
| 6 | Granny Smith apples, cored, peeled and cut into ¼-inch slices | ⅔ | cup Calvados or applejack brandy |

Melt butter in a skillet. Add apple slices and sauté, turning, until lightly browned. Remove apples from skillet with a slotted spoon, reserving drippings in skillet.

Add sugar to skillet and stir until dissolved. Add brandy and simmer 3 to 5 minutes, stirring constantly. Return apples to skillet and simmer until heated through.

Yield: 6 to 8 servings

A good side dish for pork, beef or chicken.

Brown Sugar Broiled Fresh Fruit

2	large bananas, sliced ⅜-inch thick	1	cup brown sugar
2	tablespoons lemon juice	6	tablespoons butter, melted
1	cup halved or sliced strawberries	¾	cup slivered almonds
2	oranges, peeled and cut into bite-size pieces		

Toss banana slices with lemon juice and arrange in a 7x11-inch baking dish. Cover with strawberry slices, then oranges.

Mix brown sugar, butter and almonds and sprinkle over fruit. Broil 6 inches from the heat source until sugar melts and almonds are slightly toasted; be careful not to burn. Serve at brunch or lunch, or as an ice cream topping for dessert.

Yield: 6 servings

In a pinch, Mandarin oranges can be substituted for the fresh oranges.

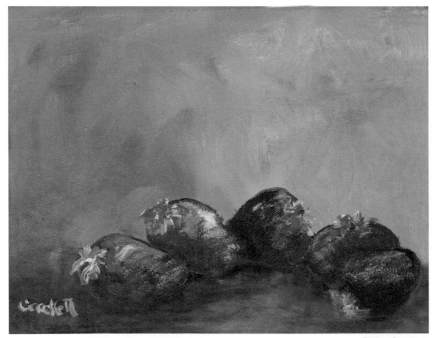

Cathy Crockett

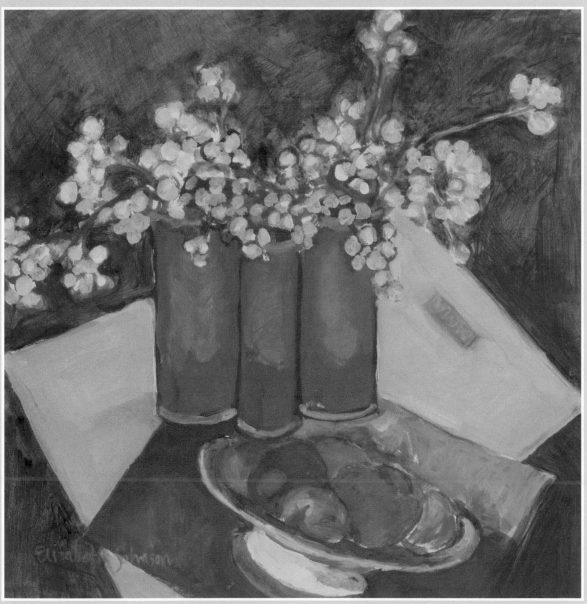

Elizabeth Johnson

"With coarse rice to eat, with water to drink, and my bended arm for a pillow – I have still joy in the midst of these things."

~Confucius

For better or worse, few of us live as simple a life as Confucius did, but we do understand the comfort he enjoyed from simple rice. Rice and pasta are the comfort foods we rely on to feed the hungry—whether our families or the homeless. The texture is satisfying, the sauces that enhance them are tasty, and they feed so many!

Take the recipe called My Mama's Lasagna. The parishioner who submitted it gives this dish credit for bringing up happy memories of "Mama" who prepared it every Christmas Eve. "We would go to the 5 o'clock family service at St. Andrew's and come home to this most wonderful smell and lots and lots of family for Christmas Eve." The comfort such memories evoke is indescribable. Such are the gifts of pasta and rice.

The following pages contain memorable recipes for these staples. Many food writers say that Americans' favorite dish is macaroni and cheese. But relatively few have tasted gourmet Fancy Mac and Cheese, with all its enhancements. Then there are so many others: Seafood Pasta, Chicken and Spaghetti, Linguine with Veal, Capers and Tomatoes, and Vegetable Pastas featuring asparagus and spinach. You will want to try them all.

That southern staple, Red Beans and Rice, heads up the pages on rice, that nutritious and filling wonder food, the food that holds off starvation for thousands around the world.

Pasta, Rice and Grains

Chicken Spaghetti Sauce

1 whole chicken, cooked, or
 4 large chicken breasts
2 tablespoons olive oil
1½ cups chopped onion
½ cup chopped bell pepper
2 stalks celery, chopped
1 tablespoon minced garlic
8 ounces fresh mushrooms, sliced
2 teaspoons dried marjoram
2 teaspoons dried basil
2 teaspoons dried fennel
1 tablespoon dried oregano

2 bay leaves
2 cubes chicken bouillon
1 tablespoon sugar
2 teaspoons Worcestershire sauce
2½ cups canned tomatoes
1 cup tomato paste
1¼ cups tomato sauce
 salt and pepper to taste
 pasta of choice
 freshly grated Parmesan cheese and parsley for
 garnish

Debone chicken, placing bones in a stock pot with water to make stock for cooking pasta. Set meat aside.

Heat olive oil in a skillet. Add onion, bell pepper, celery and garlic and cook about 5 minutes over medium heat. Add mushrooms and cook 5 minutes. Add chicken, marjoram, basil, fennel, oregano, bay leaves, bouillon, sugar, Worcestershire sauce, tomatoes, tomato paste and tomato sauce. Simmer slowly for 45 minutes. Season with salt and pepper.

Meanwhile, cook chicken bones in water to make a stock. Remove bones from stock. Add pasta to stock and boil 8 to 10 minutes or until al dente; drain. Serve chicken sauce with pasta, garnished with Parmesan cheese and parsley. Sauce freezes well.

Yield: 8 to 10 servings

Fancy Mac and Cheese

1	pound pasta, such as penne, shells or ziti	1	(3-ounce) package cream cheese
2-3	shallots, chopped	½	cup grated Asiago cheese
½-1	tablespoon butter	1	cup sour cream
6	tablespoons butter	½	cup sun-dried tomatoes, chopped
⅓	cup flour		juice of 1 lemon
3	cups milk		salt and pepper to taste
⅓	(8-ounce) jar roasted peppers, finely chopped or puréed	2	teaspoons dried marjoram
		1	(16-ounce) bag fresh baby spinach

Cook pasta in boiling water until al dente. Drain and set aside. Sauté shallots in ½-1 tablespoon butter; set aside.

Melt 6 tablespoons butter in a saucepan. Blend in flour, then milk. Cook and stir until thickened. Add sautéed shallots, roasted peppers, cream cheese, Asiago cheese, sour cream, tomatoes, lemon juice, salt and pepper and marjoram.

Place spinach in a large bowl. Pour hot cream sauce over top and stir until spinach is wilted. Add pasta and stir well. Transfer mixture to a lightly greased 9x13-inch baking dish.

Bake, uncovered, at 350 degrees for 45 minutes. Remove from oven and let stand 10 minutes before serving.

Yield: 8 to 10 servings

To serve as an entrée, add chicken or shrimp.

Favorite Chicken Spaghetti

1	stick butter	1	(16-ounce) can English peas (optional)
3	bell peppers, chopped	1	(28-ounce) can whole tomatoes, undrained
3	onions, chopped	1	(6-ounce) can tomato paste
1	cup chopped celery	1	(8-ounce) can tomato sauce
2	cloves garlic, minced	2	tablespoons Worcestershire sauce
2	cups fat free chicken broth, or more as needed	2	tablespoons white wine
8	chicken breasts, cut into pieces		salt and pepper to taste
8	ounces fresh mushrooms, sliced	1	pound dry vermicelli pasta
1	(8-ounce) can water chestnuts, chopped	8	ounces shredded sharp Cheddar cheese

Melt butter in a large stock pot. Add bell pepper, onion, celery and garlic and cook gently until tender. Stir in 2 cups broth. Add chicken, mushrooms, water chestnuts, peas, tomatoes with juice, tomato paste, tomato sauce, Worcestershire sauce, wine and salt and pepper.

Cook pasta according to package directions; drain. Add drained pasta to sauce. Add more broth if mixture is too dry. Stir in cheese. Be careful to not let mixture get too dry.

Yield: 7 to 8 quarts

Recipe is easily halved and freezes well.

Four Cheese Pasta and Beef

6	ounces penne pasta		1	cup sliced green onion
¾	pound ground chuck		1	(3-ounce) package cream cheese
	salt and pepper to taste		½	cup shredded Swiss cheese
1	(14-ounce) can stewed tomatoes, pasta- or Italian-style		½	cup shredded Parmesan cheese
			½	cup shredded sharp Cheddar cheese

Cook pasta until al dente; drain and set aside.

Brown ground chuck, stirring to break up clumps. Drain off fat and season with salt and pepper. Add tomatoes to beef and cook, uncovered, until slightly thickened. Stir in onion and cream cheese.

Toss in drained pasta and shredded cheeses. Cover 2 minutes to melt cheese.

Yield: 4 to 6 servings

Lemon-Scented Marinara Sauce with Capers

2	cups canned crushed tomatoes		2	tablespoons flour
1	clove garlic, minced			juice of 1 lemon
2	tablespoons capers, drained			salt and pepper to taste
	zest of 1 lemon			lemon zest for garnish
¼	cup olive oil			

Cook tomatoes, garlic, capers and lemon zest over medium heat for 15 minutes.

Meanwhile, in a small saucepan, blend olive oil with flour and cook until bubbling. Add flour mixture to tomato sauce and simmer, uncovered, for 15 minutes. Sauce will reduce. Run sauce through a food mill. Stir in lemon juice. And season with salt and pepper.

Serve sauce hot or cold over cooked pasta, garnished with lemon zest.

Pasta, Rice and Grains

FUNERAL LASAGNA

6-8	dry lasagna noodles	¾	teaspoon garlic powder
1-1½	pounds ground beef	2	teaspoons dried oregano
1	onion, chopped	½	teaspoon black pepper
8	ounces fresh mushrooms, sliced	½	teaspoon paprika
1	(15-ounce) can tomato sauce	2	teaspoons dried rosemary
2	bay leaves	1	(24-ounce) carton cottage cheese
1	teaspoon dried parsley	1½	cups Parmesan cheese
¾	teaspoon dried Italian seasoning	1	pound mozzarella cheese, sliced
¾	teaspoon celery salt		

Cook lasagna noodles in boiling water for 15 minutes; rinse and drain.

Meanwhile, brown beef with onion in a 10-inch skillet. Add mushrooms and sauté briefly. Add tomato sauce, bay leaves, parsley, Italian seasoning, celery salt, garlic powder, oregano, pepper, paprika and rosemary.

In a 2-quart oblong glass baking dish, layer noodles, meat sauce, cottage cheese and Parmesan cheese, repeating layers once and ending with an extra layer of noodles on top. Top with mozzarella cheese.

Bake at 350 degrees for 30 minutes.

Yield: 6 to 8 servings

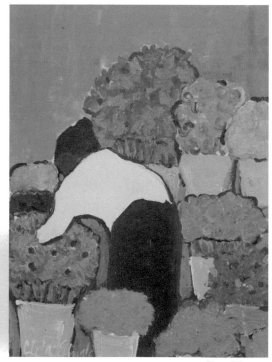

When my children were small and would see these ingredients in the kitchen, they immediately asked, "Who died?" It was our constant and omnipresent "Funeral Dish".

Cleta Ellington

Gourmet Chicken Spaghetti

3	pounds chicken		1	cup Parmesan cheese
8	ounces dry spaghetti, broken into thirds		2	tablespoons lemon juice
4	tablespoons butter		⅓	cup white wine
¼	cup flour		½	teaspoon cayenne pepper
1	cup cream		1	teaspoon dry mustard
1	cup chicken broth		1	teaspoon salt
1	cup mayonnaise			paprika and Parmesan cheese for topping
1	cup sour cream			

Cook chicken in boiling water in a stockpot. Remove chicken and debone, reserving stock in pot. Bring stock to a boil. Add spaghetti to pot and cook until al dente; drain.

Melt butter in a skillet. Blend in flour and cook until bubbly. Add cream and 1 cup chicken broth. Cook and stir until thickened. Stir in chicken, drained pasta, mayonnaise, sour cream, 1 cup Parmesan cheese, lemon juice, wine, cayenne pepper, mustard and salt. Mix well and transfer to a 3-quart casserole dish. Sprinkle with paprika and extra Parmesan cheese.

Bake at 350 degrees for 30 to 40 minutes.

Yield: 8 servings

May be made ahead and frozen.

For variety, ½ teaspoon garlic powder can be added with the other seasonings, and ½ cup sliced mushrooms, sautéed in 4 tablespoons butter can be added with the chicken.

Lacey's Shrimp Fettuccine

5 green onions, chopped
2 cups sliced mushrooms
2 cloves garlic, minced
2 tablespoons olive oil
4 tablespoons butter
1 pound peeled raw shrimp
2 teaspoons salt

8 ounces medium flat noodles
4 tablespoons butter
¾ cup Romano cheese
¾ cup Parmesan cheese
1 cup heavy cream
4 tablespoons chopped fresh parsley

Sauté green onion, mushrooms and garlic in olive oil and 4 tablespoons butter in a large skillet over medium heat until mushrooms are softened. Add shrimp and sauté until pink. If mixture is too watery, pour off some liquid. Season with salt, cover and keep warm.

Cook noodles in boiling salted water in a saucepan until tender. Drain noodles in a colander. While draining, melt 4 tablespoons butter to saucepan, then add drained noodles back into pan with butter. Add both cheeses and cream and mix well. Add shrimp mixture and toss to combine. Sprinkle with parsley and serve.

Yield: 4 to 6 servings

Freezes well, but canned mushrooms freeze better than fresh.

LINGUINE WITH VEAL, CAPERS AND TOMATOES

1	tablespoon olive oil	2	tablespoons chopped capers
1	pound veal scaloppini, cut into strips	3	sprigs basil, chopped chiffonade
¼	teaspoon salt	¼	teaspoon salt
	freshly ground black pepper to taste	8	ounces dry linguine pasta
3	shallots, minced		freshly grated Parmesan cheese and whole basil leaves for garnish
2	cloves garlic, minced		
1	(28-ounce) can crushed tomatoes		

Heat oil in a large skillet over medium heat. Add veal and sprinkle with ¼ teaspoon salt and pepper to taste. Cook 2 minutes on one side or until just lightly browned. Remove veal to a platter; set aside.

Add shallots and garlic to same skillet and cook and stir over medium heat for 3 minutes or until softened. Add tomatoes, capers, chopped basil and ¼ teaspoon salt and pepper to taste. Bring to a boil. Reduce heat to medium-low and cook 10 minutes or until flavors come together.

Meanwhile, cook pasta according to package directions in a large pot of boiling water; drain, but do not rinse.

Add veal strips to sauce and heat 1 minute. Divide drained pasta among individual serving bowls. Top with veal and sauce. Sprinkle with Parmesan cheese and garnish with whole basil leaves.

Yield: 4 servings

Lasagna with Beef, Lamb and Italian Sausage

¼	cup olive oil	1	tablespoon chopped fresh parsley
1	medium onion, finely chopped	1	tablespoon chopped fresh basil
1	small carrot, finely chopped	1	teaspoon dried oregano
2	stalks celery, finely chopped	2	bay leaves, bruised
1	pound ground beef, or combination of beef or lamb and Italian sausage		salt and freshly ground black pepper
1	(8-ounce) can whole Italian tomatoes, undrained and finely chopped	8	ounces fresh or dried lasagna noodles
2	cloves garlic, minced	1	pound ricotta cheese
1	cup whole milk	1	pound mozzarella cheese, coarsely shredded
½	cup dry red or white wine	4	ounces Parmesan cheese, coarsely grated
			chopped fresh parsley for garnish

Heat olive oil in a skillet. Add onion, carrot and celery and cook until tender; remove vegetables with a slotted spoon. Add ground beef to drippings in skillet and cook until browned; drain excess fat. Add cooked vegetables back to skillet along with tomatoes, garlic, milk, wine, parsley, basil, oregano and bay leaves. Simmer 1 hour. Season with salt and pepper.

In a large pot, bring 3 quarts salted water to a boil. Add noodles and cook, uncovered, until tender; drain.

Layer one-third of noodles in a well-greased 3-quart casserole dish. Spread one-third of meat sauce over noodles and top with one-third of ricotta cheese and one-third of mozzarella cheese. Repeat layers twice. Sprinkle Parmesan cheese on top and garnish with fresh parsley.

Refrigerate overnight, if time permits, or freeze. When ready to bake, bring lasagna to room temperature. Bake at 325 to 350 degrees for 40 minutes or until hot and bubbly.

Yield: 6 to 8 servings

My Mama's Lasagna

2	pounds ground beef	2	bay leaves	
2	(6-ounce) cans tomato paste		salt and pepper to taste	
4	(14½-ounce) cans stewed tomatoes		garlic to taste	
½	cup water	1	package dry lasagna noodles	
¼	cup chopped fresh parsley	1	pound American cheese, sliced or shredded	
1	tablespoon sugar	1	pound Swiss cheese, sliced or shredded	
1	tablespoon chopped fresh basil	1	pound Parmesan cheese, grated	
1	cup chopped onion			

Brown beef in a skillet. Add tomato paste, stewed tomatoes, water, parsley, sugar, basil, onion, bay leaves, salt and pepper and garlic. Simmer over low heat for at least 3 hours, stirring occasionally.

Noodles can be cooked according to package directions, but it is not necessary. Dry noodles will cook as the lasagna bakes.

Spread a small amount of sauce in a lasagna pan. Layer half of noodles over sauce. Spread half of remaining sauce over noodles. Top with a layer of half of each cheese. Repeat layers, ending with cheeses.

Bake, loosely covered with foil, at 350 degrees for 30 to 45 minutes. Remove foil during final few minutes of cooking.

Yield: 8 to 10 servings

You may add mushrooms, celery or flavorings of your choice to the sauce before simmering.

Walker's White Lasagna

1 pound ground veal or sirloin	4 cups Béchamel Sauce (recipe below)
1 pound sweet or hot Italian sausage, casings removed	1 pound dry lasagna noodles, cooked and drained
salt and pepper to taste	1 pound fresh spinach, or 2 (10-ounce) packages frozen, cooked
1 pound ricotta cheese	1 pound mozzarella cheese, shredded
1 egg	2 cups freshly grated Parmesan cheese
2 tablespoons chopped fresh parsley	

Sauté ground veal and sausage in a skillet until browned, stirring to break up lumps. Drain off fat and season with salt and pepper.

In a mixing bowl, beat together ricotta cheese, egg and parsley.

To assemble, spread 1 cup Béchamel Sauce in a greased 9x13-inch deep casserole dish or pan. Layer as follows: one-third the noodles, half each of the meat mixture, spinach, ricotta mixture and mozzarella, one-third of the Parmesan and one-third of the remaining sauce. Repeat layers once. Top with a final layer of remaining noodles and sauce.

Bake at 350 degrees for 1 hour. Sprinkle with remaining Parmesan cheese and bake 15 to 30 minutes longer or until bubbly.

Yield: 8 to 10 servings

Be sure to use a deep dish as this overfills a 9x13x2-inch pan. Lasagna can be frozen, preferably before cooking.

BÉCHAMEL SAUCE

1 stick butter	½ teaspoon white pepper
¾ cup flour	¼ teaspoon nutmeg, or more to taste
4 cups milk, heated	½ teaspoon Tabasco sauce
½ teaspoon salt	

Melt butter in a saucepan. Blend in flour and cook and stir 2 minutes so mixture is frothy but does not brown. Remove from heat. Rapidly whisk in milk until well blended. Return to medium heat and stir while bringing to a boil. Cook and stir 1 minute. Remove from heat and add salt, pepper, nutmeg and Tabasco.

Sauce can be made ahead and refrigerated until ready to use. Cover with plastic wrap touching the sauce to prevent a skin from forming on the surface.

Vegetable Lasagna

VEGETABLE SAUCE

½ cup olive oil
1 carrot, finely chopped
1 stalk celery, finely chopped
1 medium onion, finely chopped
2 small zucchini, thinly sliced

8 ounces fresh mushrooms, sliced
1 (8½-ounce) can LeSeuer peas, drained
¼ cup chicken broth
¼ cup heavy cream

PESTO SAUCE

1 cup olive oil
3 cloves garlic
3 cups fresh spinach leaves
½ cup chopped pecans
6 fresh basil leaves

2 teaspoons pine nuts
4 ounces Parmesan cheese, grated
8 ounces ricotta cheese
 salt and pepper to taste

BALSAMELLA SAUCE

1 stick butter
½ cup unbleached flour
2½ cups milk
1 teaspoon salt

1 (8-ounce) package lasagna noodles, prepared according to package directions, or homemade

Heat olive oil in a skillet. Add carrot, celery, onion, zucchini and mushrooms and sauté until tender. Stir in peas, broth and cream and simmer until slightly thickened.

Combine all pesto ingredients in a food processor and purée; do not overblend.

For balsamella sauce, melt butter in a saucepan. Blend in flour and cook and stir 1 minute. Whisk in milk and salt until smooth. Bring to a boil. Cook and stir 2 minutes.

To assemble, alternate layers of pasta and sauces, beginning and ending with a pasta layer, in a greased 9x13-inch casserole dish. Refrigerate overnight, or freeze. When ready to bake, bring to room temperature.

Bake at 350 degrees for about 40 minutes.

Pasta, Rice and Grains

Pasta Umbria

8 ounces dry pasta of choice, angel hair works well	1 (8-ounce) jar marinated artichoke hearts, drained
6 cups salted water	2 cloves garlic, minced
2 pounds medium to large shrimp, peeled and deveined	1 tablespoon lemon zest
salt and pepper to taste	¼ cup chopped fresh Italian parsley
½ cup olive oil, divided	Romano or Parmesan cheese and fresh parsley for garnish
½ cup pine nuts, toasted, reserving 1 tablespoon for garnish	

Cook pasta in boiling salted water until al dente.

Meanwhile, sprinkle shrimp with a little salt and pepper and toss with 2 teaspoons olive oil. Heat 2 tablespoons olive oil in an iron skillet over medium heat. Add shrimp and sauté 2 minutes on each side or until pink. Transfer to a small platter; reserving skillet.

When pasta is cooked al dente, drain well. While draining, heat remaining olive oil in same skillet. Add ½ cup pine nuts, artichoke hearts, garlic, lemon zest, parsley and cooked shrimp. Cook and stir until heated. Place drained pasta in a medium bowl. Pour shrimp mixture over pasta and toss. Sprinkle with reserved pine nuts, parsley and grated cheese.

Yield: 6 servings

If you have all ingredients ready beforehand, this is actually a very quick dish to prepare. Add salad and bread and you have a good supper dish for company.

Seafood Pasta

2½ sticks butter
2 teaspoons salt
1 teaspoon dried basil
½ cup chopped fresh parsley
2 tablespoons Worcestershire sauce
1 teaspoon dried thyme
½ teaspoon garlic powder
1 tablespoon black pepper

2 tablespoons lemon juice
2½ pounds raw peeled shrimp or 2 pounds crawfish tails
8 ounces fresh mushrooms, sliced and sautéed in butter
12 ounces dry angel hair pasta
8 ounces processed American cheese loaf, shredded

Melt butter in a skillet. Stir in salt, basil, parsley, Worcestershire sauce, thyme, garlic powder, pepper and lemon juice. Add shrimp and cook 5 to 10 minutes or until pink. Stir in mushrooms.

Meanwhile, cook pasta until al dente. Drain and return to pan. Add shredded cheese to hot pasta and stir until melted. Mix shrimp mixture into pasta and pour into a 3-quart casserole dish.

Bake at 350 degrees for 20 to 30 minutes or until bubbly. Or, cover with plastic wrap and microwave until heated.

Yield: 15 servings

Joe Howorth

Shrimp and Asparagus Pasta

2	tablespoons olive oil	2	cups chicken broth
2	tablespoons butter	1	pound dry fettuccine pasta
1	pound asparagus, cut into 1½-inch pieces	⅓	cup Parmesan cheese
1	yellow bell pepper, diced	¾	cup peeled and cooked shrimp
1	red bell pepper, diced		salt and pepper to taste
2	teaspoons minced garlic	⅓	cup Parmesan cheese
1	bunch green onions, chopped		

Heat olive oil and butter in a large skillet. Add asparagus and cook until lightly browned. Stir in bell peppers, garlic and green onion and cook about 1 minute. Add broth and bring to a boil. Reduce heat and add pasta. Simmer 10 minutes.

Stir in ⅓ cup cheese and shrimp. Season with salt and pepper and cook until shrimp are hot. Sprinkle with ⅓ cup Parmesan cheese and serve.

Yield: 4 to 6 servings

Spinach Pasta with Scallops and Parsley Sauce

10-12 ounces spinach pasta, fresh if available
4 tablespoons butter
½ cup minced fresh parsley
1 shallot, minced
½ cup dry white wine
1 pound sea scallops
1 cup half-and-half
½ cup heavy cream
 salt and freshly ground white pepper to taste
 cayenne pepper to taste
1 cup freshly grated Parmesan cheese
½ cup chopped fresh parsley
 Parmesan cheese and parsley for garnish

Cook pasta in a large pot of boiling water; drain.

Meanwhile, heat butter in a skillet. Add parsley and shallot and sauté. Add wine and cook until reduced to about 8 tablespoons. Cut scallops into slightly less than ½-inch thick slices. Add scallop slices to wine reduction and cook 1 minute. Add half-and-half and heavy cream and season with salt and white and cayenne peppers. Simmer 2 minutes, adjusting seasonings to taste. Remove from heat and add 1 cup Parmesan cheese and parsley.

Serve sauce over drained pasta. Garnish with extra parsley and Parmesan cheese.

Yield: 4 servings

Virginia Shirley

Pasta, Rice and Grains

TALLARENE

2 pounds ground chuck
 salt and pepper to taste
2 onions, chopped
1 red bell pepper, chopped
2 cloves garlic, chopped
 sliced fresh mushrooms
1 (28-ounce) can diced tomatoes

1 tablespoon chili powder
2 tablespoons Worcestershire sauce
1 (11-ounce) can Niblets corn
1 (2¼-ounce) can sliced ripe olives
2 cups sharp Cheddar cheese, shredded
8 ounces dry medium noodles, cooked and drained

Season ground chuck with salt and pepper and cook in a skillet until browned, stirring to break up. Transfer to a Dutch oven. Add onion, bell pepper, garlic and mushrooms to skillet and sauté 3 to 4 minutes; add mixture to cooked meat.

Add tomatoes, chili powder and Worcestershire sauce to Dutch oven. Simmer about 20 to 25 minutes. Add corn and olives and adjust seasoning as needed. Cool.

When cooled, add cheese and pasta to meat mixture and transfer to a 9-inch square baking pan. Bake at 350 degrees until hot.

Yield: 4 servings

Red Beans and Rice

1	pound dry red beans, small dark red beans preferred	1½	cups chopped celery
2	quarts water	⅔	cup chopped green bell pepper
1	ham bone	½	teaspoon dried thyme
2	pounds smoked andouille or Country Pleasin' pork sausage, cut into 1-inch pieces	1	bay leaf
3	cloves garlic, crushed	1	teaspoon Worcestershire sauce
1½	cups chopped yellow onion	¼-½	teaspoon Tabasco sauce
¾	cup chopped green onion	1	teaspoon minced fresh parsley
		3	cups steamed rice

Rinse beans well and drain in a colander. Place beans in a large heavy pot with a lid and add 2 quarts water and ham bone. Bring to a boil. Reduce heat and simmer 40 minutes.

Brown sausage in a skillet and drain off fat. Add sausage to cooked beans. Cover and cook over low heat for 1 hour, stirring occasionally.

Add garlic, all onions, celery, bell pepper, thyme and bay leaf. Continue cooking, covered, over low heat for 1½ hours or until beans are soft.

Stir in Worcestershire sauce, Tabasco sauce and parsley. Simmer over low heat for 5 minutes. For creamier beans, remove a few and mash, then return to pot. Remove bay leaves. Serve over fluffy rice with a green salad and French bread.

Yield: 4 servings

TO COOK SAUSAGE FOR RED BEANS AND RICE

Any kind of sausage is fine. In Louisiana, the traditional sausages are andouille, Italian and smoked, either hot or mild. Any kind of ham, especially tasso (spicy, smoked and boneless pork) or cochon du lait (suckling pig), is also perfect. Boudin, another traditional Louisiana sausage, is made with rice, so it is not usually used. Kielbasa is a great Polish sausage. Why not! Venison, turkey, you name it. Use one or any combination.

Some cooks cook the sausages in the red beans, but it adds grease to the dish. Try this: put the sausages in a pan and pour water over them. Boil away the water to remove some of the fat and then brown the sausages. Add some sliced onion and a bottle of beer. Cook until the beer reduces and is syrupy and the onion begins to caramelize.

Pasta, Rice and Grains

Kicked-Up Rice

2 tablespoons or more unsalted butter or
extra virgin olive oil
1 medium onion, chopped
½ bunch green onions, chopped

1½ cups uncooked long-grain rice
1 cup dry white vermouth
2 cups chicken broth

Heat butter over medium heat in a heavy saucepan. Add all onions and sauté. Stir in rice and continue to sauté until rice turns milky. Add vermouth and cook and stir a few seconds or until liquid is absorbed. Add broth and cook, covered, for 20 minutes or until liquid is absorbed. Remove from heat and let stand, covered, for several minutes. Fluff with a fork when done, but it is best not to stir rice or uncover while rice is cooking.

Yield: 6 servings

Great with red beans and rice. Recipe doubles easily.

Lentil Casserole

2 ounces Swiss cheese, shredded
2½ cups chicken broth
½ cup white wine
¾ cup chopped onions
½ cup brown rice
¾ cup dry lentils

¼ teaspoon dried basil
¼ teaspoon dried oregano
¼ teaspoon dried thyme
¼ teaspoon garlic powder
¼ teaspoon lemon pepper
2 ounces Swiss cheese, sliced

Combine all ingredients except sliced cheese and place in a Dutch oven. Bake, covered, at 325 degrees for 1½ to 2 hours, stirring twice.

Arrange cheese slices in a ring on top of lentil mixture. Bake until cheese melts.

Yield: 4 servings

Very easy and very healthful.

St. Peter's (Oxford) Chicken Casserole

1	(16-ounce) can seasoned French-style green beans, drained	1	cup mayonnaise
1	(6-ounce) package wild herb rice, prepared according to package	2	teaspoons lemon juice
		½	cup sherry
1	(8-ounce) can sliced water chestnuts	1	tablespoon Worcestershire sauce
2	cups chopped cooked chicken	1	teaspoon onion salt
1	(10¾-ounce) can cream of celery soup		slivered almonds
1	(2-ounce) jar diced pimentos	½-¾	cup crushed herb stuffing mix

Layer beans, cooked rice, water chestnuts and chicken in a 9x13-inch casserole dish.

In a bowl, mix soup, pimentos, mayonnaise, lemon juice, sherry, Worcestershire sauce and onion salt. Pour mixture over casserole layers. Top with slivered almonds and crushed stuffing crumbs.

Bake at 350 degrees for 45 minutes or until bubbly and browned on top.

Yield: 8 servings

Pasta, Rice and Grains

Oriental Rice Pilaf

RICE PILAF

8 ounces wild rice, prepared according to
 package directions and rinsed
8 ounces white rice, prepared according to
 package directions and rinsed
1 bunch green onions, chopped
6 ounces cashews, chopped
1 cup chopped fresh parsley

1 (7-ounce) can mushroom pieces, drained
1 (5-ounce) can ripe olives, sliced
1 red bell pepper, chopped
1 green bell pepper, chopped
1 (2-ounce) jar sliced pimento
1 cup chopped celery

DRESSING

12 ounces olive oil
½ cup soy sauce
¼ cup lemon juice

1 tablespoon minced garlic
2 tablespoons minced fresh ginger
 salt and pepper to taste

Combine all rice pilaf ingredients.

In a food processor, combine all dressing ingredients and process.

Just before serving, add dressing to pilaf and mix. Serve immediately.

Yield: 8 servings

Roz Roy

Paella

¾ pound smoked sausage
 extra virgin olive oil
2 pounds chicken thighs
 salt and freshly ground black pepper
I small onion, chopped
3 cloves garlic, minced
1-3 yellow, red or green bell peppers, cut into strips
¾ cup fresh green peas or chopped asparagus

2-3 large tomatoes, peeled and chopped
¼ teaspoon pulverized saffron
6 cups chicken broth, heated
3 cups uncooked short-grain rice
2 pounds raw large shrimp, peeled and deveined
I pint raw oysters, drained
I pound Louisiana crawfish, cooked and peeled
 parsley and lemon for garnish

Pierce sausage and place in a 17-inch paella pan. Cover with cold water and bring to a boil. Reduce heat and simmer 5 minutes. Drain and slice; set aside.

Heat olive oil in paella pan. Pat dry chicken and season with salt and pepper. Brown chicken well on all sides in olive oil. Transfer chicken to a plate. Brown sausage slices in pan drippings; remove sausage and drain, leaving drippings in pan.

Add ¼ cup olive oil to pan drippings and heat. Add onion, garlic, pepper strips, peas and tomato and cook briskly, stirring constantly, until most of liquid in pan is evaporated.

Dissolve saffron in heated chicken broth. Add rice to vegetables in pan. Stir in chicken broth, I cup at a time; cook and stir until liquid is absorbed before adding more. After adding last cup of broth, bring to a boil, then remove from heat and adjust seasoning as needed.

Arrange chicken, sausage, shrimp, oysters and crawfish on top of rice. Bake at 400 degrees in the bottom of the oven for 20 to 30 minutes or until all liquid is absorbed by the rice and grains are tender but not soft. At no point should the paella be stirred after it goes in the oven.

When paella is done, remove from oven and drape a towel loosely over the top. Let rest 5 to 8 minutes. Garnish with parsley and lemon wedges.

Yield: 6 to 8 servings

Serve with Orange and Cucumber Salad (page 116).

Nutty Wild Rice

1½ cups chopped pecans	3½ cups chicken broth
3 cups water	1 cup chopped celery
1 cup uncooked white long-grain rice	¾ cup chopped onion
1 teaspoon salt	1 stick unsalted butter
2 (6-ounce) packages dry wild rice mix	1 cup golden raisins

Spread pecans on a baking sheet. Bake at 325 degrees for 3 to 5 minutes or until toasted.

Bring 3 cups water to a boil in a saucepan. Add white rice and salt and cook, covered, over low heat for 18 minutes. Drain any water remaining in pan.

Prepare rice mix according to package directions, using broth instead of water.

Sauté celery and onion in butter until translucent.

Combine both rice mixtures, sautéed vegetables, toasted pecans and raisins and pour into a greased 9x13-inch casserole dish. Bake 20 to 30 minutes or until thoroughly heated.

Yield: 8 servings

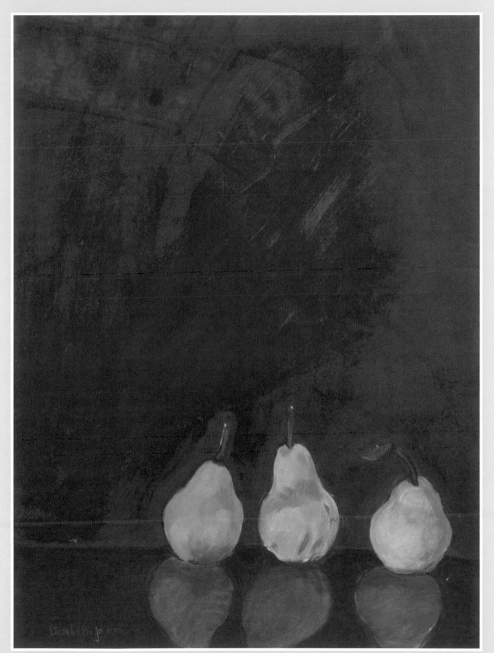

Elizabeth Johnson

"There's no sauce in the world like hunger."

~Cervantes

Imagine a BLT without mayonnaise. Or shrimp without rémoulade.

Imagine beef or pork ribs without barbecue sauce, or chicken without teriyaki.

All are perfectly good foods, but without the sauce? Unthinkable.

M.F.K. Fisher wrote in her *How to Cook a Wolf*, "When we exist without thought or thanksgiving we are not men [or women] but beasts." How can we not be thankful for whoever invented sauces? That person is long lost to our collective memories, but still we can breathe a "thank you" as we spread a tasty pesto over a baked potato or into a bowl of pasta.

Thinking of sauces and marinades brings up the image of Dr. Johnson, that giant of 18th century literature, in his favorite restaurant, The Cheshire Cheese, dipping his bread into the deep brown beef sauce he savored. He's the one who wrote, "A man who is tired of London is tired of life." He also wrote, "He who does not mind his belly will hardly mind anything else."

From Tomato Marmalade to Lime Basil Aïoli to Cranberry Jezebel, you'll find here a treasure chest of fine sauces and marinades to enhance your favorite dishes.

\mathscr{S}AUCES AND \mathscr{M}ARINADES

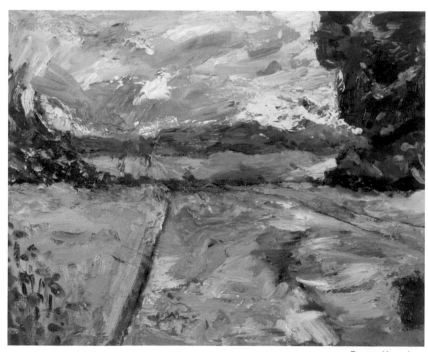

Baxter Knowlton

Mayonnaise

⅓ cup canola oil
1 egg
½ teaspoon salt
¾ teaspoon dry mustard

¼ teaspoon paprika
2 tablespoons fresh lemon juice
⅔ cup canola oil

Combine ⅓ cup oil, egg, salt, mustard, paprika and lemon juice in a food processor fitted with a metal blade. Process 10 seconds.

With motor running, add ⅔ cup canola oil in a slow, steady stream.

Yield: about 1 cup

Lime Basil Aïoli

1 egg
1 tablespoon fresh lime juice
1 teaspoon sea salt
½ teaspoon cayenne pepper

½ clove elephant garlic (optional)
1 cup vegetable oil
6-8 small basil leaves, chopped

Combine egg, lime juice, salt, cayenne pepper and garlic in a food processor. Turn on motor. Add oil in a slow, steady stream.

Add chopped basil and pulse to combine. Adjust seasonings before removing from food processor. Refrigerate.

Yield: 10 ounces

Microwave Hollandaise

4 tablespoons unsalted butter
 juice of 2-3 lemons
2 egg yolks, beaten

2 tablespoons cream
½ teaspoon dry mustard
 dash of Tabasco sauce

Melt butter in a microwave in a 2-cup glass measuring cup. Add lemon juice, egg yolk, cream, mustard and Tabasco. Whisk together. Microwave on high, whisking every 25 seconds, until thickened.

Yield: about 1 cup

Do not double recipe; make 2 batches if needed.

Pascagoula Rémoulade Sauce

1 pint mayonnaise
½ cup Creole mustard
2 tablespoons yellow mustard
1 tablespoon prepared horseradish
1 teaspoon Worcestershire sauce
½ cup finely chopped celery
½ cup finely chopped bell pepper

⅓ cup finely chopped onion
1 clove garlic, finely minced
 juice of ½ lemon
 (may need other half if not very juicy)
 salt to taste
 dash of Tabasco sauce

Combine all ingredients. Adjust seasonings to taste.

This is wonderful over shrimp as a shrimp cocktail, as an appetizer dip for shrimp or over shredded lettuce and topped with grated hard-boiled eggs.

Fresh Basil Pesto

⅓ cup pine nuts	½ cup extra virgin olive oil
2 cups packed fresh basil leaves	½ cup Romano or Parmesan cheese
3 medium cloves garlic, minced	salt and pepper to taste

Pulse pine nuts a few times in a food processor. Add basil and pulse a few more times. Add garlic and pulse a few more times.

With motor running, slowly add olive oil in a steady stream. Scrape down sides of food processor with a rubber spatula. Add cheese and pulse until blended. Season with salt and pepper.

Yield: 1 cup

Serve over pasta or baked potatoes, or spread on toasted baguette slices. Can be prepared ahead and frozen.

Cranberry Jezebel

1 cup water	½ cup pineapple preserves
½ cup granulated sugar	3 tablespoons prepared horseradish
½ cup light brown sugar	1 tablespoon Dijon mustard
1 (16-ounce) bag fresh cranberries	

Combine water and both sugars in a saucepan and bring to a boil. Add cranberries and simmer 10 minutes. Cool. Stir in preserves, horseradish and mustard. Chill.

Yield: 3 cups

This is delicious on fowl or pork. It can also be served over Cheddar cheese on crackers as an appetizer.

Tomato Marmalade

3 medium oranges
2 lemons
6 cinnamon sticks
1½ tablespoons whole cloves

12 cups peeled and chopped unripe fresh tomatoes, drained (about 6 pounds whole tomatoes)
6 cups sugar
1½ teaspoons kosher salt

Thinly slice oranges and lemons. Quarter slices and remove seeds, leaving rinds intact.

Tie cinnamon sticks and cloves in a spice bag or in cheesecloth.

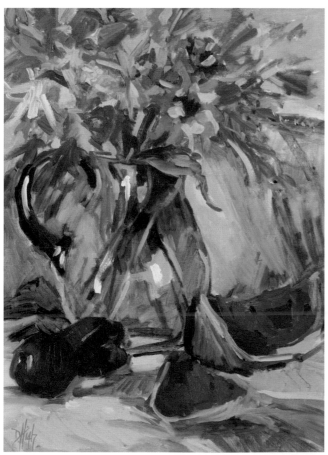

Debbie High

Combine drained tomatoes, sugar and salt in a 6- to 8-quart saucepan and stir well. Add orange and lemon slices and spice bag. Bring to a boil, stirring frequently. Cook (at about 220 degrees) for 45 minutes or until thickened. Cooking time will depend on water content of tomatoes. Because of the lack of pectin, marmalade will not really set and will be a thinner consistency than jelly or jam. Remove from heat and remove spice bag. Skim off foam if needed.

Immediately fill hot, sterilized half-pint jars with marmalade, leaving a ¼-inch headspace. Wipe jar rims with a clean, damp cloth. Place hot lids on jars and secure tightly with bands. Process in a boiling water bath for 5 minutes. Remove and allow to cool.

Yield: 3 to 4 pints

Do not use ripened tomatoes; they are too juicy and will make the marmalade too watery.

Sauces and Marinades

California Marinade

1 cup salad oil
¾ cup soy sauce
½ cup fresh lemon juice
¼ cup Worcestershire sauce

¼ cup yellow mustard
½ teaspoon coarsely cracked black pepper
2 cloves garlic, minced

Combine all ingredients and mix well. This marinade is delicious for meat or seafood and may be stored in the refrigerator.

Mrs. Coon's Teriyaki Marinade

1 generous tablespoon chopped garlic
1½ tablespoons chopped or grated fresh ginger
⅓ cup brown sugar

1 teaspoon sesame oil
1 cup soy sauce
¼ cup pineapple juice

Combine all ingredients. This amount is sufficient to marinate 2 pounds beef, pork or chicken. Marinate at least 6 hours or preferably overnight. Grill, bake, broil or sauté meat as desired.

If a bland soy sauce is used, add ¼ cup wine to the marinade.

Mustard Bar-B-Que Sauce

1 stick butter
1 cup prepared mustard

1 cup vinegar
salt and pepper to taste

Melt butter in a saucepan. Stir in mustard and vinegar and season with salt and pepper. Bring to a boil to blend ingredients. Remove from heat and baste meat with sauce.

Ann's Yankee Barbeque Sauce

2 cups ketchup
2 teaspoons freshly grated ginger
4 tablespoons butter
½ cup Worcestershire sauce

¼ cup lemon juice
2 teaspoons minced garlic
¼ cup honey
2 teaspoons ground coriander

Combine all ingredients in a saucepan. Bring to a boil and stir to blend. This makes enough sauce to cover 8 pounds of pulled pork or 2 racks of spare ribs.

Clear Barbeque Sauce

2 eggs
1 cup vegetable oil
1 cup apple cider vinegar
2 tablespoons salt

1 teaspoon white pepper
1 tablespoon poultry seasoning
12 chicken breasts

Beat eggs in a bowl. Add oil and beat again. Add vinegar, salt, pepper and poultry seasoning and mix well.

Dip chicken in sauce, drain and place on a grill. Turn chicken every 8 minutes or as needed. Baste with sauce each time chicken is turned.

Yield: 12 servings

Cranberry Relish

1 large orange
2 cups fresh cranberries, coarsely chopped
1 cup sugar

2 large apples, unpeeled and chopped
1 (8-ounce) can crushed pineapple, drained
1 cup chopped pecans

Grate orange to obtain zest. Peel orange and chop pulp into ½-inch cubes. Mix orange zest, pulp, chopped cranberries and sugar in a bowl and refrigerate until sugar dissolves.

Add apple, pineapple and pecans to cranberry mixture and mix well. Chill before serving.

Sauce for Salmon

1	tablespoon extra virgin olive oil	2	tablespoons small capers
1	clove garlic, minced	1	teaspoon lemon-pepper seasoning
¼	cup freshly squeezed lemon juice	1	cup sour cream

Heat olive oil over medium heat. Add garlic and cook 1 minute. Stir in lemon juice, capers and lemon-pepper seasoning. Cook 5 minutes. Stir in sour cream. Cook 5 minutes longer. Serve over grilled salmon.

To grill salmon, heat grill until hot. Add 1 tablespoon extra virgin olive oil and 1 pat butter to pan. Brush additional oil on salmon fillet and season as desired. Grill salmon about 2 to 3 minutes on each side, turning salmon only once. Serve immediately.

Bread and Butter Squash Pickles

8	cups thinly sliced yellow squash	4	green bell peppers, thinly sliced
2	cups thinly sliced white or yellow onion	2	teaspoons mustard seed
½	cup salt	2	teaspoons celery seed
2	cups apple cider vinegar	3	cups sugar

Combine squash and onion and sprinkle with salt. Set aside 1 hour. Drain and rinse.

Mix vinegar, bell pepper, mustard seed, celery seed and sugar in a saucepan and bring to a hard boil. Add squash and onion and return to a hard boil. Pour mixture into hot sterilized jars. Seal well.

Yield: about 4 pints

This is time consuming, but worth it, especially if you double and give away as gifts.

Lucy Mazzaferro

Hosford Fontaine

The guest will be "lifted, willy-nilly, to heavenly levels, for never was there a dessert more delicate, more fragrant, more sophisticated and naïve" than Diplomate au Kirsch.

~M.F.K. Fisher

"Dessert everyone?" the host asks his guests. "Oh, I couldn't, I know I shouldn't, but, well, just a tiny serving please." We can't resist them. We can't resist them because they are the perfectly satisfying end to a superb meal, or to enjoy with tea, or to sneak for an afternoon snack.

Among the irresistible recipes in this section, the one for Almond Cheesecake Amaretto comes with a warning: Could be flammable! It seems that occasionally some of the sugar spills out of the baking pan and catches fire. This happened once when Todd Donatelli, former Canon at St. Andrew's, and his wife Becky were vacationing with some fellow communicants. He and Becky got this prize-winning recipe from his brother, and wanted to introduce it to their friends, so they prepared this gourmet treat and slipped it into the oven. They were enjoying congenial talk, when Tim Cannon "said most calmly, 'There are flames coming out of the oven.'" Panic ensued, but luckily they doused the flames and, most importantly, saved the cheesecake.

Judith Travis's mouthwatering recipe for Nannie's Buttermilk Pound Cake provided her daughter Kathy with a chance to impress her "Yankee" colleagues at Johns Hopkins. Having tried the food her friends brought to their get-togethers and finding it lacking, she presented them with this heirloom pound cake. They were so impressed they begged for more and also for the recipe, proving to Kathy that "southern cooking is better."

These recipes run the gamut of all things good: fruit, chocolate, caramel, berries, custards and puddings; ice cream, including that rarely needed but oh, so heavenly Snow Ice Cream, sherbets, cakes, cookies, and pies. All are tried and true and offer all kinds of culinary delight.

\mathcal{D}ESSERTS

Blond Brownies

2 packages graham crackers
 (8-9 rectangular crackers per package)
2 (14-ounce) cans sweetened condensed milk

1 (12-ounce) package semi-sweet chocolate
 chips
 pecans or walnuts (optional)

Roll graham crackers between wax paper to make crumbs. Mix crumbs in a bowl with milk and chocolate chips. Add nuts, if using.

Spread mixture in a 9-inch square greased glass baking dish. Bake at 350 degrees for 30 minutes.

The mother of a St. Andrew's parishioner, who was a great cook, hostess and devoted Episcopalian, made these brownies for family and many other lucky folks in Memphis.

Coconut Squares

1 stick butter
1 cup flour
3 tablespoons brown sugar
2 eggs, beaten
¼ teaspoon baking powder

1½ cups brown sugar
2 tablespoons flour
½ teaspoon salt
½ cup nutmeats
1 cup coconut

Combine butter, flour and 3 tablespoons brown sugar and press into an 8-inch square baking dish. Bake at 350 degrees for 10 minutes. Cool 5 to 10 minutes.

Mix eggs, baking powder, 1½ cups brown sugar, flour, salt, nutmeats and coconut. Pour mixture over partially baked crust. Bake 20 minutes longer. Cool before cutting.

Yield: 12 to 16 servings

Alternate 1 cup nutmeats and ½ cup coconut if preferred.

Aunt Vi's Brownies

3 sticks butter
6 (1-ounce) squares unsweetened chocolate
4 cups sugar
4 jumbo eggs
2 cups flour

4 jumbo eggs
3½ cups chopped pecans
2 teaspoons vanilla
 dash of salt

Melt butter and chocolate together. This can be done in the microwave as long as the chocolate does not get too hot; cook at about half-power in 2 minute increments, stirring well between increments.

Add sugar to chocolate batter. Beat 4 eggs and add to mixture. Add flour and stir well; do not use an electric mixer. Beat remaining 4 eggs and add to batter. Stir in pecans, vanilla and a dash of salt. Pour batter into 2 greased 8-inch square baking dishes.

Bake at 350 degrees for 45 to 60 minutes. Do not overcook. When ready, the top will be cracked around the middle. Cool completely before cutting as the center will be quite soft until it cools.

Brown Sugar Brownies

2 eggs
2 cups brown sugar
2 teaspoons vanilla
1 cup flour

1½ sticks butter, melted
1 cup pecan pieces
 powdered sugar

Beat eggs in a mixing bowl. Add brown sugar, vanilla and flour, beating after each addition. Beat in melted butter. Stir in pecans. Pour into a 9-inch square greased baking dish.

Bake at 350 degrees for 30 to 33 minutes. Dust with powdered sugar when cool enough to cut.

Divine Divinity or Never Fail Divinity

3 cups sugar
¾ cup white cane syrup
¼ cup water

2 egg whites
1 teaspoon vanilla
1 cup chopped pecans

Combine sugar, syrup and water in a saucepan. Boil until mixture forms a hard ball when dropped into cold water. Mixture should "click" when it hits against the side of the cup.

Meanwhile, beat egg whites until stiff. Pour hard-ball stage mixture slowly over whites. Add vanilla and beat until mixture holds its shape. Stir in pecans. Drop from heaping teaspoonfuls onto wax paper.

Yield: 3 dozen

Amaretto Truffles

12 (1-ounce) squares semi-sweet chocolate
1 stick butter
2 egg yolks

½ cup heavy cream
¼ cup amaretto
 finely chopped almonds or cocoa

Melt chocolate in the top of a double boiler. Remove from heat and stir in butter, 1 tablespoon at a time.

Beat egg yolks until thick and lemon colored. Gradually stir about one-fourth of hot mixture into yolks, then add back to remaining hot mixture, stirring constantly. Stir in cream and amaretto. Return to heat and cook 1 minute or until mixture is thickened and smooth, stirring constantly. Cover and refrigerate overnight or until firm enough to roll into balls.

Roll into 1-inch balls. Roll balls in chopped almonds or cocoa. Store in refrigerator.

Yield: 42 balls

Texas Taffy Pull

1½ cups cane molasses
1½ cups sugar
1½ teaspoons vinegar

½ cup water
¼ teaspoon salt
3 tablespoons butter

Combine all ingredients except butter in a large, heavy saucepan. Cook over low heat, stirring constantly, until sugar dissolves. Boil moderately until mixture reaches 240 degrees, soft-ball stage. Add butter and boil slowly to 265 degrees, hard-ball stage, stirring frequently. Remove from heat. Wipe pouring surface of pan. Pour taffy all at once onto an oiled surface, such as a shallow baking sheet, a platter or a marble slab. Cool until comfortable to handle.

Fold in edges, then pull or roll. (The more you pull, the better.) When children tire, spread taffy out onto a cutting surface and cut into bite-size pieces. After it hardens, wrap individual pieces in wax paper.

Yield: about 1 pound

This is a great indoor activity on a cold or rainy day.

Peanut Butter Chocolate Fudge

1 (12-ounce) package peanut butter chips
1 (14-ounce) can sweetened condensed milk, divided
2 tablespoons butter
1 (6-ounce) package semi-sweet chocolate chips
2 tablespoons butter

Spread wax paper in an 8-inch casserole dish.

Melt peanut butter chips in a saucepan with two-thirds of sweetened condensed milk and 2 tablespoons butter. Spread mixture over wax paper in dish.

In same saucepan, melt chocolate chips with remaining one-third sweetened condensed milk and 2 tablespoons butter. Spread over peanut butter mixture. Chill 2 hours.

Turn fudge out onto a board and remove wax paper. Cut into small cubes; fudge is very rich. Store in a covered container in the refrigerator.

Yield: 2 to 3 dozen

MAMA'S CHOCOLATE SAUCE

1 (1-ounce) square unsweetened chocolate
6 tablespoons butter
½ cup sugar
½ cup heavy cream, or more if desired
1 teaspoon vanilla

Combine chocolate, butter and sugar in the top of a double boiler. Heat to a simmer. Slowly drip in cream. Reduce heat to low and cook 10 minutes. Sauce will bubble up while cooking and stay creamy if not cooked too long. Remove from heat and stir in vanilla.

TRIPLE CHOCOLATE CLUSTERS

1	cup white chocolate chips	1½	cups chopped pecans or walnuts
1	cup milk chocolate chips	1½	cups broken pretzels, any shape
1	cup semi-sweet chocolate chips		

Melt all chocolate chips in the top of a double boiler over low heat, stirring constantly. Remove from heat. Carefully stir in pecans and pretzels until evenly coated.

Drop by tablespoons onto wax paper-lined baking sheets. Cool in refrigerator at least 1 hour or until hardened, or speed cooling by placing in freezer. Store in an airtight container in refrigerator for up to 1 month.

Yield: 6 dozen

Alternate melting method: Place all chocolate chips in a large microwave-safe bowl. Microwave on high for 20 to 30 seconds. Stir well with a spatula. Repeat process until smooth. Note: chocolate keeps its shape as it melts. You must stir it well at each interval to disperse the heat and monitor the melting progress. Usually it takes 3 to 4 intervals in the microwave for melting, depending on power of microwave.

THIS MAKES GREAT TEACHER'S GIFTS, PARTY SNACKS, ETC.

If chocolate passes its smooth state into a clumpy, crumbly state, throw it out (or eat it) and start over! It will not recover from this "burned" state, and it will not coat or stick to the other ingredients.

The Best Chocolate Cake

2 eggs
2 cups buttermilk
2 teaspoons vanilla
2½ cups flour
½ teaspoon salt

2 cups sugar
2 teaspoons baking soda
4 (1-ounce) squares bittersweet chocolate
1 stick butter
Icing (recipe below)

Beat eggs with buttermilk. Add vanilla. Sift together flour, salt, sugar and baking soda and add to egg mixture.

Melt chocolate with butter in the top of a double boiler, or carefully in a microwave. Add to egg mixture and beat thoroughly. Pour batter into 2 greased and floured 9-inch cake pans.

Bake at 350 degrees for 30 minutes. Frost with icing.

ICING

1 pound confectioners' sugar, sifted
½ cup evaporated milk
2 teaspoons vanilla

4 (1-ounce) squares bittersweet chocolate
1 stick butter

Combine sugar, milk and vanilla in a mixing bowl. Melt chocolate and butter together and add to sugar mixture. Mix well. If icing is not thick enough to spread nicely, add more sifted confectioners' sugar.

Chocolate Angel Food Cake

1 cup sifted cake flour
¼ cup cocoa powder
14 egg whites
¼ teaspoon salt

1 teaspoon cream of tartar
1 teaspoon vanilla
1½ cups sifted sugar

Sift flour with cocoa four times; set aside.

In a large bowl, beat egg whites until foamy. Add salt, cream of tartar and vanilla and continue to beat until soft peaks form. Fold in sugar, 1 tablespoon at a time. Sift cocoa mixture over egg whites and fold in. Turn batter into an ungreased 10-inch tube pan.

Bake at 350 degrees for 45 to 50 minutes. When done baking, invert cake onto a rack and allow to cool in pan. Run a knife between the cake and the edges of the pan to release cake from pan. If you do not have an angel food cake cutter, insert 2 forks into cake, back to back and gently pull slices apart.

CHOCOLATE WHIPPED CREAM

2 cups heavy cream
⅞ cup sugar

5 teaspoons cocoa powder

Place all ingredients in a mixing bowl but do not stir. Refrigerate several hours or overnight. Whip when ready to ice cake. Garnish with strawberries.

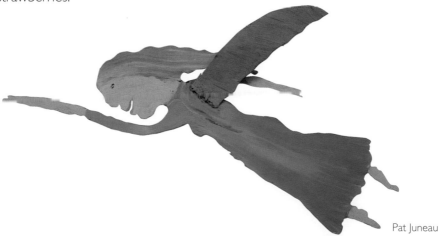

Pat Juneau

Desserts

Nannie's Buttermilk Pound Cake

2 sticks butter (no substitutions), softened
3 cups sugar
5 eggs, separated
⅓ teaspoon baking soda

1 cup buttermilk
3 cups flour
2 teaspoons vanilla
confectioners' sugar for topping

Cream butter with sugar. Beat egg yolks well and add to creamed mixture. Dissolve baking soda in buttermilk. Add flour and buttermilk mixture to batter alternately. Mix in vanilla. Beat egg whites well and fold into batter. Pour batter into a greased and floured Bundt pan.

Bake at 325 degrees for 1 hour, 10 minutes. Check for doneness. If cake is browned but not done inside, cover with foil and continue to bake until done. Cool on a wire rack for 15 minutes. Turn out onto a plate and sprinkle with confectioners' sugar.

One-half recipe is just right for a loaf pan.

Ginny Futvoye

Lemon Buttermilk Pound Cake

BATTER

2	sticks unsalted butter, softened
2	cups sugar
2½	cups all-purpose flour
2	teaspoons baking powder
4	eggs
3	egg yolks
½	cup buttermilk
1	tablespoon lemon zest
1	tablespoon fresh lemon juice
1	teaspoon vanilla

Beat butter and sugar together until fluffy. Mix flour and baking powder and add to creamed mixture. Beat on low speed for 2 minutes.

In a separate bowl, mix eggs, egg yolks, buttermilk, lemon zest, lemon juice and vanilla. Add mixture to batter in 3 additions, beating for 1 minute between additions. Pour batter into a greased and lightly floured Bundt pan.

Bake at 350 degrees for 1 hour. Cool in pan 5 to 10 minutes. Remove from pan to a cake rack.

LEMON GLAZE

½	cup water
½	cup sugar
⅓	cup fresh lemon juice
1	teaspoon vanilla

To make glaze, combine water and sugar in a small saucepan. Bring to a boil and cook 1 minute. Remove from heat and add lemon juice and vanilla. Brush glaze evenly over warm cake, using all of glaze.

Yield: 12 to 15 servings

Serve with a berry compote made of strawberries, raspberries and blueberries mixed with ¼ cup sugar and 2 tablespoons Grand Marnier.

Tres Leches
(Milk Cake)

1½ cups all-purpose flour
1 teaspoon baking powder
1 stick unsalted butter, softened
1 cup sugar
5 eggs
½ teaspoon vanilla

1 (14-ounce) can sweetened condensed milk
1 (12-ounce) can evaporated milk
1½ cups heavy cream
1 teaspoon vanilla
1 cup granulated sugar

Sift together flour and baking powder; set aside

Cream butter and 1 cup sugar together until fluffy. Add eggs and ½ teaspoon vanilla and beat well. Add dry ingredients, 2 tablespoons at a time, and mix until well blended. Pour batter into a greased and floured 9x13-inch baking pan.

Bake at 350 degrees for 30 minutes. Remove from oven and pierce several times with a fork. Combine condensed milk and evaporated milk and pour over cooled cake.

Whip cream, 1 teaspoon vanilla and 1 cup sugar until thick. Spread over top of cake. Store cake in refrigerator.

This cake is made with 3 layers: cake, filling and topping. There are 3 types of milk in the filling and topping (condensed milk, evaporated milk and heavy cream.) This is an excellent cake for milk lovers!

1	cup granulated sugar	2	teaspoons baking soda
1	cup brown sugar	1	teaspoon salt
1	cup butter, melted	2	cups corn flakes, lightly crushed
2	eggs	2	cups quick oats
1	teaspoon vanilla	1	cup chopped pecans
2	cups all-purpose flour	½	cup sliced almonds, crushed
1	teaspoon baking powder	1	cup coconut

Cream together both sugars, butter, eggs and vanilla; set aside.

In a very large bowl, mix flour, baking powder, baking soda, salt, corn flakes, oats, pecans, almonds and coconut. Make a well in the center. Add creamed mixture to center and mix well. This can be done by hand.

Drop by 1 tablespoon at a time, or use a cookie scoop, onto parchment paper-lined baking sheets or onto a baking stone. Bake at 325 degrees for 6 to 7 minutes; no longer than 9 minutes. Cool on a wire rack.

Yield: about 4 dozen cookies

Self-rising flour can be substituted for the all-purpose flour, baking powder, baking soda and salt.

Each sheet of parchment paper can be used about twice.

Butterball Cookies

1 pound butter, softened	4½ cups sifted all-purpose flour
1 cup plus 2 tablespoons light brown sugar	1 teaspoon vanilla

Cream butter. Gradually sift in brown sugar. Add flour and vanilla and mix well. Let stand at room temperature overnight.

Form mixture into balls and roll in sugar. Place on an ungreased baking sheet. Bake at 350 degrees for 15 to 20 minutes.

Yield: 3 to 4 dozen

Mary Ann's Swan Kisses

3 egg whites	1 cup blanched hazelnuts, toasted and ground
1 cup brown sugar	1 pint fresh raspberries
1 teaspoon vanilla	1 pint heavy cream, whipped
1 teaspoon strong, good-quality brewed coffee	fresh mint for garnish

In the large mixing bowl of an electric mixer, beat egg whites until foamy. Gradually add brown sugar and continue to beat until stiff. Fold in vanilla, coffee and hazelnuts. Beat until stiff.

Using 2 teaspoons, shape batter into rounds and drop about 1 inch apart onto 2 large greased baking sheets. Bake at 250 degrees for 1 hour or until kisses are dry to the touch. Let cool on baking sheets for a few minutes, then transfer with a spatula to a wire rack to cool completely.

To serve, place a few kisses on a small dessert plate. Spoon some raspberries and whipped cream alongside and garnish with a mint sprig.

Yield: about 3 dozen kisses

Hidden Kisses

2 sticks butter, softened
⅔ cup granulated sugar
½ teaspoon vanilla
¼ teaspoon almond extract
1⅓ cups all-purpose flour

¾ cup finely chopped pecans
1 (13-ounce) package chocolate kisses, unwrapped
1½ cups confectioners' sugar

Cream butter, granulated sugar, vanilla and almond extract in a large bowl. Stir in flour and blend well. Mix in pecans. Cover bowl and refrigerate dough for 1 hour.

Press a scant tablespoon of dough around each kiss, covering completely. Shape into balls and place on ungreased baking sheets.

Bake at 375 degrees for 10 to 11 minutes. Cool slightly. Transfer to a rack to cool completely. Roll cooled cookies in confectioners' sugar.

This is a great cookie for an engagement party. The name is symbolic and the burst of chocolate in the middle of the cookie is like the early days of a marriage...filled with delicious surprises!

Holiday Cookies

2	sticks butter, softened	1	teaspoon salt
1	cup sugar	3	cups flour
1½	teaspoons vanilla	1½	teaspoons baking powder
1	egg		flour for cookie cutters
1	teaspoon water		

Cream butter, sugar and vanilla by hand or with an electric mixer. Add egg and water and beat until fluffy. Mix in salt, flour and baking powder. Divide dough in half, wrap in plastic wrap and chill for 1 hour.

Roll out dough on a lightly floured surface to ⅛-inch thick. Cut into desired shapes, dipping cookie cutters in flour each time before cutting cookies. Transfer to a greased baking sheet with a spatula.

Bake at 375 degrees for 6 to 8 minutes. Cool slightly before removing from pan.

Yield: about 27 large cookies

GLAZE

3¾	cups confectioners' sugar	½	teaspoon lemon extract (optional)
3	egg whites	2	tablespoons water
½	teaspoon cream of tartar		

Combine all glaze ingredients and beat 6 to 8 minutes. Dip 1 side of cookies in glaze and smooth with hand or a spatula. Store in a covered container for 1 week in refrigerator, or up to 1 month in freezer.

These cookies make special gifts when decorated with colored icings available at craft stores. They are lovely on trays for Christmas and Easter gatherings as well as baptism lunches and other special occasions.

Merry Christmas Cookies

3 eggs
2 sticks butter, softened
1 cup brown sugar
3 cups flour
½ cup sherry
½ cup milk
½ teaspoon baking soda

1 tablespoon fresh cinnamon
7 cups chopped pecans
¾ pound white raisins
1 pound candied pineapple, chopped
1 pound candied cherries, chopped
½ pound dates, chopped

Mix together eggs, butter, brown sugar, flour, sherry, milk, baking soda and cinnamon in a mixer. Blend in pecans, raisins, pineapple, cherries and dates with a large spoon or with hands. Drop dough onto well-greased baking sheets.

Bake at 300 degrees for 30 minutes.

Yield: 30 large or 40 small cookies

Miriam Weems

Rosemary Cookies

1½ sticks butter, softened
¼ cup sugar
⅛ teaspoon salt

3 tablespoons chopped fresh rosemary
1½ cups plain flour

Cream together butter, sugar, salt and rosemary. Mix in flour. Form dough into a ball and refrigerate 30 minutes.

Roll out dough into a thin sheet and cut into rounds. Place on a greased baking sheet. Bake at 375 degrees until golden. Serve with Stilton or blue cheese.

Turnbull Sugar Cookies

1 cup vegetable oil
2 sticks unsalted butter
1 cup confectioners' sugar
1 cup granulated sugar
2 eggs
½ teaspoon cream of tartar

½ teaspoon baking soda
½ teaspoon salt
1 teaspoon vanilla
5¼ cups plain flour
sugar for topping

Combine all ingredients and mix well. Roll dough into 1-inch balls and place on a lightly greased baking sheet. Flatten each ball with the bottom of a glass dipped in sugar.

Bake at 350 degrees for 10 to 12 minutes.

Yield: about 4 dozen cookies, depending on size of balls

Every time we went to Turnbull, my grandmother's old home place in Monroe County, Alabama, a neighbor would bring over a tin of these cookies for our enjoyment. We would lick the bottom of the tin to get the very last crumbs. Best sugar cookies, EVER!

ALLELUJAH CHEESECAKE

CRUST

1⅓	cups fine vanilla wafer crumbs	⅓	cup sugar
5	tablespoons unsalted butter, melted	1	teaspoon cinnamon

FILLING

5	(8-ounce) packages cream cheese, softened	¼	teaspoon salt
1¾	cups sugar	¼	teaspoon vanilla
3	tablespoons flour	5	eggs, room temperature
¾	teaspoon lemon zest	2	egg yolks, room temperature
¾	teaspoon orange zest	¼	cup heavy cream

Combine all crust ingredients and press into the bottom of a 9-inch springform pan; chill.

Beat cream cheese with an electric mixer until light and fluffy. In a separate bowl, combine sugar, flour, lemon and orange zest, salt and vanilla. Gradually add mixture to cream cheese, beating constantly. Add eggs and egg yolks one at a time, beating well after each addition. Gently stir in cream. Pour filling over chilled crust.

Bake at 500 degrees for 10 minutes. Reduce heat to 200 degrees and bake 1 hour. Turn heat off and allow cheesecake to cool in oven. Remove from oven and let stand at room temperature for 30 minutes. Chill several hours or overnight. Remove sides of pan before garnishing.

For garnish, top with any fruit, such as blueberries, strawberries, peaches, grapes or apricots. Melt preserves in any of those flavors and pour over fruit.

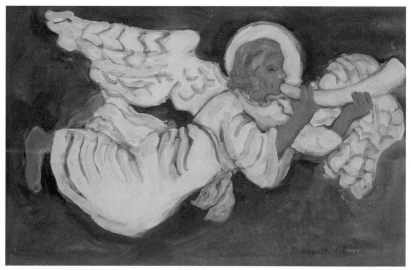

Elizabeth Johnson

Almond Cheesecake Amaretto

CRUST
2 cups chocolate wafer crumbs
2 tablespoons slivered almonds
½ cup sugar
1 teaspoon cinnamon
4 tablespoons butter, melted

FILLING
6 (8-ounce) packages cream cheese, softened
2½ cups sugar
5 eggs
4 ounces amaretto
½ cup heavy cream

TOPPING
1½ cups sour cream
5 cups sugar
2 ounces amaretto
½ cup slivered almonds, toasted

Combine all crust ingredients and press firmly into a 10-inch springform pan. Cool crust in refrigerator for 10 minutes.

To make filling, beat cream cheese with an electric mixer on low speed until smooth. Add sugar and blend until dissolved. Add eggs one at a time, beating well after each addition. Add amaretto and cream and blend on low speed for 7 minutes. Pour filling into chilled crust. Bake at 375 degrees for 1 hour. Shut off heat, crack open oven door and let cool in oven for 3 hours.

For topping, mix sour cream, sugar and amaretto and spread over cooled cake. Sprinkle almonds around top edge of cake. Cover with wax paper and refrigerate overnight.

Yield: 16 servings

For a nice decorative touch, on wax paper, lay a group of toasted slivered almonds with tips touching a chocolate chip in the center. Place in microwave and heat until chip is soft enough for almond to melt into it; cool. Decoration will resemble a flower.

Almond Macaroon Pudding Soufflé

Gran's Christmas Surprise

1	(¼-ounce) envelope unflavored gelatin
¼	cup cold water
3	eggs, separated
¾	cup sugar
2	cups milk
1	teaspoon vanilla

12 large or 24 small almond macaroons, broken into small crumbs, 2 tablespoons reserved for garnish

2 packages ladyfingers
sweetened vanilla-flavored whipped cream for topping

Sprinkle gelatin over cold water in a small bowl to dissolve; let stand.

In a mixing bowl, beat egg yolks well. Add sugar and continue to beat. Scald milk in a saucepan. Slowly pour hot milk into egg yolk mixture to temper the eggs, then return mixture to saucepan. Cook and stir mixture until custard coats a spoon. Add dissolved gelatin to custard, stirring to dissolve. Mix in vanilla and half of the macaroon crumbs. The crumbs will dissolve in the custard.

Beat egg whites until stiff peaks form. Gently fold whites into custard along with the other half of the macaroon crumbs.

Line an 8-inch springform pan with ladyfingers. Pour custard into pan and chill at least 4 hours or preferably overnight.

To serve, remove soufflé from pan and cut into wedges, or spoon custard out of the bowl into stemmed sherbet glasses. Top with a dollop whipped cream and sprinkle with reserved macaroon crumbs.

Yield: 8 servings

Bon Ton's
Whiskey Bread Pudding

1 loaf French bread, day old
1 quart milk
3 eggs
2 cups sugar
2 tablespoons vanilla

1 cup raisins, soaked 1 hour in whiskey and
 drained
3 tablespoons butter, melted
 Whiskey Sauce (recipe below)

Soak bread in milk. Combine mixture with hands until well mixed. Add eggs, sugar, vanilla and drained raisins. Stir well.

Pour melted butter into a 9x13-inch glass baking dish. Add pudding mixture. Bake at 350 degrees for 45 minutes. Cool.

Cut pudding into squares and punch fork holes in pudding. Pour sauce over pudding and broil until hot.

WHISKEY SAUCE
1 stick butter
1 cup sugar

1 egg, beaten
¼ cup whiskey

Cook butter and sugar in the top of a double boiler until sugar dissolves and mixture is very hot. Add beaten egg and whisk briskly. Allow to cool. Stir in whiskey.

Yield: 6-8 servings

CHAMPAGNE VANILLA SABAGLIONE WITH BERRIES

6 egg yolks, room temperature
¾ cup sugar
1 tablespoon vanilla
1 cup champagne, room temperature

 pound cake, thinly sliced
1 cup fresh strawberries
1 cup fresh raspberries

Whisk together egg yolks and sugar in the top of a double boiler. Add vanilla. Whisk in champagne. Bring water to a boil in the bottom of double boiler, then reduce heat to a simmer. Cook, whisking constantly, for 10 minutes or until custard loses its foam and begins to thicken.

Vera Stephenson

Arrange cake slices in the bottom of custard cups. Top with berries. Pour custard over cake and berries. Serve warm or cold.

Yield: 6 servings

Brandied Cranberry Squares

BRANDIED CRANBERRY SAUCE
4 cups fresh or frozen cranberries
2 cups sugar

⅓ cup brandy or orange juice

DOUGH
1½ cups rolled oats
1½ cups flour
1½ cups brown sugar

1 tablespoon baking powder
2 sticks butter

Spread cranberries in a 9x13-inch baking dish. Sprinkle evenly with sugar. Cover dish and bake at 300 degrees for 1 hour. Remove from oven and carefully stir. Mix in brandy. Store in a jar in refrigerator.

To make dough, mix oats, flour, brown sugar and baking powder in a bowl. Blend in butter until crumbly. Press two-thirds of dough into a 9-inch square baking pan; reserve remaining mixture.

Spread 1 cup cranberry sauce over dough. Sprinkle reserved dough over sauce. Bake at 350 degrees for 30 minutes.

Yield: 3 cups sauce

CRÈME BRÛLÉE

12 egg yolks
½ cup superfine granulated sugar
5 tablespoons vanilla (from a fresh bottle)

1 quart heavy cream, warmed
1 cup light brown sugar

Beat egg yolks with granulated sugar. Add vanilla and warmed cream a little at a time. Pour mixture into brûlée cups, filling each three-fourths full. Place cups in a pan of water. Bake at 300 degrees for 50 to 60 minutes. Cool. Refrigerate 12 to 24 hours.

Put brown sugar through a sieve to remove lumps. Lightly sprinkle brown sugar over custard so that sugar is ¼-inch thick and no custard is showing.

Preheat a broiler to 350 degrees. Place custard 6 inches from heat source and broil 3 to 4 minutes, watching carefully. Sugar will caramelize to a dark golden crust. Chill thoroughly before serving.

Yield: 12 servings

This recipe won an award several years ago at a charity function in which tv personality Gary Collins was a judge.

MOTHER'S GINGERBREAD WITH LIME CREAM

2 cups flour
2 teaspoons baking soda
1 teaspoon cinnamon
1 teaspoon ground cloves
1 tablespoon grated fresh ginger, or
 1½ teaspoons ground ginger
1 cup unsulphured molasses

1 cup boiling water
2 sticks butter, melted
1 cup sugar
3 eggs
2 teaspoons baking soda, dissolved in
 2 tablespoons hot water

Sift together flour, baking soda, cinnamon and cloves. Mix in ginger; set aside. In another bowl, mix molasses with boiling water.

Pour melted butter into a large bowl. Beat in sugar and eggs. Mix in dry ingredients. Whisk in molasses mixture and dissolved baking soda. Pour batter into a greased 9-inch square pan.

Bake at 350 degrees for 45 minutes.

LIME CREAM SAUCE

2 eggs
½ cup sugar
 zest of 1 lime

⅓ cup freshly squeezed lime juice
4 tablespoons unsalted butter
2 cups heavy cream

Whip eggs and sugar with an electric mixer on high speed until doubled in volume and light in color. Mix in lime zest and juice. Cook mixture in the top of a double boiler over high heat for 20 to 30 minutes or until very thick, whisking often. Remove from heat and stir in butter in small pieces. Strain and cool.

Whip cream until soft peaks form. Fold cream into lime mixture. Refrigerate until ready to use.

Yield: 9 servings

Old-Fashioned Lemon Sauce

2 egg yolks	1½ tablespoons cornstarch
1 cup water	juice of zest of 2 lemons
1 cup sugar	2 tablespoons butter

Whip egg yolks with water. In a separate container, mix sugar and cornstarch. Combine both mixtures in a saucepan. Mix in lemon juice and zest. Cook, stirring constantly, over low heat until thickened. Stir in butter.

Yield: eight (2-tablespoon) servings

This delicious sauce can be served over ice cream, pound cake or gingerbread.

Fudge Pudding

4 eggs	2 heaping tablespoons cocoa powder
2 cups sugar	1 cup chopped pecans
½ cup sifted flour	1 teaspoon vanilla
1½ sticks butter, melted	dash of salt

Beat eggs. Cream in sugar. Add flour and mix. Combine butter and cocoa powder and add to creamed mixture. Mix well. Add pecans, vanilla and salt and mix well. Pour batter into an ungreased pan. Place pan in a larger pan filled with water.

Bake at 350 degrees for 1 hour. The pie will be crispy on the top and soft on the bottom. It is great served hot with ice cream on top, but it can be made ahead and served at room temperature.

Yield: 6-8 servings

Homemade Banana Pudding

(with Coconut and Chocolate Pie Custard variations)

CUSTARD

1	cup sugar	1	cup whole milk
2	tablespoons cornstarch	½	cup water
5	tablespoons margarine	1	teaspoon vanilla
4	eggs yolks	3	bananas, sliced
1	(5-ounce) can evaporated milk	½	(12-ounce) box vanilla wafers

MERINGUE

4	egg whites	6	tablespoons sugar
¼	teaspoon cream of tartar	1	teaspoon vanilla

In a Dutch oven, combine sugar, cornstarch and margarine. In a separate bowl, beat egg yolks. Add evaporated milk, whole milk and water to yolks and mix. Add yolk mixture to Dutch oven. Cook slowly, stirring constantly, over medium-high heat until mixture begins to thicken. Stir in vanilla and remove from heat.

Arrange a single layer of vanilla wafers in an oven-proof serving pan. Add a layer of banana slices. Use about half of pudding to form another layer over banana slices. Repeat layers.

For meringue, use an electric mixer to beat egg whites with cream of tartar in a clean bowl. When whites start to thicken, gradually add sugar, 1 tablespoon at a time. Beat in vanilla. Beat until stiff peaks form. Spread meringue over pudding. Bake at 400 degrees until meringue browns slightly.

Coconut Pie: Reduce eggs to three. Add 1 cup coconut to custard mixture and spoon into a baked pie shell. Top with meringue and sprinkle with coconut.

Chocolate Pie: Reduce eggs to three. Increase sugar to 2 cups and add 3 tablespoons cocoa powder to the dry ingredients. Spoon chocolate mixture into a baked pie shell and top with meringue.

Yield: 8 servings

St. Columba Hotel's Sticky Toffee Pudding

BATTER

¾ cup chopped dates
1 cup water
1 teaspoon baking soda
1 stick butter, softened

⅔ cup confectioners' sugar
2 eggs, lightly beaten
1 teaspoon vanilla
1½ cups self-rising flour

SAUCE

1 cup light brown sugar
½ cup heavy cream

1 stick butter

Combine dates and water in a small pan. Bring to a boil. Blend in baking soda and allow to cool to room temperature.

Beat butter and sugar in a small bowl with an electric mixer until light and creamy. Add eggs one at a time, beating thoroughly after each addition. Mix in vanilla and beat until combined. Transfer to a larger bowl.

Using a metal spoon, fold in flour and date mixture and stir until just combined; do not overbeat. Pour batter into a greased 10-inch cake pan.

Bake at 350 degrees for 50 minutes or until a skewer comes out clean when inserted into center of the pudding. Leave in pan 10 minutes before turning out.

To make sauce, combine sugar, cream and butter in a small saucepan. Cook and stir until butter is melted and sugar is dissolved. Bring to a boil. Reduce heat and simmer 2 minutes.

Cut cake into wedges and place on a serving platter. Pour sauce over top to cover all pieces. Serve immediately with berries, if desired, and extra sauce on the side.

Yield: 6 to 8 servings

This is a wonderfully delicious English dessert that was discovered in a visit to England. We have had several versions of it and found this rendition the best. (Some who had it in the "mother country" described it as a "religious experience".) It is from St. Columba Hotel on the Scottish island of Iona. St. Columba, an Irish monk founded a monastic settlement in 1561 on Iona.

Nana's Lemon Cup Pudding

1	cup sugar	⅓	cup lemon juice
¼	cup flour	2	teaspoons lemon zest
	dash of salt	3	eggs, separated
2	tablespoons butter, melted	1½	cups milk, scalded

Combine sugar, flour, salt and butter in a mixing bowl. Add lemon juice and zest.

Temper egg yolks by adding a tablespoon or two of the hot milk into the yolks and stir, then add egg yolk mixture into the rest of the hot milk. Add to lemon mixture.

Beat egg whites until stiff peaks form. Fold whites into lemon mixture. Pour into a ungreased 1- to 1½-quart glass bowl. Set bowl in a shallow pan filled with 1 inch of water.

Bake at 325 degrees for 45 minutes. Serve hot, cold or at room temperature. This can be made ahead.

Yield: 6 servings

Sister Hicks' Cold Lemon Soufflé

1 (¼-ounce) envelope unflavored gelatin	¾ cup fresh lemon juice
¼ cup cold water	¾ cup sugar
5 eggs, separated	1 cup heavy cream, whipped
¾ cup sugar	Raspberry Sauce (see below) (optional)
2 teaspoons lemon zest	

Soften gelatin in cold water; set aside.

Beat egg yolks with ¾ cup sugar in a large saucepan. Cook and stir over low heat until thickened. Stir in softened gelatin. Add lemon zest and juice and mix well. Chill in saucepan in refrigerator for 30 to 40 minutes.

Beat egg whites to soft peaks. Beat in ¾ cup sugar and beat until stiff peaks form. Fold whites into chilled yolk mixture. Fold in whipped cream. Pour into a serving container, cover and chill overnight. Serve with Raspberry Sauce, if desired.

Yield: about 2½ quarts

Sister Hicks was the legendary Secretary of the Mississippi House of Representatives for many years.

RASPBERRY SAUCE

1 (16-ounce) package frozen raspberries, thawed	1 tablespoon cornstarch
2 tablespoons sugar, or equal-measure sugar substitute	2 tablespoons fresh lemon juice
6-8 fresh strawberries	2 tablespoons Kirsch

Purée raspberries in batches with sugar and strawberries. Force purée through a strainer or a sieve into a saucepan; discard seeds.

Mix cornstarch and lemon juice and add to strained mixture. Bring to a boil. Cook until thickened. Remove from heat and stir in Kirsch. Chill in refrigerator. Sauce with keep in refrigerator for weeks.

Yield: 2 cups

Desserts

Panna Cotta

1	(¼-ounce) package unflavored gelatin		pinch of salt
2	tablespoons cold water	½	teaspoon vanilla
3	cups heavy cream	1	cup sour cream
½	cup sugar	8	mint leaves

Sprinkle gelatin over cold water; let stand 5 minutes to soften.

Warm heavy cream with sugar, salt and vanilla in a 3-quart saucepan over medium-high heat; do not boil. Stir in softened gelatin until thoroughly dissolved. Remove from heat and cool 5 minutes.

Spoon sour cream in a medium bowl. Gently whisk in warm cream mixture, a little at a time, until smooth. Taste for sweetness and add sugar as needed. Pour mixture into a serving bowl. Cover and chill 4 to 24 hours.

Serve with Berry Sauce (recipe below) or Balsamic Sauce (recipe below). Garnish with mint leaves.

Yield: 6 servings

BERRY SAUCE
1 (10-ounce) package frozen raspberries in syrup, thawed 1 pint fresh strawberries, sliced

Purée raspberries in a food processor until smooth. Pass purée through a sieve to remove seeds. Place strawberry slices in a medium bowl. Gently fold in raspberry purée. Cover and refrigerate.

BALSAMIC SAUCE
6 cups balsamic vinegar 1 cup dark brown sugar

Combine vinegar and brown sugar in a saucepan. Simmer over low heat until sauce reduces to 1½ cups. Delicious drizzled over panna cotta.

PRALINE CUSTARD

1	(8-ounce) package cream cheese, softened		dash of cinnamon
3	eggs, lightly beaten	½	teaspoon salt
⅔	cup sweetened condensed milk	1⅓	cups hot water
1	teaspoon vanilla	1	pint fresh raspberries for garnish

Beat together cream cheese and eggs until fluffy. Mix in milk, vanilla, cinnamon and salt. Gradually stir in 1⅓ cups hot water. Pour mixture into a greased 1½-quart glass casserole dish. Place dish in a 9x13-inch baking pan with high sides. Pour hot water into outer pan to 1 inch in depth.

Bake at 325 degrees for 45 minutes or until center is set. Remove custard dish from water and cool. Refrigerate until well chilled.

Unmold custard onto a glass tray. Drizzle with Praline Sauce (recipe below) and garnish with fresh raspberries.

Yield: 12 servings

PRALINE SAUCE

3	tablespoons butter	½	cup half-and-half
1	cup brown sugar	1	cup pecans, toasted and chopped
½	cup light corn syrup	1	teaspoon vanilla

Melt butter in a heavy saucepan over low heat. Add sugar and corn syrup and cook 5 to 8 minutes, stirring constantly.

Remove from heat and gradually stir in half-and-half. Cook another minute. Remove from heat. Stir in pecans and vanilla. Drizzle 1 cup of sauce over custard. Serve the remaining sauce on the side, if desired.

Tipsy Cake

2-3 packages ladyfingers
 plum jelly
 white wine to taste (optional)
6 eggs
½-1 cup sugar

2 tablespoons vanilla
4 cups milk
 chopped pecans
1½ cups heavy cream, whipped

Split ladyfingers and arrange them flat on a large round platter. Dot ladyfingers with jelly and wine.

Make a custard sauce by mixing eggs, sugar and vanilla in a blender. Heat milk in a saucepan. Add egg mixture to hot milk. Cook and stir until custard coats the spoon. Spoon custard over ladyfingers.

Sprinkle with pecans and top with spoonfuls of whipped cream.

The custard can be prepared ahead and assembled just before serving.

Buttermilk Sherbet

4 cups buttermilk
1 cup sugar
⅔ cup fresh lemon juice

zest of ½ lemon
mint sprigs and thin lemon slices for garnish

Combine all ingredients and process in a small ice cream freezer. When serving, garnish with mint and lemon slices.

Yield: 6 servings

Refer to this recipe as "Lemon Sherbet" for guests who do not think they like buttermilk.

Catherine's Citrus Cheesecake

CRUST
1½ cups graham cracker crumbs
4 tablespoons butter, melted

½ cup sugar

FILLING
1 (8-ounce) package cream cheese, softened
1 (14-ounce) can sweetened condensed milk
1 (12-ounce) can frozen lemonade concentrate

1 (8-ounce) container sour cream
1 (8-ounce) container frozen whipped topping, thawed

Combine all crust ingredients and press into the bottom and two-thirds of the way up the sides of a greased springform pan. Bake at 325 degrees for 8 minutes. Cool completely before filling.

To prepare filling, mix cream cheese and milk with an electric mixer until smooth. Add lemonade concentrate. Very slowly mix in sour cream, scraping down sides of bowl. Fold in whipped topping. Check bottom of bowl for any unmixed filling. Pour filling into cooled crust and freeze.

To serve, remove from freezer before eating meal; cheesecake will be ready at serving time.

Lime Kiwi Banana Ice Cream

1 cup whole milk
½ cup vanilla yogurt
1 cup heavy cream
1½ cups equal-measure sugar substitute
½ cup chopped banana
½ cup chopped kiwi

juice and zest of 1 lime
1 teaspoon vanilla
dash of salt
½ cup chopped banana for garnish
½ cup chopped kiwi for garnish

Combine all ingredients except garnishes and process in a 2-quart frozen yogurt/sorbet/ice cream machine.

To serve, garnish with chopped banana and kiwi.

Any other seasonal fruit, such as strawberries or blueberries, can be substituted if kiwi is not available.

Peach Ice Cream

1 quart half-and-half
2 cups sugar
1 cup whole milk
2 cups finely chopped peaches

1 teaspoon almond extract
2 tablespoons peach schnapps
½ teaspoon salt

Whisk together half-and-half, sugar and milk until sugar dissolves. Stir in peaches, almond extract, schnapps and salt and place in a plastic container. Freeze. Before frozen solid, remove from freezer and let stand a few minutes or until softened but not thawed.

In batches, blend in a food processor. Refreeze until solid.

Yield: 8 to 10 servings, about ½ gallon

Peppermint Ice Cream Dessert

1¼ cups finely crushed vanilla wafers (32 wafers)
4 tablespoons butter, melted
1 quart peppermint ice cream, softened
3 ounces unsweetened chocolate
1 stick butter

3 eggs, separated
1½ cups sifted confectioners' sugar
½ cup chopped pecans
1 teaspoon vanilla

Toss wafer crumbs with 4 tablespoons melted butter. Reserve one-fourth of mixture and press remaining mixture into a 9-inch square pan. Spread softened ice cream over crumb crust in pan and freeze.

Melt chocolate with 1 stick butter over low heat. Beat egg yolks well. Temper yolks by adding 1 to 2 tablespoons melted chocolate mixture to yolks and stir, then gradually add back to chocolate mixture. Stir in confectioners' sugar, pecans and vanilla.

Beat egg whites until stiff peaks form. Fold whites into chocolate mixture and spread over frozen ice cream. Top with reserved crumbs. Freeze.

Yield: 8 servings

Snow Ice Cream

1 (14-ounce) can sweetened condensed milk
½ cup water
1 teaspoon vanilla

½ cup sugar
snow

Combine milk, water, vanilla and sugar. Add snow until ice cream reaches correct consistency.

Peppermint Ice Cream Pie with Hot Fudge Sauce

4	tablespoons butter	½	teaspoon vanilla	
3	(1-ounce) squares semi-sweet chocolate	½	gallon peppermint ice cream, softened	
2	cups crispy rice cereal		Hot Fudge Sauce (recipe below)	

Melt butter with chocolate on the stovetop or in the microwave. Add cereal and stir until cereal is evenly coated. Press mixture into a greased pie pan. Chill 30 minutes.

Spread ice cream over cereal crust. Freeze.

When ready to serve, make chocolate sauce. Drizzle sauce over individual slices of pie.

If peppermint ice cream is not available, substitute ½ gallon vanilla ice cream mixed with 1 cup crushed peppermint candy, ½ teaspoon peppermint extract and, if desired, a drop of red food coloring.

HOT FUDGE SAUCE

2	(1-ounce) squares unsweetened chocolate	1	teaspoon vanilla
1	(14-ounce) can sweetened condensed milk		

Melt chocolate in a glass measuring cup in the microwave. Add milk and vanilla. If too thick, thin with a little water.

Southern Strawberry Sorbet

4	cups fresh strawberries	2	cups buttermilk
2	cups sugar		

Purée strawberries with sugar in a food processor or blender. Add buttermilk and blend well. Pour mixture into a 9x13-inch baking dish. Freeze 1 hour.

Transfer mixture to food processor or blender and whip. Return to freezer for at least 4 hours.

THREE FRUIT FREEZE

4	cups sugar		juice of 6 oranges, strained
6	cups water		juice of 6 lemons, strained
I	pint half-and-half	6	bananas, mashed

Heat sugar and water in a saucepan until sugar dissolves. Remove from heat and let stand until cool. Add half-and-half, orange and lemon juices and mashed banana. Pour mixture into an ice cream freezer and process until frozen. If desired, spoon individual servings into 5-ounce paper cups, cover with plastic wrap and store in freezer.

Yield: 15 to 18 servings

This recipe was passed down from my grandmother to my mother and then to me. We used to make this with a hand-cranked freezer and served after Sunday lunch at our plantation home in Franklin, Mississippi. This is 6 miles south of Lexington and my mother was born in the house. All three generations lived there together.

Apple Kuchen

CRUST
2	cups all-purpose flour
½	cup sugar
¼	teaspoon salt

½	teaspoon vanilla
2	sticks butter, cut into 1-inch slices

FILLING
1	(8-ounce) package cream cheese, softened
¾	cup sugar

1	teaspoon vanilla
1	egg, room temperature

TOPPING
2	tablespoons sugar
1½	teaspoons cinnamon

3	Granny Smith apples, peeled and thinly sliced

Combine flour, sugar and salt in the large bowl of a food processor fitted with a steel blade. Pulse to combine. Add vanilla. Add butter, a few slices at a time, and mix until mixture resembles cornmeal. Press mixture into a lightly greased and floured 9x13-inch pan. Bake at 400 degrees for 12 to 15 minutes or until lightly browned. Set aside to cool.

To prepare filling, beat together cream cheese, sugar and vanilla in a bowl until creamy. Stir in egg. Pour filling over cooled crust.

For topping, mix sugar and cinnamon in small bowl. Arrange apple slices in three rows over the filling. Sprinkle with cinnamon-sugar mixture.

Bake at 350 degrees for 20 to 25 minutes or until firm.

Yield: 24 servings

Richard J. Moor

Blueberry Sour Cream Pie

PIE

1 cup sour cream	1 teaspoon vanilla
¾ cup sugar	2½ cups fresh blueberries
2½ tablespoons all-purpose flour	1 prepared pie crust, unbaked
1 egg, beaten	

TOPPING

6 tablespoons flour	2 tablespoons sugar
4 tablespoons unsalted butter, chilled and cut into pieces	⅓ cup chopped pecans

Cream sour cream and sugar together. Add flour and mix. Add egg and vanilla and mix. Gently mix in blueberries. Pour mixture into pie crust. Bake at 400 degrees for 25 minutes.

To make topping, cut together flour and butter. Mix in sugar. Add pecans and mix. Sprinkle topping over baked pie. Return to oven and bake 12 to 15 minutes longer. Cool to room temperature. Chill before serving. Serve with whipped cream, if desired.

Chess Pie

2	tablespoons flour		½	cup milk
1½	cups sugar		1	scant teaspoon lemon juice
2	tablespoons cornmeal		1	teaspoon vanilla
1	stick butter, melted		1	(10-inch) pie crust, unbaked
3	eggs, lightly beaten			

Sift flour, sugar and cornmeal together into a bowl. Add melted butter and mix. Stir in egg, milk, lemon juice and vanilla. Pour mixture into pie crust.

Bake at 325 degrees for 45 minutes or until center is firm. Refrigerate until ready to serve.

Yield: 8 servings

Cranberry-Mincemeat Tarts

8	(3½-inch) tart shells, unbaked		½	cup granulated sugar
1	cup fresh cranberries		¼	cup brandy
1	cup prepared mincemeat		½	cup coarsely chopped walnuts
⅓	cup light brown sugar			

Prick bottom and sides of tart shells and place on a baking sheet. Bake at 350 degrees until golden brown.

Rinse cranberries with cold water, removing stems and any spoiled berries; drain. Place cranberries in a large saucepan. Add mincemeat and both sugars and bring to a boil. Cook 10 minutes, stirring occasionally. Add brandy and walnuts and mix well. Remove from heat. Fill baked tart shells with cranberry-mincemeat filling.

Bake at 400 degrees for 15 minutes or until set. Cool on a wire rack. Top with whipped cream.

CRANBERRY WALNUT PIE

1	cup sugar	3	tablespoons butter, melted
¼	cup flour	½	teaspoon orange zest
1	(16-ounce) package cranberries	2	prepared pie crusts, 1 baked and 1 unbaked
½	cup golden raisins	1	egg
⅓	cup chopped walnuts	1	tablespoon water
¼	cup fresh orange juice		

Mix sugar and flour; set aside. Pulse cranberries in a food processor until pea-size. Combine cranberries with raisins, walnuts, orange juice, butter and orange zest.

Sprinkle half of sugar mixture over the bottom of the baked pie crust. Top with a layer of half of cranberry mixture. Repeat layers. Place unbaked pie crust on top and cut decorative shapes or simple slits in pastry to allow steam to escape.

Beat egg with water and brush over top crust of pie. Bake at 400 degrees for 45 minutes. Cool on a wire rack.

Yield: 8 servings

MERINGUE FOR PIES

2 egg whites
¼ cup cream of tartar

¼ cup sugar
½ teaspoon vanilla

Whip egg whites with cream of tartar until starting to stiffen. Add sugar and whip to peaks. Beat in vanilla at the end.

Spread meringue over pie filling, making sure meringue is sealed to the crust edge and that there are no holes.

Bake at 350 degrees for 10 minutes or until browned.

Be sure that pie filling and crust is totally cooled before adding meringue. If the meringue is sealed, the crust will not be watery.

Grandmother Nicholson's Pecan Pie

3	eggs		pinch of salt
½	cup sugar	1	teaspoon vanilla
1	cup light corn syrup	1	pie crust, unbaked
1	cup chopped pecans		

Beat eggs with a fork. Add sugar and corn syrup. Add pecans, salt and vanilla and beat thoroughly. Pour mixture into unbaked pie crust.

Bake at 300 degrees for 45 minutes.

If using a store-bought pie crust, bake pie crust and filling in an iron skillet.

Easy and always a hit!

Pecan Pie
(St. Andrew's Bazaar)

2 teaspoons of flour (stir into sugar)

1	cup sugar	1	teaspoon vanilla
¾	cup corn syrup	¼	teaspoon salt
¼	cup pancake syrup	1	cup chopped pecans
4	tablespoons butter, melted	1	(9-inch) pie crust, unbaked
3	eggs, lightly beaten		

Combine sugar, corn syrup, pancake syrup and melted butter in a mixing bowl. Beat slowly. Add egg, vanilla, salt and pecans. Pour mixture into unbaked pie crust.

Bake at 350 degrees for 50 minutes or until set. If top of pie is getting too brown while baking, cover with a sheet of foil.

Pie can be baked ahead and frozen.

Pumpkin Pie

3½ cups cooked pumpkin
1 cup light brown sugar
1 cup granulated sugar
3 tablespoons light molasses
3 tablespoons bourbon or dark rum
4 egg yolks
1 cup heavy cream
¾ cup whole milk

1 tablespoon cinnamon
1 tablespoon ground ginger
¼ teaspoon nutmeg
¼ teaspoon ground cloves
5 egg whites
 pinch of salt
2 tablespoons granulated sugar
1 pie crust, unbaked

Jean Seymour

Beat pumpkin with brown sugar, 1 cup granulated sugar, molasses, bourbon, egg yolks, cream, milk, cinnamon, ginger, nutmeg and cloves until smooth.

In a small bowl, beat egg whites until foamy. Beat whites with salt until soft peaks form. Gradually, by sprinkling, beat in 2 tablespoons granulated sugar. Beat one-fourth of the whites into pumpkin mixture, then fold in remaining whites. Spoon mixture into pie crust just to the rim.

Bake at 450 degrees for 15 minutes. Reduce oven temperature to 350 degrees and bake 15 minutes longer. Turn off oven and leave oven door ajar for 20 to 30 minutes to allow pie to finish baking.

Serve with freshly whipped cream flavored with bourbon or rum, whichever liquor was used in pie.

St. Andrew's Cathedral Fudge Pie

3	tablespoons cocoa powder	1	(5⅓-ounce) can evaporated milk
1½	cups sugar	1	teaspoon pure vanilla extract
1½	sticks butter, melted	1	(9-inch) pie crust, unbaked
2	eggs		

Combine cocoa and sugar in a mixing bowl. Pour in melted butter and mix with an electric mixer. Beat in eggs, milk and vanilla.

Place pie crust in a greased glass pie dish. Pour liquid mixture into pie crust. Place pie on a baking sheet.

Bake at 325 to 350 degrees for 45 to 50 minutes. The pie will be shaky and look undercooked. Remove from oven and let stand until completely cooled. Refrigerate overnight.

This is a very rich and fudgy pie. It is the recipe we made every year for the day of the Bazaar — Everyone loved it!

Scotch Apple Pie

4 apples, peeled and sliced
 juice of ½ lemon
½ cup granulated sugar
I stick butter, softened

I cup granulated sugar
I cup brown sugar
I cup flour

Arrange apple slices in a greased pie pan or shallow casserole dish. Sprinkle lemon juice and ½ cup granulated sugar over apple and let stand.

Cream butter with I cup granulated sugar, brown sugar and flour. Drop mixture over apple slices.

Bake at 300 degrees until bubbly. Serve with cheese or whipped cream.

Yield: 3 to 4 servings

Pie can be made ahead and frozen.

Meringues

6 egg whites
2 cups sugar

2 teaspoons baking powder
I tablespoon vinegar

Beat egg whites until stiff, adding sugar and baking powder gradually while beating. Add vinegar last. Shape meringue into circles on a foil-lined baking sheet. (Do not use an insulated baking sheet.)

Bake at 250 degrees for I hour. Remove from sheet while hot. Serve with ice cream and your favorite sauce or fruit, or fill with Lemon or Lime Curd (page 303). Store in an airtight container.

Topsy Turvy Apple Pie
(to die for!)

GLAZE AND CRUST

¼ cup brown sugar, or more if needed

I tablespoon butter, melted, or more if needed

I tablespoon corn syrup

¼ cup pecan halves, or more if needed

I (15-ounce) package refrigerated pie crusts, softened

FILLING

⅔ cup sugar

2 tablespoons flour

½ teaspoon cinnamon

4 cups peeled and thinly sliced apples, Granny Smith preferred

Combine brown sugar, butter and corn syrup in a 9-inch glass pie pan. Mix well and spread evenly in the bottom of the pan. Arrange pecans over mixture. Place I refrigerated pie crust over the pecans.

For filling, mix sugar, flour and cinnamon in a small bowl. Arrange half of apple slices over pie crust in pan. Sprinkle with half of sugar mixture. Repeat apple and sugar mixture layers. Top with remaining pie crust. Seal edges and flute. Cut slits in top crust and place pie on a foil lined baking sheet.

Bake at 425 degrees for 8 minutes. Reduce oven temperature to 350 degrees and bake 35 to 45 minutes longer. After removing from oven, immediately run knife around edge of pie to loosen. Invert pie onto a serving plate.

ℒEMON ℂURD

1 cup sugar	1 stick unsalted butter, cut into small pieces
6 egg yolks, beaten and strained	zest of 1 lemon
½ cup fresh lemon juice, strained	

Place sugar, egg yolks and lemon juice in a medium saucepan over low heat, or in a double boiler over simmering water. Whisk to combine, then switch to a wooden spoon. Cook slowly, stirring constantly, until mixture coats back of spoon. Cook a few minutes longer but do not boil. Remove from heat. Stir in butter and lemon zest. Cool. Cover with plastic wrap until ready to use.

Use a zester before cutting lemon and make strips to decorate top of curd. Limes may be substituted for Lime Curd.

Cut circles in a pastry crust with a biscuit cutter. Prick circles with a fork and press into mini muffin tins. Bake pastry cups and cool completely before adding lemon curd. Mini tart shells may also be used.

WHIPPED CREAM

1 pint heavy cream, chilled *1-2 teaspoons confectioners' sugar*

Chill a stainless steel bowl in the freezer. Add cream to chilled bowl. Beat with an electric mixer on high. When cream starts to thicken, add sugar and beat until peaks form; do not overbeat.

If serving over fresh berries in a bowl, add a little Grand Marnier to the cream instead of the confectioners' sugar.

COMMITTEE

EDITORS

Susan Goza Hill
Anne Stallworth McKeown

Ann Brock
Meredith Creekmore
Helen DeFrance
Dottie Donaldson
Susan Duke
Darian Green Gibson
Jimmy Rosen
Judith Travis

Artist Unknown

RECIPE TESTING CHAIRMEN

Gayle Adams	Judy Morris
Christine Barron	Dianne Morse
Helen Dalehite	Melissa Neville
Ouida Drinkwater	Susan Osborne
Betty Hise	Kent Peters
Katie Lampton	Sharon Rhoden
Sandra McLaurin	Rose Lee Robinson
Thad McLaurin	Grace Smith

ℳARKETING 𝒞OMMITTEE

CHAIRMAN Nancy Flowers Seepe

Thorne Butler
Ellen Gully
Melinda Prather
Pamela Prather
Alice Skelton
Olivia Thompson

ART FROM THE COLLECTIONS OF:

Gayle & Holmes Adams	Meredith & Jimmy Creekmore	Margaret & Bill McLarty
Jim Becker	Dottie & Joe Donaldson	Anne & Alan Perry
Beverly Blake	Susan & Frank Duke	Tillie & Jimmy Rosen
Ann Brock	Darian Green Gibson	Susan S. & Howard Jones
Virginia & Minor Buchanan	Claudia & Robert Hauberg	Ollie & Bob Thompson
Cathedral Church of Saint Andrew	Susan & Bill Hill	Miriam & Tommy Weems

SPECIAL THANKS AND ACKNOWLEDGEMENTS

To Bill Hill for his financial guidance

To Dorothy Hannah Kitchings for connecting our purpose and passion with wonderful recipes and artwork from cathedral communicants in her introductions

To John Fontaine for his foreword following the time line of feasting at St. Andrew's

To Duke Cain for his printing assistance

To Gloria Walker for the opportunity for presales at the Parish Party Soireé

To Holmes Adams for his wise council

CONTRIBUTORS

Barbara Adams
Gayle Adams
Claire Sykes Alexander
Alex Allenburger
Susan Allenburger
Ivy Alley
Ann Allin
Betty Allin
Lee Allison
Ann Anderson
Ida Anderson (dec)
James Anderson
John Anderson
Lois Anderson
Sara Anderson
Christine Barron
Bryan Barry
Temple Barry
Esther Baugh
Ellen Bear
Betty Beck
Honey East Bennett
Brenda Bethany
Dot Bittick
Ginger Blanchard
Susan K. Bock
Cathy Boyle
Jan Brackett
Julie Braswell
Michele Breaux
Frank Briggs
Mary Jo Briggs
Ann Brock
Jane Brock (dec)
Dubar Brown
Virginia Buchanan
Celia Burnham
Jean Burns
Duke Cain
Clara Frances Cannon
Marsha Cannon
Charlotte Carlton
Carol Carrothers
Robin Carter

Julia Chadwick
Nancy Cheney
Jim Child
Sybil Child
Laura Clapp
Roger Clapp
Ashley Cole
Gwen Cole
Emma Connolly
Robert Connolly
Anne Cook
Betsy Copeland
Meredith Creekmore
Janie Criddle
Susan Culbertson
Dean Dabbs
Helen Dalehite
Joan Dattel
Marcia Davis (dec)
Brenda Day
Dick Dickerson
Dottie Donaldson
The Very Rev. Todd Donatelli & Becky
Judy Lane Douglass
Cheryl L. Drennan
Jennifer Drinkwater
Ouida Drinkwater
Pat Drinkwater
Wayne Drinkwater
Betty Duckworth
Frank Montgomery Duke
Helen Duke
Susan Duke
Ella May East
Ella Edwards
Debby Egger
Gay and David Elliott
Donna Evans
Deborah Feldman
Ellen Ann Fentress
Charlotte Field (dec)
Mike Flannes
Spence Fletcher
Eleanor Fontaine
John Fontaine

Mary Ann Fontaine
Crew Hall Fowler
Sheryl Fox
Larry Franck
Darian Gibson
Dianne Goetter
Jeff Good
Nan Graves Goodman
Irene Graham
Janice and Russ Grant
Kathy Gray
Billie Green
Mary Sydney Green
Nicki Green
Susan and A.W. Greer
Ellen Gully
Eve Hall
Emma George Hamilton
Mary Beth Harkins
Weegie Harris
Claudia Hauberg
Robert Hauberg
Corinne Hegwood
Merle Henderson
Barry Duke Hendricks
Catherine N. Hester
Joan Hewes
Bill Hill
Susan Hill
Betty Hise
Sis Holland
Anne Hooker
Ross Hooper
Anna Howard
Kathy Howard
Mary McCollum Hughes
Danielle Ireland
Charles Jackson
Lee Jackson
The Rev. David Johnson
Kathy Johnson
Susan and Howard Jones
Linda Kay
Kathleen Keeton

Beverly Kelly
Dave Kelly
Linda Kennedy
Cheryl Kirchner
Beth Kitchings
Van Lackey
Barbara Ladner
Donna Lander
Pamela D. Leonard
Shawn Leopard
Michelle Lewis
Lesly Lloyd
Donna Lydick
Tippy Lyell
Nan Mangum
Sandra Maris
Laurie McCarley
Anne Stallworth McKeown
Merrill McKewen
Elizabeth McKinley
Sandra McLaurin
Thad McLaurin
Susan McNease
Diane Meakin
Jean Medley
Emily Merrill
Peter Meyers
Jean Miller
Allen Mize
Pink Nance Mize
Amelia Montjoy
Kellye Montjoy
Joe Morris
Judy Kell Morris
Melanie and Jim Morris
Frances Morrison
David Morse
Diane Morse
Frances Morse
Rosemary Mosby
Durden Moss
Martha Lou Nance
Betsy Nation
Bill Nation
Frances Jean Neely
Sandy Nelson
Melissa Neville
Bettye Nicholson
Jo Timberlake Nicholson

Susan Nix
Sandy Norton
Donna Orkin
Diana O'Toole
Amanda Overby
Chan Patterson
Kay Patterson
V. A. Patterson
Charlotte Paul
John Paul
Carol Penick
Anne Perry
Kent Peters
Mary Ann Petro
Bill Phelps
Pamela Prather
Malinda Prather
Hank Rainer
Nancy Ranager
Karen Redhead
Betty Lou Reeves
Rodger Reeves
David Reynolds
Sandi Rhoden
Sharon Rhoden
Tom Rhoden
Sarah Ridgway
Susan Ridgway
Anne Robertson
Linda Robertson
Rose Lee Robinson
Leah Roland
Kay Rone
Nancy Sanders
Rebekah Sanders
Connie Schimmel
Betty Scott
Jeff Selman
V.V. Selman
Ann Yerger Simpson
Marcie Skelton
Grace Smith
Janet Smith
Jean Speed
Lecia Spriggs
Eula Stanley
Joye Steele
Alison Steiner
June Stevens

The Rev. Carol B. Stewart
Sue Stock
Flo Stover
Ward Sumner
Joe Surkin
Katharine McKee Surkin
Evelyn Tackett
Helene Tann
Jackie Tatum
Sandy Temple
Cynthia Temples
Ann Thomas
Helene Thompson
Olivia Thompson
Phyllis Thompson
Callie Thornhill
Lee Threadgill
Larry Tiller
Judith Travis
Dorothy Triplett
Patsy Turner
Laura Underwood
Paul Vanderberry
Lynn Vanderford
Virginia Vardaman
Dorsey Wade
Gloria Walker
Maribeth Wann
Kathryn Watkins
Julian Watson
Betti Watters
Miriam Weems
Elizabeth Weir
Frances White (dec)
Anita Whitley (dec)
Posey Wideman
Sallye Wilcox
Elizabeth Copeland Wilmer
Polly Keller Winter
Joe Wise
Alabel Wiser
David Womack
Susan Womack
Celia Wood
Dan Woodliff
Deniese Thornhill Wright
Melanie Wright
Monroe Wright (dec)
Carey Yelverton
Sally Yelverton

CONTACT THE CRISIS LINE

An emergency hot line. Assists callers by listening and referring them to various agencies when necessary.

GOOD SAMARITAN CENTER*

Assists families and individuals in crisis in central Mississippi. Operates NUTS (Neat Used Things for Sale) second hand store, Cooks Meals-on-Wheels and runs a Montessori daycare for children from metro Jackson.

GRACE HOUSE

Shelter for those diagnosed as HIV positive, Grace House houses a social worker and counselor.

HABITAT FOR HUMANITY – METRO JACKSON

30 volunteers per day to 'blitz-build' a new house in one week. All skill levels welcome!

HARBOR HOUSE

Treatment center for alcohol or drug addiction. Helps those who may not be financially able to seek treatment at other facilities.

JACKSON FREE CLINIC

Open from noon until 4 P. M. and staffed with volunteer doctors, nurses, medical students and non-medical volunteers who provide medical care to inner city people.

LUTHERAN EPISCOPAL SERVICES IN MISSISSIPPI*

Volunteers do hurricane relief work on the Gulf coast and assist families resettled in Jackson.

MCLEAN FLETCHER CENTER*

Offers counseling at no charge to children who have experienced a trauma due to violence, a death or other life-changing event.

NORTH MIDTOWN COMMUNITY DEVELOPMENT CORPORATION

Seeks to redevelop Midtown through housing restoration, education, improved quality of life and economic development. They have an after school tutoring program and also have a GED and Tutoring Center for adults.

OPERATION SHOESTRING

Founded in 1968. Volunteers assist in after school and summer programs for families and children: enrichment, reading, parenting, the arts. Food pantry.

ROWAN MIDDLE SCHOOL

Our adopted school, St. Andrew's assists by collecting school supplies and sponsoring teacher appreciation events.

STEWPOT COMMUNITY SERVICES*

~ Billy Brumfield House

~ Food Pantry

~ Matt's House

~ Sims House

~ Soup Kitchen

~ Summer Camp

Founded or co-founded by parishioners from St. Andrew's Cathedral.

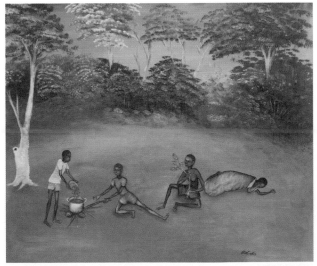

Bol Aweng

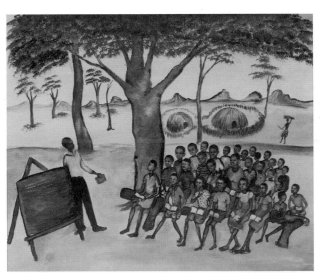

Bol Aweng

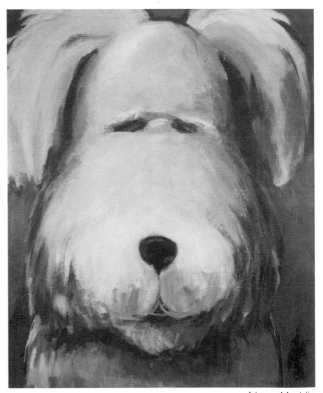

Nancy Mauldin